Surpassing the Spectacle

Culture and Politics Series

GENERAL EDITOR: HENRY A. GIROUX, PENNSYLVANIA STATE UNIVERSITY

Postmodernity's Histories: The Past as Legacy and Project (2000)
Arif Dirlik
Collateral Damage: Corporatizing Public Schools—A Threat to Democracy (2000)
Kenneth J. Saltman
Public Spaces, Private Lives: Beyond the Culture of Cynicism (2001)
Henry A. Giroux
Beyond the Corporate University (2001)
Henry A. Giroux and Kostas Myrsiades, editors
From Art to Politics: The Romantic Liberalism of Octavio Paz (2001)
Yvon Grenier
Antifeminism and Family Terrorism: A Critical Feminist Perspective (2001)
Rhonda Hammer
Welcome to Cyberschool: Education at the Crossroads in the Information Age (2001)
David Trend

Forthcoming

Dangerous Memories: Educational Leadership at a Crossroads
Barry Kanpol
Ethics, Institutions, and the Right to Philosophy
Jacques Derrida, edited and introduced by Peter Pericles Trifonas
Growing Up Postmodern
Ronald Strickland, editor

Surpassing the Spectacle

Global Transformations and the Changing Politics of Art

Carol Becker

ROWMAN & LITTLEFIELD PUBLISHERS, INC.
Lanham • Boulder • New York • Oxford

ROWMAN & LITTLEFIELD PUBLISHERS, INC.

Published in the United States of America
by Rowman & Littlefield Publishers, Inc.
4720 Boston Way, Lanham, Maryland 20706
www.rowmanlittlefield.com

12 Hid's Copse Road, Cumnor Hill, Oxford OX2 9JJ, England

Chapter 1 was first published, in radically different form, in *The Review of Education/Pedagogy/ Cultural Studies* 17 (1996), pp. 385–95.
Chapter 8 appeared in an earlier form in *Performance Research* 5, no. 3 (winter 2000).
Chapter 9 appeared in an earlier form in *Art Journal* 57, no. 2 (summer 1998), pp. 87–107.
Chapter 10 appeared in an earlier form in *Art Journal* 58, no. 2 (summer 1999), pp. 22–29.
Chapter 11 was first published, in radically different form, in *The Review of Education/Pedagogy/ Cultural Studies* 19 (1997), pp. 193–208.
Chapter 12 appeared in an earlier form in *Art Journal* 59, no. 3 (fall 1999), pp. 45–47.

The epigraph on p. 87 is by George Oppen, "Route" in *Collected Poems*, copyright © 1975 by George Oppen. Reprinted with permission of New Directions Publishing Corp.

Color plate: Chris Ofili/Victoria Miro Gallery, *Holy Virgin Mary*, 1996, mixed media, 243.8 cm × 182.8 cm.

British Library Cataloguing-in-Publication Information Available

Library of Congress Cataloging-in-Publication Data

Becker, Carol.
 Surpassing the spectacle : global transformations and the changing politics of art / Carol Becker.
 p. cm.—(Culture and politics series)
 Includes bibligrapical references and index.
 ISBN 0-7425-0919-2 (cloth : alk. paper)—ISBN 0-7425-0920-6 (pbk. : alk. paper)
 1. Art and society—United States—History—20th century. 2. United States—Social life and customs—20th century. I. Title. II. Series

N72.S6 B3827 2001
700'.103—dc21 2001044382

Printed in the United States of America

♾ ™ The paper used in this publication meets the minimum requirements of American National Standard for Information Sciences—Permanence of Paper for Printed Library Materials, ANSI/NISO Z39.48-1992.

For Herb Schiller

Contents

Preface ix

Acknowledgments xi

Introduction 1

1 The Artist as Public Intellectual 11

2 The Nature of the Investigation: Art-Making in a Post-Postmodern Era 21

3 The Art of Testimony 35

4 Brooklyn Museum: Messing with the Sacred 43

5 Betrayal 59

6 Trial by Fire: A Saga of Gender and Leadership 65

7 Reconciling Truth in South Africa 77

8 Memory and Monstrosity 87

9 The Second Johannesburg Biennale 101

10 The Romance of Nomadism 117

11 Art and Ecology 127

12 GFP Bunny and the Plight of the Posthuman 137

13 Surpassing the Spectacle 143

Index 153

About the Author 161

Preface

On the morning of September 11, 2001, I was headed for South Africa via Atlanta. We left Chicago at 6 a.m. and some minutes before our scheduled arrival were told that we were in a holding pattern because there were too many other planes also trying to land. We didn't as yet know why. By 9 a.m., when we finally did land, the passengers on my flight began to rush to make their respective connections, but we were all stopped in our tracks by hundreds of other travelers frozen and mute in front of airport monitors. The image that greeted us on arrival—the first plane shooting into and through the World Trade Center—will never be forgotten. It will forever mark the lives of those who watched it happening in real time, as have the assassinations of John F. Kennedy, Bobby Kennedy, and Martin Luther King, Jr.

With thousands of others, I was decanted from a grounded Atlanta airport into chaos, finally arriving at a run-down hotel trapped between two expressways. After three days glued to CNN with the rest of America, I finally was able to leave for South Africa, where I spent a week in mourning and conversation with a spectrum of people—from government officials to township women in Kwazulu Natal—all of whom were equally fixated on the week's horrific events.

It is not that all we thought before September 11 is now wrong; a great deal of serious intellectual and artistic work done before that date bears great relevance to all that has occurred. Work around globalization; restorative justice; democracy; difference; and many of my own essays to follow, written between 1996 and 2001, focus on such concerns. Rather, it is that our collective consciousness has changed, and even our discourse

around these issues has begun to transform. What was imminent but invisible has now been actualized. What was unimaginable now haunts our consciousness, unrelentingly. Where there was complacency there is now trauma. Urgency marks all political discussions. New communities have arisen based on heroic gestures and compassion, as have those founded on their inversion—fear and hatred. The role of intellectuals and educators working in various disciplines has become increasingly important. Many such thinkers have moved quickly to assume their roles as public intellectuals and write informed, sophisticated commentaries, while most U.S. citizens scramble to learn the complexities of societies to which we paid little attention before.

Surpassing the Spectacle was already in its final stages of production when these catastrophes took place, but I felt it was essential, as I am certain other writers and artists will as well in relationship to their own work, to acknowledge that the process of reading these essays is inevitably transformed for me, as well as for the reader, by all that has occurred. Culture critics, working out from the present moment, are always affected by world events. Inevitably there is the desire to reposition one's arguments in relationship to changes in history. But rarely do events transform the physical, psychic, intellectual, and spiritual landscape as dramatically as those of September 11. In response, some of the essays to follow seem disconcertingly prescient, while others might perhaps be reframed to acknowledge all that has been learned, were I able to reimagine them now. Nonetheless, when I reread the proofs for this book some months ago, I found myself surprised by the seriousness of its political tone. Perhaps we all had some inkling that we were on a precipice. But what at that time might have felt forbidding in its *gravitas* now seems all too appropriate.

Grateful to have the vehicle of writing, I understand my work, and this book in particular, as a moment in an ongoing process of collective analysis that demands constant vigilance from us all to achieve a very necessary clarity of thought. It seems imperative to note that to love one's country at this time, as at all times, *is* to engage its domestic and foreign policies critically. It is this criticality that will allow us to move our collective imaginings forward with intelligence, so that we might create what Edward Said, quoting Pierre Bourdieu, calls "realist utopias"—just, equitable, safe societies that now, more than ever, need us to dream them into existence.

Chicago, Illinois
October 6, 2001

Acknowledgments

Many of these essays began as lectures that I gave over the last few years at art schools, colleges, universities, galleries, and museums from Anchorage to Johannesburg. I have reworked them innumerable times in accordance with the responses I received. The questions raised by artists, students, educators, administrators, public-policy makers, the passionate statements made by various audience members in many different locations around the world, have truly caused me to reevaluate my premises. From these public presentations I was able to observe a great deal about what was actually heard when I read from these essays and what was lost. I also learned what issues mattered most to socially conscious people interested in art and democracy. For all the help that my various audiences have offered in this regard and for their enthusiasm about the ideas represented in these essays, I am very grateful.

The School of the Art Institute, my home for over twenty years, supported the completion of this book by granting me a long-overdue sabbatical that allowed me the psychic space to complete this text. For their confidence that I would use this opportunity well, I thank my colleagues, especially all the members of the Cabinet, President Tony Jones, the Office of the Dean, and, in particular, Jana Wright.

The Rockefeller Foundation offered me precious and blissful time at their Study Center in Bellagio. Not only was I able to work in the fabulous Villa Serbelloni, but there I met an intriguing group of people who affected my thinking on many issues and also became close friends.

I would like to thank my coeditorial board members at *Art Journal* and, in particular, Janet Kaplan and John Farmer for encouraging the development

of certain ideas into essays and allowing me the creative space to play—in both form and content.

Jean Fulton has worked closely with me as my editor on so many projects that I truly cannot imagine completing a book without her. Once again she has been a superbly intelligent reader, offering criticisms and suggestions that have invariably improved the quality of the text. The book is considerably more lucid because of her help.

Henry Giroux, my dear, dear friend and comrade, once again provided access for me to move this book forward. I thank him for always encouraging my work and for introducing me to Dean Birkenkamp at Rowman & Littlefield, who has been supportive from our first encounter. Christine Gatliffe also helped immeasurably to shepherd the manuscript into book form.

I would also like to thank friends in South Africa who helped me to understand the meaning of the Truth and Reconciliation process in South African society, especially: Andries Botha, Wilmot James, Ora Joubert, Marilyn Martin, Albie Sachs, Julia Teale. Alex Boraine was more than generous in taking time to provide specific information at the early stages of my investigation.

Those astonishing friends who saw me through a few unexpected turns on the path need to be thanked here as well: Alda Blanco, Matthew Goulish, Lin Hixson, Roberta Lynch, Brigid Murphy, Judith Raphael, Kathryn Sapoznick, and Carole Warshaw. Thank you also to Carlos Blanco, Iris Blanco, and Anita Schiller, who over the last years read many of these essays, always with care and insight. My special gratitude to the Ven. Samu Sunim who has taught me to value the "unknowing mind" and to Jack Murchie for a thousand kindnesses along the way.

This book is dedicated to Herb Schiller, friend and teacher, who is missed by many at a time when so much of what he predicted over decades in his writing has now so disastrously become reality. I continue to be inspired by his spirit and his unrelenting determination always to put up a good fight.

Introduction

> The society whose modernization has reached the stage of integrated spectacle is characterized by the combined effect of five principal features: incessant technological renewal; integration of state and economy; generalized secrecy; unanswerable lies; an eternal present.
>
> —Guy Debord[1]

In my attempts to comprehend the increasing degree to which the spectacle dominates U.S. society and to imagine surpassing it, even in thought, I have returned again and again to the writings of Guy Debord. It is astounding how refreshing and relevant they still seem.[2] First published in 1967, his most well-known text, *Society of the Spectacle*, has since penetrated many aspects of critical writing about contemporary society. This quixotic manifesto was Debord's call to arms to overthrow a system of dominance that he believed turned *being* into *having* and *having* into *appearing*—thus alienating himself and his fellow citizens from the economic and cultural reality of their situation.[3] His impassioned, confident, unequivocally enraged voice articulates the dilemma of the shrinking public sphere and the failures of social criticism to permeate the phenomenon he terms *the spectacle*. Debord writes: "There is no place left where people can discuss the realities which concern them, because they can never lastingly free themselves from the crushing pressure of media discourse and of the various forces organized to relay it."[4] No matter how much Debord attempts a clear definition, the spectacle still eludes us because it is so all-encompassing, inclusive of everything relating to the economy as well as its "self-representation." "The spectacle," he

1

writes, "is not a collection of images, but a social relation among people mediated by images."[5]

Debord is amazed that French society has turned against a two-hundred-year tradition of self-examination and that it now no longer encourages "criticism or transformation, reform or revolution."[6] For Debord this is the result of the spectacle that has come to dominate all aspects of reality such that nothing can exist outside it and no organized movement yet exists to effectively depose it. In such a distorted situation, the more important that social issues become, the more they are hidden. It insidiously causes citizens to feel mistrustful of political discourse, impotent to effect change, and convinced that they must separate themselves from the political in order to live meaningful, joyful, creative lives. Such reactions are death to a democracy, and yet Debord sees no way out, short of revolution—a word that has long ago passed out of contemporary rhetoric, even among the most radical social critics and activists. "The spectacle isn't the world of vision, it is the vision of the world permeated by the powers of domination."[7] Penetration into all aspects of daily life is now complete. And over time we have organically absorbed Debord's concept to mean everything woven into the invisible veil that prevents us from making a clear evaluation of our situation or organizing to change it.

The 2000 presidential election was a terrifying example of spectacle culture at its most confusing and contradictory. While many were disgusted, angry, and disenfranchised by an unjust voting process, others seemed lulled into semidelirium, casting votes against their own self-interests, for a candidate whose politics champion protecting the well-being of only a very particular group of citizens.

A Bush presidency had once seemed inconceivable. How did it become possible? Why would so many Americans choose a president who appears so provincial, inexperienced, reluctant, vacuous, arrogant and, most significant, uninterested in international affairs? There were those who didn't believe Bush was smart enough and others who weren't sure he was competent enough, yet they voted for him. On election day one voter told a National Public Radio reporter that he was voting for Bush even though Bush hadn't done a good job as governor of Texas. "But," he offered optimistically, "maybe he'll do better as president." While Bush's intelligence was rated low even among some of his supporters, Al Gore was repeatedly ostracized for being "too smart," a liability in the United States where "too smart" is equated with smart aleck—the kid in fourth grade (often a he) who always had his hand up first to answer the teacher's questions. But who could ever be too smart when the issues facing our own country and the rest of the world are so daunting? It didn't seem to matter to half the voters that George W. had traveled so little outside the United States or that he didn't appear to have any idea what the Supreme Court decision

on affirmative action actually was; rather, it mattered that they *thought* he was a nice guy, someone they might want to wake up to each morning on their television screens, someone with whom average citizens could identify as being just like them. Too many were caught in the spectacle. In Debord's terms, "When social significance is attributed only to what is immediate, and to what will be immediate immediately afterwards, always replacing another, identical immediacy, it can be seen that the uses of the media guarantee a kind of eternity of noisy insignificance."[8]

The "noisy insignificance" and false "immediacy" that catalyzed too many votes in this last presidential election had very little to do with the actual complexity of the contemporary world as it transforms around us at a rapid rate, or the day-to-day reality of representing U.S. interests within a very sophisticated and interconnected global economy. The criteria for casting votes often did not take into account the reality of a far more interwoven and fluid international situation than has ever before been witnessed. It would seem the leader of this nation, who will inevitably play a key international leadership role, would need to be truly informed about global events or at least demonstrate curiosity about the particularities of such challenges.

One of these new paradigms, the economic situation of greater global interrelatedness, has received a great deal of attention in the press. Yet few, if any, truly understand what it means to have no national boundaries in relationship to information or economics. Many find this situation disconcerting, characterized by uncertainty and a lack of coherent rules. The complexity of this new globalization leaves most people feeling less powerful than ever. And so while some are embracing this change wholeheartedly, others, out of fear, are attempting to revive nationalist fervor in many parts of the world, fighting to keep all barriers up and fortified. Even those who are sympathetic to these changes are unable to understand the breadth of this new situation or to imagine how to effect change within it. Jean-Marie Guehenno writes: "We are caught between the solitary individual and a globality that cannot be mastered but which it is no longer possible to ignore."[9] And Frederic Jameson writes: "Globalization is rather a kind of cyberspace in which money capital has reached its ultimate dematerialization, as messages which pass instantaneously from one nodal point to another across the former globe, the former material world."[10]

One aspect of the divided vote for U.S. president is represented by what Terry Eagleton calls the split between cosmopolitanism and fundamentalism—those who understand and are open to this new global, diversified, and dematerialized world versus those who want to retreat to very conservative notions of home, family, religion, and national boundaries. These opposed forces exist within each nation and across nations as well.

In one example of this divide, the United States has often split between urban and rural, with each geographic region mistrustful of the values of the other. Major cities in the United States tend to reflect a cosmopolitanism, a worldview more similar to those of other large urban centers around the world than those of small towns in America.

At the heart of this ambivalence about change is a tendency to want to simplify the complexity of U.S. society through the denial of difference. In his important book *The Uses of Disorder* (1996), Richard Sennett focuses on the desire on the part of many U.S. citizens, at times represented in the move from urban centers to the suburbs, to simplify and deny the otherness, difference, and complexity of American life by attempting to create a more homogeneous sense of community.[11] Sennett writes of the value of living in close proximity and of necessity with a wide range of people in New York neighborhoods and how significant this was to the well-being of early twentieth-century U.S. society:

> The old neighborhoods in cities were complex precisely because no one group had the economic resources to shield itself; the brownstone dwellers did not have the money to live one family to a house, and so shield the housing unit from influences outside the circle of one family.[12] . . . None of these areas of activity had enough power to control its own limits as a community. None of them was rich and centralized enough to wall itself off, and so each suffered the intrusion of others by necessity.[13]

Now, those with greater abundance construct the myth of "coherent community life" based on the illusion of sameness, rather than on the integration of difference.[14] Abundance, in other words, increases the power to create isolation in communal contacts at the same time that it opens up "an avenue by which men can easily conceive of their social relatedness in terms of their similarity rather than their need for each other."[15]

With the proliferation of gated communities, this type of isolation has reached new levels of literality. In Sennett's terms, the move to and embrace of suburbia was about escaping the urban and creating a world that could be completely controlled. The illusion of control is equated with the security of sameness. If all houses look alike, if people interact with others only like themselves, if everyone has the same clothes, cars, and aspirations, then life *should* stay ordered. But in fact this has not been the case.

The world was shocked by events at Columbine High School in Littleton, Colorado, for example, precisely because it was a white middle-class suburban school. How could teenagers from supposedly "good homes" kill their peers? It would appear that the vacuum created by greater homogenization may have contributed to the inability of the school community to deal with complexity and difference. The result: an ostracization of those who do not conform, and a difficulty for those outside the

mainstream to fully experience and embrace their own otherness. When such a process coincides with adolescence—a time when teenagers seek peer group acceptance above all else—a fear of difference can result. Sennett understands such a society, fatally stuck in adolescence, as a "society of fear" willing to be "dull and sterile" in order that it not be "overwhelmed."[16] By contrast, when there is a fuller spectrum of acceptable difference, it allows varying points of view, as well as the creativity that can accompany such otherness, to emerge as desirable. Sennett terms this phenomenon *uses of disorder*.

It is therefore not coincidental that at this time, when U.S. society seems caught between the complexity of a global economy, rapid technological change, tendencies to fundamentalist ideology, and an inevitable internal reckoning with its own self-image, we have chosen the most blank American president to date—a person who seems the least able to articulate contradictions, the last person to gravitate to complexity in art and literature, or to be interested in the subtleties of the myriad cultures that make up our society and our own newly globalized reality: a perfect figure to embody the vacuity of the integrated spectacle. Does this choice reflect an insidious desire for the safety that comes with dullness, with the absence of curiosity and imagination? Or are people simply seeking escape from a feared, unknown future, and the desire to return to a simplicity that never did exist and certainly will not exist in the future?

At the start of the new millennium, what would constitute effective responses to the powerful, ubiquitous phenomenon of the spectacle? I would venture to say anything that punctures the veil—challenges the status quo, asks difficult questions about the actualization of democracy and the quality of human relationships under advanced capitalism, helps to create theory that ultimately brings people together under a coherent critique of the social totality, and, as Debord suggests, "goes alone to meet unified social practice."[17]

Artists flock to the ambiguities and marginalities that cause others to flee. They find inspiration in the seeming disorder of urban life. Aware of and even known to revel in their own otherness, artists desire environments where they do not need to conform to a uniform version of adult behavior, acceptable work, or relationships. They then create around themselves the possibility of living the lifestyle that feels freest and most-encouraging of creativity. These centers of artistic production are in principle the opposite of suburban malls. They are about creative pursuits and fearless originality. They are not about acceptability of taste or mere repetition and reproduction.

Because artists bring new ideas about seeing, fabricating, and responding to history into the society, their work encourages disequilibrium, creates its own type of unpredictable disorder. Although it may take decades

to reach assimilation, over time these ideas become acceptable and are absorbed within the society. When this absorption is complete and these innovations of thought, images, or techniques have lost their creative edge, then it is time to generate more new concepts.

This regeneration of the imagination has always been the labor of artists, designers, and writers. But in a society seeking sameness and assimilation, while fleeing its most painful secrets, creative people are inevitably marginalized or even punished for fulfilling this expectation. Artists often raise the questions society seeks to mask and in so doing provoke its ire. If artists are willing to engage issues of sexuality, ethnic identity, racism, gender, history—personal and collective—alienation, and despair, when others are not, then of course they will appear to oppose those for whom repression of such concerns is a way of life. The impropriety of these issues resides not in having *experienced* such conflicts but, rather, in giving them form and bringing them into public awareness.

In their desire to absorb new images, artists naturally also seek out the complexity of a global environment, finding in that complexity the richness they need to develop their work. But increasingly the art world, which likes to think of itself as cosmopolitan, has also been threatened with homogenization—a flattening out of the visual landscape. Even with the proliferation of international biennials and a supposedly global art market, the international art world apparatus has been far too willing to accept uniformity—limited versions of what is fashionable in art-making that are often determined by the New York aesthetic. It would be a shame if now, as the world of artistic creation truly has the opportunity to become bigger, it actually became smaller. But because art also exists in history, it often must fight against the same trends, banalities, conflicts, obscurities, and complexities that can stifle and paralyze other aspects of society. It too must counteract the effects of the spectacle. Debord writes: "The real life of modern poetry and art—is obviously hidden, since the spectacle, whose function is to make history forgotten within culture, applies, in the pseudo-novelty of its modernist means, the very strategy which constitutes its core."[18]

In other words, nothing is free from the distortions and abstractions caused by the spectacle. Western artists and intellectuals, well aware of this phenomenon, have responded to the dominance of signs over reality for decades—the free-floating sign that has lost its signification, the role of the media in creating this phenomenon, and the obliteration of consciousness that allows a reality riddled with contradictions to be manipulated, diminished, and made acceptable to so many. We have long understood how the media flatten rather than problematize reality. Most generators of text and image understand, "An argument that cannot be summed-up in a single sentence has no media value."[19] And we are learn-

ing to live with the intangible and often absurd situation in which information is power, even though it would appear that the "primary goal of information is to acquire more information."[20]

This tension is at the heart of the dynamic of our societies; the world is becoming a gigantic stock exchange of information that never closes. The more information there is, the more imbalances there are, as in a great meteorological system—a wind that creates a depression here causes high pressure elsewhere.

What is particularly frightening about this entire interrelated ecosystem is that few can predict where the wind will blow next, or who and what might be swept up and away. We now live daily with such precariousness and the compulsion to acquire as much information as we can to stave it off. The greatest instability of all is the degree to which Americans have accepted this unknown new world—enamored as we are with technology—without understanding to what extent technology is an ideology that conveniently distracts us from the deeper problems eroding our society. Debord writes, "The spectacle is the main production of present-day society."[21] And now it diverts us from the problems facing global society as well, which is why the Seattle demonstrations in response to the meetings of the World Trade Organization were applauded by so many North Americans and have captured their imaginations. The demonstrators, often very young and idealistic, stripped the veil away for a time, revealing policies dominated by multinational corporate greed. Their actions gave others permission to ask this question: What might be the alternatives to such rampant exploitative globalization?

The false equilibrium maintained by the spectacle and enlivened and accelerated by speed and desire *must* be ruptured by social actions, art, and critical discourse. It is only in those moments of disruption, combined with *repair*, to use Lewis Hyde's term,[22] that there is the possibility to see beyond the spectacle or to see that at each transitional moment new permutations of the spectacle may be created. It is therefore futile to try to keep up; rather, we need to step away and aside to observe, critique, and *then* act.

Within this situation rests the challenge for writers, intellectuals, and artists to find viable means to communicate their critique of established reality and to articulate deliberate projects that align with the goals of others, to affect collective consciousness. Such projects, although difficult to articulate, are more essential now than ever as we struggle against a takeover of American political and cultural life by what is known perversely as the "radical right."

For two decades my project has been to combine my roles as writer, educator, public intellectual, and dean to affect consciousness—my own and that of others. I have chosen to position myself in the world of art schools

because I have found these environments to be some of the very few sites left in the United States where a creative approach to pedagogy is possible. To apply a phrase from Terry Eagleton, art schools are "not wholly absorbed by the logic of utility."[23] Thus such environments potentially allow the values of play, "nonproductive" production, and constructive recklessness to take hold in an educational setting, as they often do in art-making. These values essential to creativity stand in opposition to, and can counteract the banalities and seductions of, spectacle culture.

Like Eagleton, I do not believe in creating isolated utopian environments that have no impact on the plight of the larger society. I do not trust that such environments will *inevitably* affect a greater whole. But I do believe that they can present the possibility of an alternative way of thinking about productivity and offer the opportunity to help develop creative, competent artists, designers, arts administrators, historians, educators, theoreticians, and writers who can enter society creatively—conversant in multiple discourses, armed with an analysis of spectacle culture, and capable of forming new concepts and alliances. These practitioners of culture can become both the producers of and audience for art and writing that challenge the grip of the spectacle. I always keep in mind Eagleton's admonition: "If culture is an oasis of value, then it offers a solution of sorts. But if learning and the arts are the sole surviving enclave of creativity, then we are most certainly in dire trouble."[24]

The goal surely is to imagine a society in which creativity is understood as essential to all aspects of daily life. But even though there is now a great wealth of creative production in art, music, dance, theater, and writing across disciplines within the society, I have never felt the established reality less open to its influence or further from its dream of creative freedom than I do at present. This situation makes the pursuit of such goals that much more urgent.

The essays that follow embody the challenge to imagine the unimaginable—a society that believes in and encourages the making of art while recognizing the multiple functions art and artists can serve in society, or a U.S. society willing to and even desirous of a process to redress past atrocities with full disclosure that is as sophisticated and transparent as that of the Truth and Reconciliation Commission. The essays attempt to create a useful tension around such complex concerns, to bring them into public consciousness, and to challenge established perceptions of reality. They cover a range of topics, including the role of artist as public intellectual; the situation of art-making and the education of artists in a post-postmodern climate; the myth of the global citizen and the effects of globalization on the art world; the search for truth and reconciliation in South Africa and the refusal to attempt such a process in the United States; the unreconciled pain of the Vietnam War and its relationship to public mourning; the difficulties

and possible subversions of women in leadership; the relationship between the consciousness necessary to understand the importance of art and the necessity to create ecological balance; the complexities of "modifying" nature through experiments in the posthuman; betrayal, deception, the end of innocence, and how I never got over the Dodgers leaving Brooklyn.

In each essay I have tried to exact a rent in the veil, to look closely at the social realities that have often remained so hidden or embroiled in the larger spectacle of U.S. society that one cannot see the relationships among apparently disparate topics that are in fact interrelated. Throughout, I have marveled at the power of particular visual representations to bring much-needed complexity into the lives of U.S. citizens, and yet I am continually amazed at the capacity of the prevailing spectacle culture—composed, as it is, of images—to ignore or, worse, attempt to malign or obliterate significant social statements made in art.

These essays represent the last five years of my own struggle to understand why we as a species—as nations and as individuals—allow ourselves constantly to be seduced away from our task as citizens to create a transparent democracy; why we deny the wealth of our own creativity; refuse to employ this power to envision more equitable social structures; or to mobilize our observations into actions; and how we might use our collective intelligence to transcend such ambivalence and reestablish meaning for seriously compromised words such as *humane* and *accountable* as we embark on this next millennium.

Within my ongoing dream of articulating effectively such large concerns, I have often thought of Paul Virillio—master of sprinting ahead of the spectacle to reflect on its evolution—who, while being interviewed for *Politics of the Very Worst*, said, "My work is that of a limited man who must deal with a limitless situation."[25]

NOTES

1. Guy Debord, *Comments on the Society of the Spectacle*, trans. Malcome Imrie (London: Verso, 1988), 11.

2. Guy Debord, *Society of the Spectacle* (Detroit: Black & Red, 1983) and *Comments on the Society of the Spectacle*.

3. Debord, *Society of the Spectacle*, paragraph 17.

4. Debord, *Comments on the Society*, 19.

5. Debord, *Society of the Spectacle*, paragraph 4.

6. Debord, *Comments on the Society*, 21.

7. Lee Bracken, *Guy Debord: Revolutionary* (Venice: Feral House, 1997), 131.

8. Debord, *Comments on the Society*, 15.

9. Jean-Marie Guehenno, *The End of the Nation-State*, trans. Victoria Elliott (Minneapolis: University of Minnesota Press, 1995), 96.

10. Fredric Jameson, *The Cultural Turn: Selected Writings on the Postmodern, 1983–1998* (London: Verso, 1998), 154.

11. Richard Sennett, *The Uses of Disorder* (New York: Faber and Faber, 1996).

12. Sennett, *Uses of Disorder*, 47.

13. Sennett, *Uses of Disorder*, 49.

14. Sennett, *Uses of Disorder*, 47.

15. Sennett, *Uses of Disorder*, 49.

16. Sennett, *Uses of Disorder*, 72.

17. Debord, *Society of the Spectacle*, paragraph 211.

18. Debord, *Society of the Spectacle*, paragraph 192.

19. Guehenno, *The End of the Nation-State*, 29.

20. Guehenno, *The End of the Nation-State*, 61.

21. Debord, *Society of the Spectacle*, paragraph 14.

22. Lewis Hyde, *Trickster Makes This World* (New York: Farrar, Strauss, and Giroux, 1998), 308.

23. Terry Eagleton, *The Idea of Culture* (Oxford: Blackwell, 2000), 22.

24. Eagleton, *Idea of Culture*, 21.

25. Paul Virillio, *Politics of the Very Worst: An Interview by Philippe Petit*, trans. Michael Cavaliere, ed. Sylvère Lotringer (New York: Semiotext[e], 1999), 51.

1

The Artist
as Public Intellectual

If the United States stands for civilization, a thoroughly secular notion, Europe symbolizes culture, a quasi-religious one. Art is finally compromised by a society which enthuses over it only in the auction room, and whose abstract logic strips the world of sensuousness. It is also tainted by a social order for which truth has no utility, and value means what will sell.

—Terry Eagleton[1]

Of the multiple images that exist for artists in U.S. society, most continue to be fraught with complexity and contradiction. There is, for example, the romantic image of the artist on the fringe—wild, mad, alone, ahead of his or her time, misunderstood, somewhat like the prophet raging in the desert. There is the artist as bohemian, socially irresponsible, less than adult, immersed in the pleasure principle, at times able to create something truly extraordinary and at other times able to fool the public with work that passes for art but is really fraudulent—"putting one over on its audience"—or so esoteric that only a handful of people "get it" or want to "get it." There are images of artists working out of their intuitive selves, in tune with the universe, envisioning the future. And there are also images of artists as shrewd businesspeople able to out-psyche the difficult, sophisticated, and fickle art market, make a fortune, and live like celebrities. At the same time there are images of artists whose work never sells in their lifetimes, who die unacknowledged, poor, and depressed, only to be discovered later when others can make a profit from their vision and friendship. At times we have been known to revere artists, to think of

them as unique or even superior beings who live deeply inside their creative selves, while the rest of us often forfeit these more ephemeral aspects of ourselves for jobs that we may find less fulfilling, but that might provide us with more stability and a greater anchor to the reality principle. Art collectors or museum curators pay exorbitant prices for work that has gained market value—a type of recognition and respect that often comes too late for the artist. These purchases often have everything to do with admiration for the work and little to do with attitudes about the artists who made them. We may revere the work, but we may still mistrust artists, imagine them as self-serving and lacking in the practical skills that would enable them to be statesmen or public personalities, capable of running the world. To further complicate these issues, U.S. citizens, still often seeped in a dominant though hidden puritanical tradition, may unconsciously fear the power of graven images and want to inhibit the right of secular individuals to create images that might become icons or focal points of adoration. Perhaps this is why North Americans largely do not condemn the moving images of pornography, degenerateness, violence, voyeurism of various kinds that appear on TV or in film, but become indignant when such images are frozen in time, transformed and manipulated by artists, then presented to a general public as art.

It is this ambivalence, predominant in the culture, that young artists enter into unwittingly. Such confusion causes ontological insecurity—a primal fear and uncertainty about their place in the world, an unstable location from which to meet an unarticulated and often precarious future. At the same time artists have often played into these complex ambivalences, defining themselves as a subgroup, outside society, relishing their otherness, while often at the same time longing to be embraced by society, understood, and acknowledged.

In our collective Western consciousness, and probably our unconsciousness as well, we do not have images of artists as socially concerned citizens of the world, people who could serve as leaders and help society determine, through insights and wisdom, its desirable political course. We do not typically ask artists what they think about social conditions or politics—the degeneration of our cities, our natural environment, school systems, or young people. We do not ask them to help solve these problems, even though problem solving and communication at the visual and spatial levels are much of what they are trained to do. Artists are also conscious of negotiating audience involvement and response, skills that are not taken into account when most people describe the work of artists.

I have tried for years in my own writing to articulate the vital place of artists in society because I believe in the educational process that produces them, a process that encourages the crossing of all creative and intellectual boundaries and affirms the importance of the work that results

from such training. Artists have sensibilities that are distinctive and important to the well-being of society. Were artists taken seriously within U.S. society, were they sought out for their opinions and concerns and recognized as having rare skills, some of which are about how to see the world, they would enter their chosen profession with a much greater sense of confidence and self-esteem. Were society ready to accept them into its fold as fully participating citizens whose function, like that of intellectuals, is to remain on the margins, asking the difficult questions, resisting assimilation and socialization in the traditional ways, refusing to accept the simplistic moral values that reflect the present political climate, there would be a great deal of psychic relief for artists. Perhaps under such conditions artists would be less engaged in a frantic clamor to reach the top of the art world pyramid. Artists might be freer to focus on what they do best—concentrated visual experimentation that, when successful, advances society's ability to see itself more clearly.

In their role as spokespersons for multiple points of view and advocates for a healthy critique of society, certain artists should be understood as public intellectuals—those who believe in the importance of the public sphere and who create, for a collective arena less able to house real debate, work they expect the world to recognize as potentially significant to the evolution of the species. It is the absence of such a response, and the sensationalized miscommunication of artists' intent when there *is* response, that proves most devastating for artists. In their dual role as critics and mirrors of society, artists are often negotiating the public realm—tenacious in their insistence on presenting to society a reflection of itself, without regard to whether society seeks such representation or chooses to look the other way when it is offered.

In a series of essays called the Reith Lectures, delivered in 1993 and then broadcast on the BBC, Edward Said attempted to articulate the role of public intellectuals. Out of these lectures came a very important small collection titled *Representations of the Intellectual*.[2] Writers have criticized Said's understanding of this role, citing the narrow theoretical basis for his analysis and the degree to which he presents himself as the prototype for the engaged intellectual.[3] But many do find his observations very useful, as they illuminate the potential role of artists in North American society, an association Said himself does not make but one that seems quite obvious to me. It is not surprising that Said did not include artists in his discussion; even an intellectual attuned to writers and musicians, as is Said, does not necessarily understand the work of artists as analogous to that of intellectuals, and yet in many ways it is.

Throughout, Said refers to Antonio Gramsci's notion of the organic intellectual. In the *Prison Notebooks*,[4] Gramsci writes, "All men are intellectuals, one could therefore say: but not all men have in society the function

of intellectuals."[5] Among those who function as intellectuals, there are for Gramsci two groups. The first is that of priests and teachers, those for whom knowledge can remain stable, steady, and at times even stagnant. Their job is to transmit this knowledge to the next generation. These might be called "professional intellectuals." They are distinct from what Gramsci calls "organic intellectuals," those who are "always on the move, on the make,"[6] constantly interacting with society and struggling to change minds and expand markets. These fluid intellectuals may also be what he calls "amateur intellectuals," forever inventing themselves and renegotiating their place on the border zones between disciplines, never stuck in any *one* of them. These amateurs, wedded to no one fixed body of knowledge, are open to all thought and to the renegotiation of ideas as that becomes necessary, whether through the merging of disciplines to solve complex problems—as in the creation of new disciplines called such things as cultural studies, critical studies, visual studies—or in the evolution of knowledge, as a discipline questions its own history, motivations, and methodologies and becomes self-reflexive—as in the case of the philosophy of science. Important to these distinctions is the idea that the intellectual "is an individual with a specific public role in society that cannot be reduced simply to that of a faceless professional, a competent member of a class just going about her/his business."[7]

Said affirms that the organic intellectual is one

> whose *raison d'être* is to represent all those people and issues that are routinely forgotten or swept under the rug. The intellectual does so on the basis of universal principles: that all human beings are entitled to expect decent standards of behavior concerning freedom and justice from worldly powers or nations, and that deliberate or inadvertent violations of these standards need to be testified to and fought against courageously.[8]

According to Said, there is "no such thing as a private intellectual," certainly not a private organic intellectual, "since the moment you set down words and then publish them you have entered the public realm." Adds Said, "Nor is there *only* a public intellectual, someone who exists just as a figurehead or spokesperson or symbol of a cause, movement, or position."[9] He states: "My argument is that intellectuals are individuals with a vocation for the art of representing, whether that is talking, writing, teaching, appearing on television."[10] I add to this the most obvious historical form of "representing"—the use of images in multiple forms of art-making to re-present conscious reality or dreams.

Said goes on to say

> That the vocation of the intellectual is important to the extent that it is publicly recognizable and involves both commitment and risk, boldness and vul-

nerability; when I read Jean-Paul Sartre, or Bertrand Russell, it is their specific, individual voice and presence that makes an impression on me over and above their arguments because they are speaking out for their beliefs. They cannot be mistaken for an anonymous functionary or careful bureaucrat.[11]

What makes them unique is that their voice is heard—booming from their particular orientation, carrying their unique inflection. We might say to ourselves that from everything we know about the life and work of a particular writer, the writing before us could be no other than Jean-Paul Sartre, Toni Morrison, Walter Benjamin, Nadine Gordimer. But we might just as well say of visual or performative work that it could be no other than Picasso, Max Ernst, Louise Bourgeois, Bettye Saar, Bill T. Jones, Anselm Kiefer, Andres Serrano, Carrie May Weems, Bruce Nauman. The voices of these artists are also quite unmistakable, distinct, powerful—their particular mark unique, reflecting originality in language, tone, subject matter, and style. They too have become known to us for their lives, associations, and political orientations.

Said's two categories of intellectuals, like those of Gramsci, are divided between those who simply represent the information that they were trained to pass along and those who are innovative, daring, and public in their re-presentation of their own personal interaction with the world. These distinctions hold for artists as well. Most of the artists whose National Endowment for the Arts funding was revoked in the past decade might be said to be organic artists in Said's terms. In each instance the work that was targeted for public denunciation was art that took on serious issues, passed through the iconography of the individual—the private sphere—and was placed into the public sphere. It was work that crossed borders, took a powerful stance, and risked upsetting the moral status quo by exposing conventional hypocrisies. In Said's words, the work was "resistant." What truly terrified mainstream America about this work was that it seemed to debunk so-called traditional values. The myriad discussions about this art never communicated the very strong political messages that the work put forth about gender, class, and sexual equality, or the fact that these artists cared about society enough to put their bodies on the line to represent its injustices to a general audience. The integrity of the artists and their commitments to social causes were never discussed because there was no attempt on the part of their detractors to understand their intent.

Said quotes Isaiah Berlin, who, in discussing Russian writers of the nineteenth century, talks about how conscious they were that they were "on a public stage, testifying."[12] Several artists whom politicians have tried to humiliate because of the nature of their work were most assuredly "testifying"—acting out of conscience that they considered neither

pornographic nor degenerate. Ron Athey, one of several performance
artists whose NEA grant was revoked, has often performed work focused
on his HIV-positive condition. He does body piercing and tattooing of
others on stage and, with the blood let from these exercises, makes prints,
onto paper towels. These blood prints are not made from the blood of
HIV-positive people, but when Athey hangs them high above the audi-
ence on clotheslines, they are a looming reminder of our own fear of the
proximity and ubiquity of AIDS. The content of the work is a testimony to
what it means to be young, creative, talented, and successful, as is Ron
Athey, and to suspect that you probably will not live a normal life span,
that your own death is closely hovering, that you are in easy reach of it
and it of you. The literalness of the sacrifice involved in the work is rem-
iniscent of Kafka's story, *In the Penal Colony*, in which an elaborate ma-
chine engraves words into the flesh of the sinner, denoting the crime of
which society has deemed the individual guilty. Through protracted pain
supposedly comes the realization of the meaning of the crime—the
epiphany—and then the possibility of redemption. Through the physical
comes the spiritual understanding of sin. Redemption through the body
is the task Ron Athey has set for himself. But the literalness of these per-
formances—the stark painfulness of them—frightens those who only *hear*
about the work and makes Athey an easy target for politicians eager to
discredit the metaphoric value and cathartic function he embodies in
these pieces. It is also clear that this type of work makes no sense to those
who do not think about art or the nature of symbolic representations.
Such people do not know how to "read" the work, and the literalness with
which they interpret it makes it easy to mock.

Such artists have defined their task as that of making their own per-
sonal conditions public and of taking that which is in the public domain
and translating it into the private. And yet these essential functions of in-
tellectuals, so well articulated by Said, are not valued enough in U.S. so-
ciety to secure support for the public funding of such work. Despite the
work's complexity, the media have focused on the supposed "pornogra-
phy" of the art, rather than its affirmation of what Said describes as "re-
sistant intellectual consciousness,"[13] a term he uses to describe Stephen
Dedalus, Joyce's prototypical autobiographical protagonist in *Portrait of
the Artist as a Young Man*. Such artists resist assimilation. They defy sim-
plistic descriptions or literal analysis. They attempt to reach large audi-
ences, but they refuse to render themselves benign in order to do so. They
see themselves as engaging in these activities to "advance human free-
dom and knowledge."[14] And they will not compromise.

All this is beyond conservatives like Newt Gingrich, who once likened
the National Endowment for the Arts and its funded projects to a "sand-
box" for the rich cultural elite. Most artists in the United States are neither

rich nor elite and, in truth, neither is their audience. What makes them elite in the eyes of archconservatives is that they are familiar with what is often termed avant-garde work. They are sophisticated about culture and cultural production. The anti-intellectualism rampant in the United States and deeply embedded within its cultural traditions attempts to isolate this more sophisticated art audience, equating their appreciation for such work with a type of elitism that, by inference, is deemed akin to anti-Americanism.

Right-wing intellectuals, especially those who write for the publication *The New Criterion*, denounce such artists as working against the public good. My perception is that they dislike these artists because, instead of falsely elevating society, these artists assume the role of "immanent critique" in a dialectical sense, which is to say that instead of offering superficial solutions, they expose society's inherent contradictions; and instead of pursuing absolute truths, they offer complexity, ambivalence, and, at times, aggressive confrontations with the status quo. This offends right-wing art critics, who continue to believe that artists should limit their endeavors to presenting ideals of visual beauty. Instead, these organic artists choose to confront that which haunts their own sense of reality and that of contemporary society. Their critique is fundamentally linked to their belief that the world *can* change. Embedded in their critique is hope.

If the artwork being produced by many contemporary artists cannot bring the American psyche together under one homogeneous totality, if it can no longer re-present harmonious images, this is because, to these artists, the world does not allow for such idealized image making. To them it would constitute a lie. They feel they must be true to their historical moment and to that which has been largely silenced and therefore must be stated within the public realm. Because they defy prevailing norms and refuse conventional notions of order and continuity in their work, they are rightly understood as subversive to the silent complicity around them. They also refuse the de-politicized talk-show mentality, which gives the illusion of a public realm but in fact focuses on the personal, emotional, and psychological, often negating or denying the historical-sociological moment from which these personal issues evolve. To use Oscar Wilde's phrase, these artists see themselves in "symbolic relationship to their time."[15] And those who are not able to understand the symbolic, or who do not value it, find little of merit in their work. Unfortunately this has been the fate of many of the most interesting artists of both modernity and postmodernity.

Said also writes that to the intellectual's responsibility of "representing the collective suffering and testifying to its travails . . . there must be added something else." This something else is the ability to "universalize the crisis, to give greater human scope to what a particular race or nation

suffered, to associate that experience with the suffering of others."[16] All great writing, art, and poetry has this capacity. Even the poetry of Neruda, or the paintings of Picasso, are not exempt from this requirement. No matter how particular its historical references, the work itself, through form and the emotional weight it achieves as it moves through the individual, is able to re-create and touch a deep level of human suffering. The best art goes so far into the personal that it broadens its own particularity and touches the world. Through the strength of its execution, it becomes emotionally, intellectually, and aesthetically available to a more heterogeneous audience. No matter how particular the images of Picasso's *Guernica* may be, Picasso has plunged into the nature of civil strife so deeply and found images so rooted in the historical-collective consciousness and unconsciousness that the subject becomes even more expansive than the Spanish Civil War, and the painting is transformed into an icon for all the monumental horrors and devastation of war.

Artists stand at the edge of society. Although many do try, few ever dare to hope they might create an image or representation like Picasso's, one that actually affects or changes society. This is because the task of artists, which is to pull what is personal into the public sphere, is very difficult to do and is rarely valued. Artists must find this social motivation and sense of purpose within themselves. Few artists would describe themselves as attempting to enter political life through their work; however, Said quotes Genet as having said, "The moment you publish essays in a society you have entered political life; so if you want not to be political do not write essays or speak out."[17] This is also true of artists. Once work is placed in the public sphere, it is subject to scrutiny by everyone and potentially to the range of intellectual strengths and weaknesses of the society. It has, deliberately or not, entered the public realm.

Artists are uncomfortable with the notion that once their work is presented in society, they are no longer in control of the response it might elicit. Even those artists who have made deliberately provocative work often do not understand why people react to it as they do. Once the work is in the public domain, the various publics feel they have the right to respond as they wish. And however intently artists try to imagine and control the nature of that response, they often cannot. The deeper the work probes and questions common assumptions, the more likely it is to upset someone. And if the work is shown in the United States and attempts to make a strong statement, it had best not be funded with government money, or its function as a vehicle for public debate about real societal concerns will surely be eclipsed. U.S. society has tried to position art in a small, insignificant, restricted, commercial, and mystified space, yet artists resist these definitions. Art is thus constantly pulled into a complex relationship to society by conservative groups who see artists funded by

the NEA as having betrayed the "public good." But artists who raise these issues often believe it is in the best interests of many distinct publics to have certain issues brought into the collective arena, and they believe it is their job to raise these concerns, to speak out in whatever forms are available to them. Unfortunately, the attention such work receives is too often simple notoriety rather than serious consideration and illumination of its success or failure as art.

Although I see the role of artists as a public one, only certain artists would choose to embrace this identity and would identify their task and their life's purpose as serving the public sector through the rigor and unconventionality of their work. And within this group there are those artists and art students who may at one stage appear radical in their work but who, unfortunately, will eventually fall into Said's category of "professionals." They will find a form within which to work—one that is safe, one that receives a certain level of recognition. They will become content within traditional art world parameters, and that is where they stay. In their own way they become as conservative as intellectuals who remain within their circumscribed fields, never expanding, venturing forth, crossing over, making alliances with any other worlds, or speculating on the relationship of their work to the larger whole while attempting to place their work in a more public arena. They will not take the risk of breaking the expected parameters. But they will hope, nonetheless, that their work finds an audience in the public sphere. As Said asks, what could it possibly mean to be a private intellectual? One would have to write books, make paintings, and simply lock them in a closet to achieve such an end. Yet, many of us know people whose work is intended to fit within remarkably narrow parameters.

What is it that we as audience hope to draw from the work of artists? In my sense it is not that different from what we might expect from the work of public intellectuals—that the intent of the work is to have an impact on society, to challenge existing forms, to raise significant questions, to bring ideas into society that might not yet be visible, and to do so in a way that can be accessed and, with some scrutiny, understood.

The job of those of us who are writers, intellectuals, artists, and also educators, or who someday *may* teach the next generation of public intellectuals and artists, is to up the ante in our own educational environments, to provide every opportunity imaginable for our students to be challenged in both form and content, to encourage them to become as radical in form as they are in content, to help them learn to ask themselves the most difficult questions, to push themselves as far as they can, and to be educated in such a way that they will not hesitate to take their stand within the public arena. It is also our job to take seriously the need to give our students the tools to become the sophisticated artists they

want to become. They need art-making skills, of course, but they also need knowledge that includes history, contemporary theoretical thought, and the workings of democracy in order to negotiate contemporary society. Students need to know how to think about the world analytically and to have the skills to express their "immanent critique" with authority and clarity about their work's intent.

To do this, students must meet artists and intellectuals who position themselves to be effective in these ways. They need to work with such people and to learn how they think about their work, their role in the world, and the negotiations of the complexities of these realities daily.

Perhaps if the next generation of artists emerges more committed to the public sphere, more able to articulate the complexity of their intent, less intimidated by societal ambivalences, they will feel more confident to insist that their essential importance to society be more greatly acknowledged. If they enter society clear about their role and purpose, perhaps society will take them more seriously and come to understand that in denying artists their rightful place in the public consciousness, we are in fact negating the most creative part of ourselves individually and collectively and in so doing are also damning our future to one without experimentation and the vision needed to give it meaning.

NOTES

1. Terry Eagleton, *The Idea of Culture* (Oxford: Blackwell, 2000), 25.
2. Edward W. Said, *Representations of the Intellectual* (New York: Pantheon, 1994).
3. Michael Walzer, "The Solopsist as Hero," a devastating review of *Representations of the Intellectual*, *The New Republic* 211, no. 19 (7 November 1994): 38.
4. Antonio Gramsci's *Prison Notebooks*, as cited in Said, *Representations of the Intellectual*, 3.
5. Said, *Representations*, 4.
6. Said, *Representations*, 4.
7. Said, *Representations*, 11.
8. Said, *Representations*, 12.
9. Said, *Representations*, 12.
10. Said, *Representations*, 13.
11. Said, *Representations*, 13.
12. Said, *Representations*, 13.
13. Said, *Representations*, 16.
14. Said, *Representations*, 17.
15. Quoted in Said, *Representations*, 55.
16. Said, *Representations*, 44.
17. Said, *Representations*, 110.

2

⌒∞⌒

The Nature of the
Investigation: Art-Making
in a Post-Postmodern Era

PART I: THE HUMAN PROJECT

Many have written that the experiment of modernity was an attempt to articulate, in various forms, a kind of hope for the emancipation of humanity from poverty, ignorance, inequality, and degradation. It was a belief that the categorizations that bound people to monstrous acts of injustice and relegated certain groups to horrific conditions could be overcome; that, in Althusser's phrase, "ruptures in the continuity" would occur, points of intersection could be created where an old paradigm was forced to give way to a new one. There was a belief that progress would be continuously progressive, the imagination would actualize these potentialities, and art, especially the art of the avant-garde, would play a key role in undertaking this mission. Art allowed for the poignancy of individual subjectivity to be seen, noted, and understood by the collective, and for individual artists to evaluate and comment upon their degree of freedom—or lack of freedom—within it. Totalitarian regimes of many different ideological natures therefore have condemned avant-gardism in art. They have labeled it self-indulgent and decadent because it raises too many possibilities of thought, fights against conformity and uniformity, makes strong statements about the psychic state of individuals and the arbitrariness of power, and refuses to be dictated to or function as a servant of ideology, in either form or content. The precise role of the avant-garde is to question the status quo, stir up unarticulated concerns and longings, imagine the unimaginable. In polarized political situations in particular, that art is closely linked to the

desire for freedom, whether in form or content, lends it a special potency. Nadine Gordimer writes: "Art is on the side of the oppressed. . . . What writer of any literary worth defends fascism, totalitarianism, racism, in an age when these are still pandemic? Ezra Pound is dead. In Poland, where are the poets who sing the epics of the men who have broken Solidarity? In South Africa, where are the writers who produce brilliant defenses of apartheid?"[1]

Within modernism and within avant-gardism was always the expectation of heightened rationality and greater freedom, that humanity was moving towards some clearer, greater good, even if the nature of that goodness could not be fully articulated, or even when at various times such desires were attached to concepts such as communism, socialism, proletarian revolution, liberation struggles, democracy, advanced science, high technology. While all these systems have presented the possibility of improving humanity's condition, all of them have also surprised us by being used to undermine humanity's broad interests in unexpected and sometimes brutal ways.

It has become clear that the modernist project has not succeeded. One need only read the front page of any national newspaper on any given day to note that poverty, war, child abuse, racism, and hate crimes have not been eradicated. At the same time, capitalism is now considered to be the economic solution to all ills. Although socialism seems to be reviving in parts of Europe, and the pope has literally embraced Fidel, the range of options for conceptualizing the organization of contemporary societies is still narrow, which represents a failure of the collective imagination to outwit the aggressive seductions of capitalism.

There is also a sense that advances in science and technology have not met, or cannot intrinsically meet, all human needs. In certain ways, science has created its own needs, which further polarize humans from each other. Is high-end computing meeting real needs? Solving essential problems? In some ways yes. Is it not also creating false desires and a greater inequity between rich and poor, as well as a chasm between those who live in postindustrialized, industrialized, and developing conditions, even within the same country? Are these the best uses of our energy and resources at this moment, or have we been falsely assured that technology, wherever it may take us, must be supported, because it is always progressive—i.e., moving in the direction of change? I'm not sure. Technology (and with this we need to include biotechnology) appears to be driven by its own agenda of experimentation linked to profit, while humanity now seems to serve *it*. Were we to consciously influence the use of these resources and the direction of experimentation for the actual improvement of society, meeting real needs and priorities and not those of the market, where might we take these tools of research and communica-

tion? What problems could we focus on? Might we not choose to feed everyone on the planet? Provide drugs to all those with AIDS or put all resources to finding a cure? What is at the core of the human project at this time? (And I do not mean the Human Genome Project.) What anchors us as a species to this planet and to each other? Where is the moral imperative? How can we be assured that the future will be an improvement over the past? Or should this entire way of thinking, this sense of a continuum moving towards some greater good, be seen as a modernist delusion to be abandoned so that some other paradigm might take its place?

During the 1980s and into the 1990s in the United States, many artists took the world apart in their work. Standing squarely in the center of these questions, contemplative about the potential for their role in society, they refused to be silenced. Artists can be like philosophers: they struggle with the issues of their historical moment and give shape to knowledge, often longing to step aside from these questions, but are nonetheless embroiled in them in the very fiber of their beings, inextricably implicated in the mess and in the mass. They are often caught in the discourses of the times, adding to these discourses with imagery and language, and then judged by how well their innovations bring clarity to the historical moment. In other words, they must negotiate a position of being both inside and outside society.

One day we woke up and it seemed that everyone—artists, intellectuals, designers—was using the term *postmodernism,* although no one quite knew what it meant. Francois Lyotard is correct that the *post* in postmodernism challenged the sense of a unified, coherent subject or center, and joyously, humorously, sometimes self-righteously broke with preconceived rules, refusing to replicate them. The result was that the work attempted to bring to the surface what before had been hidden; many artists' work became an "investigation" of the order and categories upon which art-making had built its assumptions. Hence the degree to which some artists could no longer paint, or no longer paint the paintings they once could, without referring to aspects of the history of Western painting—its allegiances to class privilege, commodity consumption, and a reification of the status quo. Formal certainties, even the nature of art-making materials, were called into question. Postmodernism challenged assumptions about making art and writing about art to the degree that the essay itself, the work of art itself often became embattled ground, transforming the experience of reading or viewing into something hermetic, difficult, and at times seemingly impenetrable.

Artists asked hard questions and antagonized many by confronting U.S. society with its own contradictions and by breaking with the romantic notion of standing apart from the fray. Artists came down from their Olympian heights to become "part of the problem," Terry Eagleton

writes, as they attempted to describe the sense of futility they felt when confronted with overwhelming societal needs. For example, because the U.S. government of the 1980s would not acknowledge the AIDS epidemic, artists spoke out, attacking the government for its complicity in not funding AIDS research sufficiently. Act-Up, an organization of AIDS activists, used New York City streets as its stage while becoming the moral conscience of the country on this issue. But once these points were made and the appropriate attacks on Ronald Reagan launched, the government funding for Artist's Space and the David Woynarovich catalogue, which accompanied a show by artists stricken with AIDS, was cut. In another example, Andres Serrano tried to make a statement about the pacification and plastification of the image of Jesus in popular culture with his photo, *Piss Christ*. He used urine as the fluid within which to immerse his plastic crucifix and then photographed it—at a time when people had become especially fearful of bodily fluids—and his funding was cut. Performance artist Karen Finley spoke out against the conditions for women, especially poor women, in America, by putting her naked body on the line, and her funding also was cut. The list goes on.

Socially and culturally concerned, American artists demonstrably used art as a forum for political debate. They dared ask the question: Whose America is it, anyway? They were doing the real labor of cultural workers and of organic intellectuals, in Gramsci's terms—asking the hard questions in whatever form was necessary to prevent the questions from being ignored. They were even willing to attack their own home base, the art world, as elitist. But they made a tactical error, one that has been made before in avant-garde situations—both military and cultural: they didn't realize that the people were not with them; they hadn't built a base outside the art world. They were busy investigating the structures—the relationship between concept and form—in true postmodern fashion by exposing the underpinnings of societal illusion through the art-making process, taking on serious social contradictions, and in so doing aggravated the relationship between artists and their audiences, most of whom were shocked instead of challenged. They were doing important work, but the work remained remote, insular. The ideas were good, the forms were radical, but the United States en masse wasn't ready to hear the message as it was presented—in images designed to be as visually and linguistically challenging as could be imagined. Most people were not prepared to accept the use of taxpayers' dollars for such efforts, for work that was at best confrontational and at worst even nasty.

But the U.S. audience did not understand something very basic to Europe, Latin America, and Africa, places where artists are often regarded as the moral conscience of their times. As Roland Barthes wrote, "A writer's enterprise—his work—is his *essential gesture* as a social being."[2] Or, as

Chekhov demanded, the role of the writer is "to describe a situation so truthfully . . . that the reader can no longer evade it."[3] U.S. citizens for the most part didn't grasp what many artists felt: it was their duty as artists to tell the truth about the world around them. But because this main objective was not understood, and because no consensus had been reached about the place of art in American society, artists were punished for speaking or representing their minds. And because they had not reached out and aligned with other groups committed to the same issues, they had to stand alone in their defense. In this void, politicians could easily thrust this work into a political arena, isolate it, or create their own bizarre context for it, one that pivoted around "questionable" uses of public funding.

It was this catastrophic misunderstanding between certain artists and their audiences, combined with the obliviousness of many artists to the need to bridge the gap between their sense of art and the political exploitation of controversies surrounding art, that led to explosive contradictions surrounding art in America. The consequences have been enormous. The annual budget for National Endowment for the Arts was cut from $162 million in 1995 to $99 million the following year—thereby allocating only one hundredth of 1 percent of the total federal budget to art, its minimal perceived value to American society mockingly reflected in these numbers. A struggle ensued to increase the allocations, and the budget has since been only partially restored (the budget for the year 2000 was $105 million), but the money is now designated for educational initiatives alone and can no longer be allocated for individual artists. And its funding is still miniscule in relationship to the overall federal budget, the size of the U.S. population, and the need for broad support for the arts. An additional result of such public condemnations is that many individuals and private entities who once funded individual experimentation in art have now lost their courage, and several private foundations have also refocused their funding to established community initiatives, circumventing individual artist grants altogether. While they have justified these changes in mostly economic terms, the truth is that they simply got scared. Artists—those who need the money to buy the time to make the art, write the plays, compose the music, to do the work society needs them to do to reflect back on itself—have suffered.

It seems that the ideologies of what has come before are no longer viable: not the modernist hopes for the future, that personal expression can move the agenda forward; nor the avant-garde belief that pushing the boundaries of form to incorporate radical content will transform the collective consciousness; nor the postmodern notion that a deconstructed universe without a hierarchy of value will call all authority into question and directly impact the distribution of power. While we have learned and

evolved because of these modes of thought, none of these utopian possibilities has seemed able to save us from the worst of ourselves.

There is most assuredly a crisis of meaning and loss of vision for the future of America, and art-making sits at its center—acting it out for all of us to see. We are in a moment of *post-postmodernism*, conscious of all that has come before, tired of deconstruction, uncertain about the future, but convinced that there is no turning back. I agree with Stuart Hall that the use of *post* in postmodern and post-postmodern means that we have extended, not abandoned, the terrain of past philosophical work.

In response to this juncture, many young artists I've encountered want to act: they want to be effective, to learn practical skills, to come into the city and work with groups of people to influence social policy. Recognizing that the gap between how they define art and how the general public defines art has grown dangerously wide, many artists are trying to find a way back *in*. Terms like *radical* and *cutting-edge* are now often assigned to work attempting to cross over, to come back into the fold and fabric of society but on its own terms. In the past ten years, increasing numbers of artists have worked in community-based contexts, joining well-known socially engaged artists in the United States like Suzanne Lacy, Helen and Newton Harrison, and Judy Baca by placing art in neighborhoods and nonart contexts. They may not even know all their predecessors—the tradition they are continuing—but they know they want to find a way to root themselves in community settings, to help bring art back into the public school system, to align themselves with groups outside the art world, and to find ways to make their mark in society as artists, educators, and activists. Artists have created billboards to end gang violence (Street Level Video, Chicago), hydroponic gardens to feed AIDS patients (HaHa, Chicago), installations inside in-use taxi cabs to comment on racial violence (Pepon Osorio, New York), installations in abandoned cars to call attention to domestic violence (Suzanne Lacy, Oakland), performances and even marriage ceremonies on the Mexican–American border to illuminate the absurdities of arbitrary national boundaries and the ensuing plights of immigrants (Guillermo Gomez-Peña, San Diego). These actions have now become part of a radical canon.

These young artists are also experimental. They take their models from the most hip, most creative contemporary trends. They do not want to sacrifice innovation in form just to increase the accessibility of their work, yet they want to be *in* society and *of* society. If *this* movement has romance, it is a new kind of romance—a romance about being part of the solution. They imagine themselves more like the experimental group at Carnegie Mellon's Studio for Creative Inquiry in Pittsburgh, which has taken leadership in a postindustrial land-reclamation project of brownfield land called the "Nine Mile Run Greenway Project." Artists there are

working closely with economists, engineers, and public policy analysts to reclaim land that has been harmed by industry and is now being reimagined for public use. This is the kind of project that inspires many contemporary art students.

It is as if having gone out so far, many artists no longer want to comment on their subjectivity in relationship to collectivity without actively engaging the collective in the process. They want to build a base and an audience larger than those of the art world, and do it on their terms. Many of these young artists received training infused with an avant-garde critique of society embodied in cultural studies and with what Grant Kester calls "the transgressive function of the aesthetic."[4] They assume the power of the radicalness of form. But coming back inside the larger culture is tricky business as well, especially now, when so much funding has been cut, and when artists know that building an audience for challenging work is a slow process.

What artists do changes with historical contexts and cultural settings. It evolves and devolves and then reemerges in unimaginable ways. Adorno knew that art could not completely solve social dilemmas, but he believed it could bear witness to them, and save the honor of the species by magnificently articulating its concerns and its distress and, in so doing, point a finger in the direction of change. Quoting an old French saying, he writes, "*Chaque epoque rêve la suivante* (Every epoque dreams its successor)."[5]

But Adorno did believe that art *could* solve one problem, and that is the loneliness of the spirit. Although Adorno like Lukacs knew that loneliness is also a "social product," he believed that it could be addressed by touching deeply into the historical and social core of this sense of alienation.[6] People gravitate to art because, in his terms, "Art is the negative knowledge of the actual world."[7] Humans need to find the hidden side of their own reality mirrored, elevated, or illuminated so they can resee their relationship to the world and pierce through its illusions. These goals have not changed, even though artists now work in telecommunications, installation, performance, holography, projection, synthesized sound, transgenic art, and in a broad range of community and social contexts. More and more artists can be reached directly through their own Internet home page without the intervention and mediation of curators, museums, gallery owners, or collectors. The effects of such immediacy have yet to be evaluated.

I see in the younger generation of student artists I meet a desire to seek autonomy, to no longer be infantilized through economic dependence or through a lack of understanding of how the world works. Although many are into cyber-punk music and high-tech image making, they still want to change the world like many artists who have come before. And I sincerely hope they can.

PART II: ARTIST AS CITIZEN

Given the emergence of this new breed of students, the changes in thinking that have occurred in the last two decades, the work of so many socially conscious artists, and the focus on the new millennium, it seems appropriate to challenge the way in which artists have traditionally been educated and to ask how art schools and art departments might think about educating socially engaged students. How can we transform our institutions into agents of change to make them more timely and useful to students attempting to develop new forms of practice? What new skills do students most need? What bodies of knowledge?

In this post-postmodern era, history is no longer understood as a continuum. There is also no new understanding of how to think about it, no utopian sense of where we might be, or ought to be, headed. There is only a series of projects for young artists to engage in, all in the name of the social good but none in themselves, or even collectively, leading to a new vision of social transformation. There is no clear path, no "secular redemption," as Marcuse might call it, no concept of liberation, and no apparent desire to be liberated. Students might say, liberated from what? In order to move towards what? Although many of us still structure our intellectual worlds with a past sense of progress in mind, many well-meaning politicized young people in the United States do not. They seem able to live without a sense of an imagined, improved future. And if there is no organized hope for such engaged people, simultaneously there is not much apparent despair.

Perhaps the idea that the role of art is the negation of that which exists, that it is the shadow exposing the true shape of the established reality may no longer make sense to young artists, in part because such work has often alienated its audience, exposing a truth about the contemporary situation that they did not want to reexperience, in a form that was confrontational instead of pedagogical.

One legacy of postmodernism is that my students seem happy and comfortable inhabiting complex, multiple identities. The theoretical and creative work of postmodernism attempted to depose the notion of one center and one hierarchy of value. Much of this has been internalized by younger generations, enabling students to understand that in part their identities are historically constructed. They are therefore comfortable imagining themselves in society, whether it be the larger national or global society, or the society of a school, or of specific communities where they might live or work. And, significantly, they have expanded the role of artist to include that of educator and activist. They consider everything they do to be part of their body of work.

But however powerful have been images created by artists in the United States, however pointed to the social situation, they have not nec-

essarily punctured the veil of illusion. Mass media continue to rule the United States and to daunt artists. The consciousness that many people have of its omnipotence does not seem to stop it from growing increasingly omnipresent, seemingly mediating all experience. Marcuse made clear at one time that there was a need for art to effectively communicate the indictment of reality—"art opens the established reality to another dimension: that of possible liberation."[8] His intent was that there would be a new language and images that would break with the established language and images that had become a form of domination and indoctrination. But so much work has attempted to do this and has not achieved this goal. Indeed, some work has served as repressive desublimation, Marcuse's term for a safety valve that allows the worst to be said and presented, which aids the illusion of freedom. But this type of critique has all too readily been absorbed within the social fabric. Change has not occurred, although many discourses have been established to talk about such phenomena.

Collective consciousness has been pierced by such efforts, but not enough to counter the seductions of capitalism—the illusion of ultimate gratification that it offers. What are the goals of art-making with a direct social intent if there is no longer a clarity about a desired new social order, especially now, when we are seeing our once-longed for, fought for, supposedly more egalitarian social systems transformed, like that of Russia, into our worst nightmares?

It is our challenge, those of us within cultural and educational institutions, to try to help articulate a series of collective projects for the species, in which artists and intellectuals can participate, having goals like organizing against rampant global conservatism, increased visual and conceptual illiteracy, growing political apathy, the degradation of the environment. We must also focus on preparing our students to think of themselves as international participants and assume responsibility for their unprecedented access to information. (I feel this notion of responsibility linked to information has already taken hold among young people. Hence protests against the World Trade Organization continue to grow globally.)

To address these challenges, we at the School of the Art Institute have initiated a program called "The Art of Crossing the Street," which at the foundations (first-year) level attempts to help young artists understand and encourage the multiplicity of roles they might assume in the world. Here the skills of writing, researching, articulating, planning, and working in collaboration with civic groups are combined with the philosophical and political underpinnings necessary to give them the multiple literacies they need to assume complex identities.

The program brings a broad spectrum of artists, designers, composers, and activists to the school to discuss how they make their work and to

describe the history of their own development as creative forces in the world—what questions they face, in what ways they have succeeded, in what ways they have failed. For example, on one of their field trips they visited Chicago artist Dan Peterman, who makes public functional art pieces with recycled materials. He talked about how he positioned his studio next to a recycling center. He discussed his community bicycle repair shop, conceived to bring neighborhood youth to his studio and therefore closer to his work. Students visited an artist on death row who had learned to draw in prison. I spoke about the National Artists' Coalition in South Africa, a broad-based coalition organized by thousands of artists before the ANC took power, to help monitor ANC activities in relation to art and culture, to ensure that art would still be on the agenda after the battle was won—all kinds of art-making, not just art created for the struggle. We brought Andries Botha, a South African artist, to help teach the second part of the course and discuss his role in the anti-apartheid struggle and his role now that that battle is won.

The teaching teams for the course have been multiracial, multicultural, and interdisciplinary, a mix of artists, writers, intellectuals, historians, and social scientists. Some students who took the class later became teaching assistants, their input about the future curriculum equal to that of the faculty's. The first semester focused on theory, and the second engaged the students in practice.

At the same time that "The Art of Crossing the Street" was first under way at the School of the Art Institute, architect Stanley Tigerman and designer Eva Maddox instituted a new independent design school in Chicago modeled on the Bauhaus called "Archeworks," which has implemented a socially conscious, practice-oriented curriculum. Teams are assembled that might include an architect, a fashion designer, and a sculptor; each team designs functional commodities that address certain problems. One team created a lightweight, good-looking helmet with a pointer to be worn by quadriplegic people to facilitate the use of the computer. Another designed a backpack for AIDS patients to organize and carry their daily supply of medication. Each design team not only invents its projects but also fabricates and markets them. To date Archeworks offers no degree, but it attracts students from all over the world.

These initiatives counteract what I see as the rampant infantilization of artists in the educational setting, a phenomenon that applies to designers and architects as well. I have railed against the limitations of a completely studio-based art education that does not take seriously enough the multiple literacies and competencies artists need to survive in this new globalized world—the ability to write, to think through problems clearly, to articulate their intent, to negotiate the marketplace, to move internationally in thought and action, to understand the multiple possible sites for their work,

and to see themselves as citizens and active participants in the world. I have also expressed concern that student artists, at times, are deliberately encouraged to make work *without* social content. Some faculty members place a premium on work that appears to have *no* overt social or political allegiances because, in the confusion of liberal ideology that often informs art school rebelliousness, such work appears to be more "free." Art schools have traditionally been established with this type of "freedom" in mind.

Socially engaged or political work (for lack of a better term) should not be privileged over other work; I don't believe artists should be told what to be or what to make. Rather, I am more concerned that serious questions about intent in art-making and design be asked, questions such as these: Why did you make the piece? Whom would you like your audience to be? Have you provided access for that audience to the work? What are the possible multiple venues where the work might be placed or exhibited? Is there another form within which you would like to work? What social goals are you trying to achieve? What is the dream embodied in the work? Where might it fit into society as we know it or would like to know it? With whom might you want to collaborate? Having been asked questions like these, students are prompted to think seriously about their work, their relationship to it, and its relationship to the world. I have sat in critiques where very problematic work—unresolved in content, unresolved in intent—has been discussed in purely formalist terms, but the discussion rarely addressed the intersection of form and content, which is often at the core of the work's failures.

In conjunction with training art students to see themselves in a broader social context, the School of the Art Institute is seeing the results of a decade devoted to developing art students as leaders. In 1999 the school recognized more than 130 students as leaders in the school community, ten times the number of students we would have singled out even five years earlier. These students represent diverse backgrounds as well as a broad range of issues around which they organize, from gay and lesbian or gender politics, to conditions affecting Korean or African American students, to one group called "Artists in Society." The student newspaper *F* wins many college journalism top awards every year for both form and content and in the process trains writers, artists, and writer artists to generate real dialogue in their community, while taking responsibility for their own political positions and the impact their writing has on the public conversation. A central issue for many young American art students is how to get art back into the public school system. Many of them were deprived of an art experience for most of their education. They want to know how they can change this for others.

Basic to achieving the pedagogical goals of making students more socially conscious and better prepared to enter society as engaged citizens

would be to institute required courses for all students that address the role of artists in multiple societies throughout various historical periods, so that the next generation of artists can begin to understand that the role of the artist is both a historical construct and a sociological one, which can and will be transformed. Such a course would help provide models for the students of what it means to be an artist in society. If students studied the 1960s, for example, a period that has become both romanticized and misunderstood in America, they would learn how artists, writers, and intellectuals aligned with many other like-minded groups to end the war in Vietnam; such an examination would help them to understand the potential interaction of principle with strategy. Such a course would focus on the relationship of objects made, events performed, and actions taken within cultural history, creating different locations, new sets of criteria, and referents for art-making.

To educate art students about artists' historical roles would help to counteract the effects of a society that does not seem to know *why* it needs art, as well as challenge those artists who have difficulty explaining this need even to themselves. Artists' potentially powerful role has often been reduced to that of commodity creators, scrambling for success within the art world, the gallery world, the world of *Art in America*. In the public arena, the place of art is relegated to the quadrant known as entertainment, leisure, or culture. Its importance is severely circumscribed, even when it mirrors the individual and collective vital act of living and breathing, and demonstrates the impact of the individual on the collective and the collective on the individual.

An effective pedagogical tool that helps students see art, and themselves as artists, in broader, more complex terms, is to take them to places dramatically outside their frame of reference. In 1999 we took a group of sixteen students to South Africa and Zimbabwe to study "Art and Politics in the New Southern Africa." They were a very diverse group of students from places as far-flung as Belfast, Taiwan, Los Angeles, and the South Side of Chicago. The faculty was racially diverse as well. The students came back transformed—awakened to the range of possibilities available to them. Nothing anyone could have said to them would have impacted their consciousness as much as meeting the very sophisticated, committed arts activists they met in Africa, or seeing for themselves the site of a problem as vast as squatter camps in South Africa, where 250,000 people in one site alone live without water, electricity, or indoor or outdoor plumbing, and yet find ways to elaborately decorate their homes with reused advertisements and wrapping paper. These visually oriented students learned social theory best by moving through it. Issues like colonialism, postcolonialism, the diaspora, class structures, and making the choice of a socially committed life that incorporates engaged art-making all came alive, be-

came essential, when they experienced their effects directly. Stepping off the plane and finding that the U.S. dollar could buy 10 Zimbabwe dollars at first elated our always broke students. They did not understand the repercussions of inflation on the Zimbabweans. But two days later, when there were riots and a national strike began in response to people's inability to buy the most basic food, they understood. Months later, when the students read on the Internet that a student demonstrator had been killed over such issues in Zimbabwe, they mourned because they had lived in the dorm in Africa with such committed students.

Having gone to Africa, these students are less likely to fall prey to some of the inadvertent side effects of the Internet and the rapidity of trans-global society, which can effectively collapse time and space, obliterating the real social and individual differences that exist. Such experiences allow students to have an independent way to evaluate their societal position, not just in the United States but also in the world.

Because we, as a species, keep falling short of attaining the ideal of a just and humane society, we need to acknowledge how much we mourn the failures of our societal structures to live up to our imaginings and how often this collective mourning is reflected in literature and art—from Maya Lin's Vietnam memorial, to Tony Kushner's *Angels in America*, to Pepon Osorio's installations in taxi cabs memorializing slain drivers, to Danny Martinez's inner-city march to protest gentrification and the death of community, to Simon Leung's L.A. show *Surf Vietnam*.

Society at its best is the manifestation of the desire for human community. We need to transmit this desire to young artists and then help them enter into such a project deliberately, consciously, and intelligently, and take their power from it. John Berger says art really can be a place where the distinction between "the actual and the desirable" is made "unnatural."[9] We *can* envision the world we want to live in and, once having seen it, can attempt to bring it into being. Such activity is dependent on the cultivation of the imagination, and thus needs the next generation of artists and other creative thinkers to assume their rightful place as leaders in society.

NOTES

1. Nadine Gordimer, *The Essential Gesture: Writing, Politics, and Places* (New York: Penguin, 1988), 291.

2. Quoted in Gordimer, *The Essential Gesture*, 286.

3. Quoted in Gordimer, *The Essential Gesture*, 299.

4. Grant Kester used this expression in his talk at the Littoral Conference in Aberystwhyth, Scotland, 1996.

5. Ronald Taylor, trans., ed., *Aesthetics and Politics: Theodor Adorno, Walter Benjamin, Ernst Bloch, Bertolt Brecht, Georg Lukacs* (New York: Verson, 1977), 111.

6. Taylor, *Aesthetics and Politics*, 165.

7. Taylor, *Aesthetics and Politics*, 160.
8. Herbert Marcuse, *Counterrevolution and Revolt* (Boston: Beacon Press, 1972), 87.
9. Quoted in Marcuse, *Counterrevolution and Revolt*, 105.

3

The Art of Testimony

Freud had been ill and had not written for several years when he began *Civilization and Its Discontents*, a small book designed to challenge the most basic assumptions upon which Western civilization is constructed.[1] Here he unmasks conventional notions of the organization and myths of society from those made about love and the family to the fundamentally oppressive nature of larger societal structures. He deduces that the systems of organization humans have developed to secure their own happiness may in fact be responsible for the unhappiness often associated with living in society, hence the title of the book.

It was 1929 and therefore not surprising that he would have been motivated to explore such large societal issues. At that time, the struggle (in Freud's terms) between Eros and Thanatos was already under way in Germany and Austria. Hitler was in his ascendance, and there was some foreboding of the unimaginable nightmare that was to come as he and the mechanisms of the Third Reich spread hatred against the Jews and other minorities and developed a pseudo-rational war machine the likes of which had never before been constructed. The original ending of Freud's sustained argument in this book offered a sense that, although humans did have the capacity to exterminate each other "to the last man," the force of life would most assuredly triumph over the force of death. But by 1931 Freud clearly understood that the fate of the world could easily go either way. For the second edition, to the final statement that "eternal Eros will make an effort to assert itself against its dreaded adversary," he added one line: "But who can foresee with what success and with what result?"[2] It was a frightening revision.

Critiques of Freud over decades have often accused him of dissolving politics into pathology. Yet in these philosophical writings, his particular methodology of psychoanalytic and social scrutiny allowed him to take the pulse of his own civilization, and he found it alarmingly diseased. Few models exist today for measuring the temper of a society or the motivation of the collective psyche at a particular historical moment, and yet there are times when such analyses are desperately needed, when madness, or at least neurosis, does rule politics. Freud himself acknowledged a problem inherent in such an analysis. He asked: How do you diagnose the pathology of cultural communities when everyone in the society is somehow implicated in the troubled behavior? Where can one find the "contrast" that "distinguishes" the abnormal from the normal?[3] And I would add, how can you achieve an accurate measure of the collective psyche when part of the pathology resides in the reality that only certain voices are allowed to be heard and studied while you are making that evaluation?

This is the juncture at which artists can make their presence felt. Through various creative means artists articulate the multiple collective psyches that exist in society and attempt to represent their underlying fears about the state of that society. Artists might envision notions of freedom and psychic health that may or may not exist, while also presenting the manifestations of psychic unhealth—malaise, racism, hypocrisy, despair—for all to see. But this type of anthropological, analytical, and critical work is not valued within U.S. society at this moment. If we use the cutbacks in government allocations to the National Endowment for the Arts (NEA) and the National Endowment for the Humanities as an indication, we might deduce that the United States has declared war on artists and intellectuals who present a progressive agenda, and therefore also on the process of a critical and poetic analysis of its own behavior. From where would we take our measure of collective health if those in whom we entrust the life of our dreams were ever to be silenced?

One could argue that the well-being of a democracy is in part manifested by how openly representations of its own complexity are embraced. There is no doubt that what Terry Eagleton says about culture can also be said about the perception of contemporary art in the United States: It has now become "part of the problem, rather than the solution; art is the very medium in which the battle is engaged, rather than some Olympian terrain on which our differences can be recomposed."[4] While artists seek to face the present reality, art is itself a zone of contention that makes it problematic. It is too easy a target for politicians, who can turn a general audience against contemporary artists in part because the experience of viewing new art often does not satisfy more traditional expectations for art or desires for immediate gratification.

Because serious intellectual challenges to the status quo, if they come from the left and not from the right, are often seen as un-American, and manifestations of complex thought are often criticized as elitist, and because the language of postmodernism, both in writing and in art-making, has often seemed obscure, it is not surprising that, after several decades of work by artists and intellectuals focusing on issues of race, identity politics, gender, and youth culture, the popular understanding of these issues has not changed profoundly. All of this collective work accomplished in the academy and in the art world has not sufficiently permeated the popular perception of who can claim to be an American and speak for the American experience. Thus the media continue to present the United States as a fundamentally homogeneous society with coherent values— values with which critically positioned art must inevitably collide.

So much of the work that has infuriated politicians, and for which the NEA then tried to write off its own support as "mistakes," was art that provided personal testimony, work that said, "This is my experience of daily life. Here is how I am seen or not seen in America and in the world as a woman, a gay man, a person of color, a politically and socially conscious being. This is the form through which I engage critically with my environment." Such art, which was doing the work of bringing subjective experiences into the collective, was too often met without understanding and was viewed with scorn. The Nan Goldin retrospective at the Whitney Museum of American Art (3 October 1996–5 January 1997) was an interesting example of such an endeavor. In this autobiographical exhibition "I'll Be Your Mirror," the artist's presence, in over twenty-five years of photographic work, was so direct and palpable that the show felt like a protracted performance and installation. The show made clear that Goldin loved both men and women, has lost many friends to AIDS, and has come undone from drug and alcohol abuse. She continues to use her skills as an artist to unify her fragmented world and ours. This work might terrify those who do not see art as a vehicle for chronicling the intersection of personal and social realities. Her experiences as documented could be evaluated as deviating from the norm. Her work could also be embraced as a representation of the uniqueness of each life and the deep desire we all have at times to permeate the membrane between ourselves and those we love, and hold on to those we have lost. The society outside the art world could claim her as a fellow human being—vulnerable—or it could try to portray her as a Martian. Such work, which is capable of generating an understanding of difference and offering a path toward reconciliation, can also further isolate artists from mainstream society. Its effects depend completely on the political climate into which the work is placed, how well it can control its own contextualization, and whether public funding is anywhere involved, which can further skew the issues. What

can we say of a society that has become demonstrably afraid of its own most creative people precisely because they try to represent truth and complexity as they experience it?

For those of us raised in America, this degree of forthrightness, this level of truth telling seems virtually unknown and invisible. Instead, the United States has evolved a media apparatus of such proportion that it has come to obfuscate the truth and mediate every experience we have in the public sphere, and often in the private as well, transforming politics, painful personal testimony, tragedy, and world events into entertainment. Surrounded by a veritable wall of video projection—an extravagant and impenetrable veil of maya that obscures perception and the accurate evaluation of reality—it is difficult for artists to see the impact of their work and for viewers to see it at all. The sheer scale of America is prohibitive to collectivity except at the most superficial levels often driven by the media. And inevitably advanced capitalism transforms everything into a commodity in the market.

Writers and artists are free to make the work they choose, as long as they can afford to do so without public funding. But with visual art operating for the most part in the realm of private economic exchange, there is the distinct possibility that only a small group will experience the work. In addition, there often is no written critical response to amplify and preserve the work's effect, or at least no response that can touch a broad audience. If the work becomes controversial and reaches national recognition, then it is likely that its message will be distorted and an aura of fear and repression will surround it. This is a very difficult society in which to position one's art strategically.

We might say that, as a nation, we are controlled by an ego so narcissistic and fragile that it cannot tolerate direct criticism, a psyche so repressed and rigid that each tremor reverberating from the collective knot of cathected energy threatens to explode its cohesion. It seems that it is so terrified of its own originality that it would rather be drugged into a narcoleptic, anti-depressed stupor, overstimulated by the media every waking hour, and plugged into myriad electronic devices than face its own difficult, rich, complex, and diverse identity. We also might say that the projected profile of America is that of a country that does not want to mature, arrested in its desire to project and protract its adolescence.

In this America, the popular images of artists are aligned with either the nineteenth-century romance of the starving artist alone in his garret (always a he) or an image of the most vastly successful artists like Andy Warhol, who are associated with money, Hollywood, and illusion. Warhol himself made it big in America on American terms. He was smart and talented enough to know how to project the media back to itself in its own riotous narcissism—to embrace its images, replicate them to eternity, and

transform them into art. The media loved him for this. But as deep, passionate, psychologically serious work, even Warhol's own darker images have difficulty penetrating the collective psyche, as Picasso's *Guernica* (1937) was able to do in and for Europe. Audiences in this country often become angry when there is a merger of art and politics. They want a pure aesthetic experience, and they want beauty—still caught in the idea that art with a social agenda is not free because it serves a utilitarian function. Such art is still associated with socialist realism, a prejudice reaffirmed even in the art world's own conflicted responses to the 1993 Whitney Biennial, when many critics felt they needed to react against the serious political content of the work and divide the art world into those interested in politics and those interested in aesthetics, as if one couldn't desire engagement with both.

Poet and artist William Blake believed that it was most assuredly the function of poetry—as both language and visual imagery—to express the faults of humans as well as to re-form them. He was prophetic—full of futurity—believing in the transformation of individual consciousness that would lead to the evolution of societal consciousness, convinced that the world we desire is more real than the world we passively accept. For Blake, art was the bridge linking these realities. But to carry forth this mission, art had to be "corrosive" to the illusions that had encrusted, and therefore obscured, the ability of the individual and of the body politic to envision the potential of the species.

Some American artists have thought they could achieve such ends through work that was regressive in nature. But childlike rebellion is easily absorbed into, and co-opted by, a society that seeks to remain infantilized. It might annoy some who associate high art with adult behavior to see such work, but it also cannot revolutionize perception. Art that succeeds in Blake's terms is art that attempts to acknowledge the fall from innocence. It does not romanticize that innocence, nor does it confuse rebellion with revolution. It tries to show that it is not innocence we should seek to refind but, rather, greater consciousness, and that the only way to do that is to move through the mass and mess of contradictions that stand in our way.

In the current ordeal of reconciliation in South Africa, artists and other politically aware people are insisting on facing up to their political and spiritual history until it becomes transparent, no longer mystified, no longer able to hold them hostage. At least one gnostic sect believed that even the snake in the garden was God because it brought Consciousness. Such consciousness does not prevent us from seeing clearly the world within which we live and imagining a better one; rather, it is our only way to achieve this. But for Western society it is as if the myth of the Fall rests in the idea that knowledge and understanding are a curse. Any movement

to greater consciousness is therefore met with resistance, and art certainly attempts such movement. The false innocence that America continually perpetuates, this "mystical cloud of unknowing," as James Hillman calls it,[5] can be very appealing to the rest of the world as it manifests itself in popular culture.

Others seem drawn to a society that appears to have shed the weight of the past and tradition and that also denies the reality of growing up and older, and then unself-consciously wraps itself in the image of righteousness and the good. But it is also this denial of what is in the United States that has marginalized art-making that attempts to move beyond the struggle with form and content to tackle its relationship to society. Perhaps it is the desire to return art to a childlike, unfallen, prepubescent, nonconflictual, and depoliticized state that accounts for this most recent movement in the public arts debate—away from the NEA to discussions about creating more art classes for children. While one would not want to refute such a push for art-education spending, surely we need to ask: Whatever happened to art for adults? And how did we manage to get through more than one presidential campaign without a mention of arts and humanities funding?

At this moment, when the path for art, artists, and all cultural workers in America is uncertain, when the aesthetic project must not be abandoned, we need to support artists who make truly thoughtful work— work full of thoughts—radical precisely because it refuses to simplify its meaning or reduce its multiplicity. Radical because it takes a strong stand about where we are as a society and strives to communicate its meaning to many while insisting on creating a moment of private space, an indication of subjectivity within the public sphere. And radical because it shows that neither the mind nor the body can be colonized. Such work is an emancipatory practice that relies on intervention and surprise.

Those of us who can do so need to continue to defend the intention and importance of such engaged work by creating critical discourses that provide a proper reception for it, so that its importance to society is understood, its meaning is not distorted, and it is not lost to us. Artists who create work such as this, including Fred Wilson, Goat Island, Rachel Rosenthal, Ron Athey, James Luna, Suzanne Lacy, and many more, instigate a necessary collision between what is and what wants to be—a vital component of any collective psychosocial analysis. And, they do it in public.

We can say of their work what Heiner Muller said about Pina Bausch's. The images are like "a thorn in the eye,"[6] a metaphor that I take to describe a piercing of the veil so penetrating, unassimilatable, even bloodletting, and ultimately disruptive to the homeostasis of the body politic, as well as to the collective psyche that, unless they are confronted, there will be no cure.

NOTES

1. Sigmund Freud, *Civilization and Its Discontents*, trans. James Strachey (New York: W.W. Norton, 1961).

2. Freud, *Civilization*, 92.

3. Freud, *Civilization*, 91.

4. Terry Eagleton, *Random Access*, ed. Buchler et al. (Glasgow: Rivers Oram Press, 1995), 17.

5. James Hillman, *The Soul's Code: In Search of Character and Calling* (New York: Random House, 1996), 247.

6. Heiner Muller, *Germania* (New York: Semiotext[e], 1990), 109.

4

Brooklyn Museum: Messing with the Sacred

PART I: THE EVENT

Dennis Heiner, a dapper, seventy-two-year-old devout Catholic, feigning illness, leaned against a wall in the Brooklyn Museum near the much-maligned Chris Ofili painting, *The Holy Virgin Mary*. He waited for the guard to look away, took out a plastic bottle, then slipped behind the protective shield and, with shaking hands, squeezed and spread white paint over the face and body of the image of Ofili's black Madonna. When the police asked why had he done this, Mr. Heiner responded softly, "It was blasphemous." With this enactment Chris Ofili's work entered a historical body of defaced art—from works vandalized during the French Revolution to Michelangelo's *Pieta*, Andres Serrano's *Piss Christ*, and David Nelson's infamous portrait of the late Mayor Harold Washington, *Mirth and Girth*. On 18 December 1999, Heiner was charged with a Class D felony for "mischief making, possessing instruments of graffiti, and graffiti."

Let's begin with the Brooklyn Museum, about which *New York Times* art critic Michael Kimmelman wrote: "Playing on the implications of cultural elitism, the Mayor of New York, Rudolph Guiliani, has in fact threatened one of the least elitist of New York cultural institutions." While I was growing up in Brooklyn, the Brooklyn Museum was the beloved museum of my working-class neighborhood. It was always "our" museum. Through such recent comments as, "That's my museum. Take your hands off it," spoken by Brooklyn residents, I can see that it is still *our* museum to the people of Brooklyn. This is enviable loyalty to an institution that probably serves the most ethnically and racially diverse

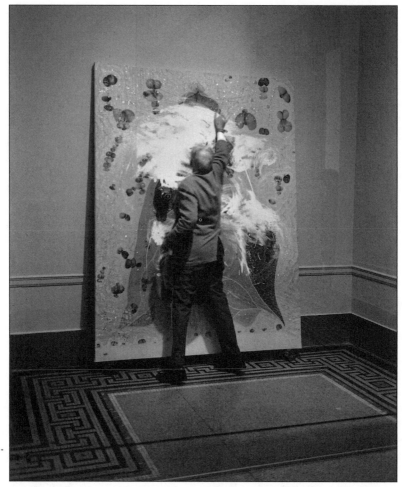

Vandalism at the Brooklyn Museum. © Philip Jones-Griffiths/Magnum Photos.

population of any major museum. And it has done so since 1823. What was museum director Arnold Lehman thinking when he committed his institution to "Sensation," a show that other American museums had refused and for which he could find no institutional partners? Whom was he attempting to please, and what audience was he hoping to attract?

Lehman knew the history of the show's reception at the Royal Academy of London—its controversies and its vandalisms, particularly in response to Marcus Harvey's rendering of the face of Myra Hindley, the notorious child murderer, in what appears to be small children's handprints. That painting outraged many, who saw its inclusion as an act of bad taste, and it was splattered with ink and eggs in London. Aware of the show's record-breaking London attendance, no doubt Lehman hoped to draw

similar large crowds, but also to attract a new audience—younger, more hip, first-time museum goers from Sheepshead Bay, Canarsie, Bensonhurst, and East Flatbush. Perhaps he also thought that curiosity about this show could entice those from Manhattan to cross the famous bridge that separates the boroughs and the classes and travel a little farther into Brooklyn than BAM (the Brooklyn Academy of Music). Wanting to position the museum as a player in the contemporary art conversation, it is likely he also hoped to appeal to his own new constituency—the thousands of young artists displaced by Manhattan's high-cost real estate and the numerous not-so-young artists and professionals who are increasingly making Brooklyn their home. If he hoped this show was dynamic enough to do all this, he was right—much to the surprise of the more jaded art world establishment to whom the show was old news.

Did Lehman go too far? Did he compromise his institution and overly sensationalize "Sensation"? The pre-show publicity and the signage at the show read as follows: This exhibition "may cause shock, vomiting, confusion, panic, euphoria, and anxiety." The show was presented as if it were some pharmaceutical drug with possible side effects or an amusement park ride to be tried at one's own risk. But the only one who suffered *all* these symptoms was probably Lehman himself. The day I was there not only did no one faint, but everyone was having a great time, especially the museum guards, who seemed thrilled to talk about and explain the art to anyone who would listen.

In addition to the buzz about the show's content, there was a lot of attention focused on the well-documented, endless compromises with collector Charles Saatchi, the wealthy former advertising executive: How much money would he give to the exhibition and under what conditions? How should the show be hung? How big and how close would the shield be to protect Ofili's *Holy Virgin Mary*? And what about David Bowie's contributions and Christie's expectations about deacquisition prospects and future sales? Everyone, it seemed, would make a profit from this show. In the end, perhaps worst of all was Lehman's unfortunate misrepresentations surrounding Saatchi's financial involvement, which probably proved the most damning to Lehman's reputation in the art world and most threatened his colleagues' willingness to support him in the future.

But I do not think Lehman should be on trial, or Chris Ofili, or even Guiliani. Central to this discussion is what these events tell us about the desperate financial situation of many American museums and society's unwillingness to adequately fund the making and showing of art. Also at issue is U.S. society's addiction to entertainment. So deluged is the public with images, so overstimulated by the media, that museums now position art *as* entertainment. Lehman is *certainly* not the first to capitalize on these obsessions. Without some dramatic hook—motorcycles, blockbuster favorites, old-master must-sees, or artists who make death masks out of their own blood—it is

increasingly difficult for museums to bring in the crowds they need to generate the revenue that shows require, just to break even in the United States. And these practices are not just intended to attract *younger* audiences.

Also in question is how and by whom artwork is contextualized. Who has the power to give meaning to the work? Once Guiliani targeted the image of the *Holy Virgin Mary* and misrepresented it as irreverent, as blasphemously splattered with dung, there was no turning back. He seized control of the event, set the terms in the public arena, and constructed the painting's *meaning* from his own ignorance. All those in the art world who were involved with the show then had to scramble to get the media to recontexualize, redefine, redescribe, and reinscribe it with the meaning the artist had intended. There was an attempt by Guiliani and others to polarize the event: either one expressed reverence for the image of the Virgin and then acted appropriately outraged by the interpretation of Ofili's work as presented by Guiliani, or one was willing to contemplate the artist's intent and risk being labeled an elitist and blasphemer. These manipulations shocked Ofili, who had not had any response like this in London and had no real power to defend or explain himself in this public situation. From the objections articulated about Ofili's image it was only a few steps to questions such as these: Does anyone have the right to imagine such an image or to show it in a public institution? And, if it is shown, is it any wonder someone felt obliged to deface it? These issues battled themselves out in the public sphere, interpreted on one side by a sensationalizing press— the *New York Post*—and on the other by a newspaper that, in this instance, was remarkably determined to educate its readers about the history of art, religion, transgression, and bodily fluids—the *New York Times*.

There was surprisingly little discussion in the media about the Ofili image itself: a black Virgin spotted with small cutouts from pornographic magazines and carefully placed, lacquered balls of dung. Perhaps this is a representation of the Virgin as both sacred and profane, capable of manifesting herself as white, black, and brown. Such ideas never emerged in most media coverage. There was little speculation about whether the race of the Madonna provoked Guiliani, perhaps even more than the elephant dung had. Nor was there much discussion about the color of the paint finally thrown at the *Holy Virgin Mary* to cover her up, seemingly to make her pure, to make her white. Why was the issue of her race avoided in most conversations?

Many New Yorkers were not deceived by Guiliani's theatrics. Among the exhibition's attendees polled about the show, 85 percent simply wanted to be left alone to formulate their own response to the art, as was witnessed by the show's large attendance. They saw Guiliani's actions for what they were—political moves intended to control, to polarize, to seduce, to appeal to a certain conservative constituency. And for the most part such strategies left New Yorkers cold.

In New York, the so-called art and culture capital of the world, the art community proved to be a great disappointment, unable to mobilize itself effectively in response. After all the previous incidents of this kind, what had the art world learned? Apparently not much. When it finally did react, it could only present a tired argument advocating freedom of expression; it failed to articulate the right and necessity of a democratic society to support the work of artists whose interpretations of the world allow us to evolve visually and intellectually.

Why did it take so long for the New York museum directors to respond? Was it because they didn't much care? Because it wasn't their museum? Because they too are dependent on New York funds and therefore were afraid of Guiliani and the potential for retaliation? Because they were immobilized by the realization that something so banal could occur in New York—a city that prides itself on sophistication, savvy, and an inability to be shocked? Because they are implicated in, and therefore uncomfortable with, the focus on the ambiguous role of donors, patrons, and issues of conflict of interest? Were they, like Philippe de Montebello, director of the Metropolitan Museum of Art, averse to defending this show and self-righteous in disassociating himself from it or Brooklyn's exhibition practices, as he made so clear in his egregious op-ed piece in the *New York Times*? Perhaps the museum directors moved so slowly to respond because it was the *Brooklyn* Museum, somewhere "over there," in a borough only few New York art museum directors ever choose to visit.

At the core of the cynicism surrounding this event is the reality that a general audience does not understand the inner workings of the art world—the world of patronage, the buying and selling of art. Nor does a general audience understand the issue of an artist's intent. Art, most people believe, is committed to higher values and therefore antithetical to commerce; it is independent and should stand above the capitalist quagmire. But alas, little can. In this instance the veil was ripped away: art came dangerously close to being marketed as entertainment and associating itself with the worst of mercenary attributes—greed. Long articles took delight in exposing the relationship between the show and those who might have reaped financial gains from its success. But exhibitions in other museums are often compromised in similar ways, if not the extent seen at Brooklyn, then to some extent—a catalogue paid for by the artist's dealer or by one of his or her collectors, a contribution by the dealer directed to the bottom line of the exhibition, board members who collect works by artists shown in their museum. Or, one could cite Dior, Faberge, and Cartier, all of whom have been financially involved in supporting major exhibitions focused on the history of their designs at the Metropolitan Museum of Art, shows that clearly enhanced their name, prestige, and therefore the value of their products. Lots of people are making money on art,

but it is usually not the artists. All of this is common practice. The "Sensa-tion" fiasco was perhaps more extreme, more overt, more crass, involving as it did the likes of Saatchi and his collection and even a rock star—David Bowie. And it took place in Brooklyn, already a bit declassé for the elite of the art world. Would Guiliani have dared to assert himself as he did had it been the Metropolitan Museum of Art, whose board includes very power-ful members of his own political party? The Brooklyn Museum was aban-doned by its colleagues, left to stand alone and explain itself as if it were unique in engaging in such practices, and perhaps just a bit hungrier for recognition and more desperate to attract visitors.

What can we say about the diverse group of visitors who attended this show in spite of, or even because of, these controversies? What was their frame of reference? A general audience in the United States does not nec-essarily see the role of art in society in broad terms, nor do they grasp the role of the avant-garde—its mandate to raise complex issues and express divergent points of view. Nor do most people think about *why* we need and want art to do this for us. Most good artists, and there were several in the "Sensation" show, do not set out to shock. They might attempt to challenge or provoke, but this is out of their own need to reflect upon and give shape to their complex and often contradictory understanding of the world. If they interpret an iconic image in a radically new way, is this not one function art should serve? If they challenge our assumptions about art, why do we not welcome this challenge and the dialogue that sur-rounds it? What are we so afraid of?

We in the U.S. art world have not done a good job of educating the gen-eral public, or ourselves, about such issues. The Brooklyn Museum con-troversy created a cathexis of issues begging to be unraveled: from the re-lationship of art to society, to the parameters of freedom of expression, to the use of taxpayers' dollars, to how "difference" is addressed in the United States. Do freedom of expression and protection of property exist only for those whose representations of reality match our own or align with those in power? What *is* the purpose of art in a democratic society?

There is much to be said about a situation in which a seventy-two-year-old devout Catholic inadvertently becomes a graffiti activist; Heiner van-dalized the work of the vandalizer. Such events often result in absurd mo-ments—like the Chicago alderman's attempt to burn David Nelson's infamous portrait of Chicago's late mayor in women's underwear on the front lawn of the School of the Art Institute. The alderman's aggressions led the police to "arrest" the painting, "for its own good." Heated human pas-sions and the laws we have defined to contain them often bump up against each other in the public arena. When this occurs, public intellectuals need to come forward to discuss how art becomes a magnet for the special cul-tural, and political issues of its times, and how societies, even democratic

ones, expose their fear of the human imagination when they act out a de-
sire to repress and punish it, simply because some feel it has gone too far.

PART II: SULLYING THE TEMPLE

> The origins, liveliness, and durability of cultures requires that there be
> space for figures whose function is to uncover and disrupt the very
> thing that cultures are based on.
>
> —Lewis Hyde[1]

What is at the core of this controversy involving visual images and others
that have occurred in the last decade in the United States? In each conflict
a basic misconception, misunderstanding, and antagonism has been re-
vealed between how a general audience imagines the role of art in U.S. so-
ciety and how artists, and those connected to various art worlds, imagine
the role of art. These perceptions are often divergent and in conflict.

A general audience might say that art should add beauty, joy, elegance,
and an element of play to the social structures. Some may even see art as
having a particular spiritual role. Those who are religious may still want
art to be in the service of the church. And there also are those who un-
derstand art as expressing the workings of the unconscious. But very few
people would say that art of necessity raises those issues a society needs
to confront, and even fewer would express gratitude for artists who prob-
lematize issues in their work. Most people would agree that art is essen-
tial to society; few could articulate why. But without an ability to explain
art's importance to society, how can we successfully defend it when it is
under attack, or even convince others of the merit of studying art as an
appreciator or practitioner?

Lewis Hyde's brilliant 1998 book, *Trickster Makes This World: Mischief,
Myth, and Art*, presents a fascinating reading of the trickster archetype in
various mythologies, including Native American and African societies as
well as in contemporary literature, music, and history. Hyde invokes
artists and thinkers such as Picasso, Duchamp, Ginsberg, John Cage, Max-
ine Hong Kingston, and Frederick Douglass as examples of those who
turned the world on its head. An understanding of the trickster archetype
and its various historical manifestations provides a useful framework
with which we can examine what happened in Brooklyn as well in other
situations where controversy has spun around art. It can also help us to
explain, even to ourselves, why there are times when society needs art *not*
to be safe and to be, of necessity, unnerving.

Hyde explains that the trickster is the one who mixes up the profane
and the sacred, who is unafraid to transgress all borders. Hyde says that

although the trickster "appears to debase" the sacred by introducing earthly dirt into his or her practice, "the visual consequence of this dirtying is the god's eventual renewal."[2] Tricksters are of this earth themselves—themselves of the fallen world—but playful in this condition nonetheless, smearing dirt on all things to bring them back *to* the world to remind us that their uniqueness is *of* the world. But at the same time that the trickster is earthly, he or she is also connected to the immaterial world—that of unconscious and spiritual association unlimited by time and space, capable of complexity or contradiction. The trickster plays with all these boundaries, treads on the borders, disrupts the prescribed order. This is the work of Hermes or Mercury, the work of what we have come to call the mercurial imagination—a type of creativity that can't resist sullying what has become oppressively sanctified, pure, and at times hidden and inaccessible. Hyde says the trickster is not immoral but rather amoral—refusing to operate within the normal conventions, not completely without respect for the sacred but out of a more personal response to archetypes that does not seek to disempower or necessarily bring shame to them but rather to reinvent them. Tricksters do not operate in the *temenos*—the sacred precinct of the temple—but rather in the *pro fanum*, the space outside the temple.[3] It is here that they use their power to invert and rearrange the order of things simply through their presence.

When we experience the work of the trickster, it is recognizable to us because this figure disenchants the enchanted, reenchants what has been sullied, moves the center farther to the peripheries, forcing a renegotiation of boundaries. He or she refuses that which is flat, linear, easily defined, and instead chooses that which resides in metaphor and ambiguity, like the workings of a dream. In Hyde's terms it is no wonder that it has been so easy to parody Communist societies. They have been so one-dimensional— flattened of all "mercuriality." They seemed sterile, austere, refusing any recognition of the unconscious. When we say that a work of art reminds us of socialist realism, it is rarely a compliment. Rather, it is usually meant to disparage the work for its lack of play or complexity. Totalitarian societies that have tried to dictate what art should be have usually forgotten that the power of the visual resides precisely in its unpredictability and incorrigibility. But this is threatening to those who fear the loss of control. When those in power attempt to legislate art's inventiveness, the trickster inevitably foils their efforts or, if irrevocably thwarted, goes into a deep sleep, leaving the world frozen and diminished.

The antithesis of the bureaucrat, the trickster plays in the realm of the sacred. The key word is *plays* and, by extension, *plays upon*. The trickster, Hermes, plays the lyre—the prized instrument Apollo seeks to possess and learn to play; but Hermes also plays the liar who refuses to tell the truth. He lies to show us that even *we* can be fooled, and he also lies and

seduces us to get what he wants. The trickster is always living by his wits, making a way out of "no way": his inventiveness is his creativity and his creativity is that of an artist—*ingenious*, involving talent and production. Not your average criminal, the trickster is wily and cunning to serve a particular end, a liar with a purpose—an artist/liar determined to give form to the formless that is begging to be manifested. Writers of fiction and poetry, as well as visual artists, are all liars to some extent, fabricating reality to move us to recognize certain truths. "Thus," Hyde says, "might we hope to have great liars at our dinner table rather than trivial pursuers of fact."[4] We understand clearly what he means. The spirit in us wants to play, to be challenged as well as entertained. It seeks what is unpredictable and new, it is drawn to the unimagined and to those who seem free of the shackles of the reality principle, those able to give themselves over to fantasy and pleasure.

What trickster act might Ofili have been up to when he titled his image the *Holy Virgin Mary*? Might he have been involved in a *deliberate* attempt to create misunderstandings? I am reminded of what D. H. Lawrence wrote in *Studies in Classic American Literature* about the work of Edgar Allan Poe and other nineteenth-century American writers who play with their readers: "Never trust the artist. Trust the tale."[5] In other words, never trust what the artist tells us he or she is doing; trust the actual effect and complexity of the work. If we only read Poe's own explanation of his work, we might actually believe that his stories were simply formulaic, about effect—a successful strategy to seduce us to terror and nothing more. We might be unwilling to deduce any psychological meaning or motivation from the work, but we would miss the brilliance of Poe's ability to replicate the workings of the unconscious and its various maladies of obsession and monomania in clinical detail, almost a century before such systems of thought were articulated by Freud.

One has to question the sincerity of an artist like Chris Ofili, who, in interviews, presented the *Holy Virgin Mary* as nothing that *should* offend. For each aspect of the work that was labeled controversial he has offered some form of explanation: The elephant dung he tells us is Nigerian iconography, signifying fecundity, fertility, godliness. To the question of the small cutouts of breasts and vaginas from pornographic magazines, he has made it clear that to him these are just little bits of femaleness to remind us that the Virgin was once mortal, that the other side of grace is gravity; the other side of purity, worldliness; of virginity, whorishness; that everything exists in its contrary. For him Mary worship is clearly not without obsession and sexual innuendo. But what of the big-toothed, big-lipped almost parody-like African mouth, we might ask Ofili? In his thinking is this an attempt to imagine the Virgin as black African, not white, to see her as playful, joyful, not in sorrow for her lost son but in

love with earthly life? Chris Ofili has presented the painting in a calm, rational light—as a series of careful decisions—but there is no doubt that, at least in Brooklyn, "Sensation" blew up around this painting. For some it was far from benign. We need to try to understand why it was volatile or why it was easy for Guiliani to get others to react to it as such.

There is no doubt that the entire painting is transformed for the viewer once one has read the title. Without that highly charged title one might imagine the figure as a portrait of an individual black woman, perhaps African, sexualized through the cutouts and made almost folkloric through the use of color and elephant dung. There might be something cryptic about such an innocent figure adorned with inserts of genitalia, but it is likely it would not have attracted much adverse attention, certainly not within the context of "Sensation," which was not a show about visual innocence. It included dismembered cross-sections of sheep and a decapitated cow's head propagating maggots, as well as perverse distortions of children's sexuality. Clean, shellacked elephant dung with no odor seemed quite tame and inconsequential in such a context. But still one might ask: What does it mean to bring dung into an art museum, a space that has almost gained the sanctity of a temple in this society? No one raised in the Western traditions of art-making can be innocent of this knowledge and, although of African descent, Ofili was trained as an artist in London, where he was raised. He knew the implications of sullying the temple and that there might be a price to pay. Once the title is read, one is forced to ask: Is the artist serious? Is he making fun? Is he having fun? Is there intention? If so, what is it? What is he saying about the Virgin? And is it in fact irreverent?

It would seem here that the trickster is at work. Not only is he making the museum dirty by bringing dung into its inner space and, in so doing, expanding the possibilities of what materials are appropriate to art-making, but he's also transforming the Holy Virgin into an exuberant, folkloric image. And, probably most controversial of all, he made his *own* representation of the Virgin, defiant of tradition, and thus created confusion. Is he serious about this portrayal, or has he tricked the art world into accepting this work and played us like the image, lighthearted, all the while knowing it would prove provocative to some? To those whose ideas about what representations are appropriate to the Virgin are very precise and come strictly out of tradition, this was completely unacceptable, even blasphemous. They might, and some did, object violently to Ofili's gesture and interpret it as an attempt to bring humiliation to the sacred and an attack on their personal belief systems.

While it is clear that Ofili has the right to make any image he chooses, the museum has the right to exhibit it, and people can decide to visit or not, it is still not clear if anyone has the right to mess with what is sacred

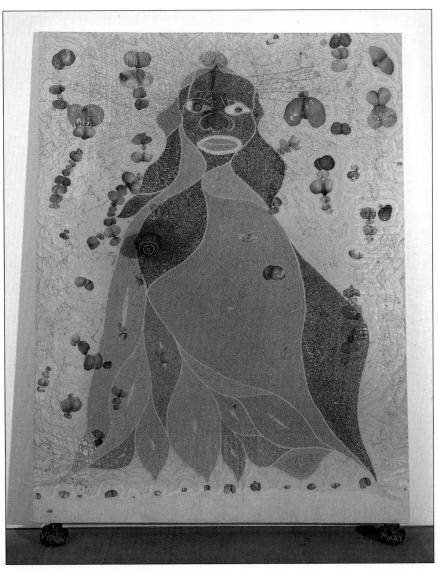

Holy Virgin Mary by Chris Ofili

to others. This is a far more complex question, one at the heart of other recent art controversies. It brings to mind a work from the 1980s, Andres Serrano's *Piss Christ*, for which Serrano submerged a plastic crucifix in a large vat of urine and then photographed it in romantic diffused light. If people saw the image without knowing its title, they would not take offense. But once the title is read, the audience assumes it knows something about the artist's intention and *Piss Christ* becomes, for some, pissing on Christ. Once this idea takes hold, no explanation incorporating Serrano's Catholicism—his stated intention to redeem the exploitations of the image of Christ—could save the photograph for some devout Catholics. They were enraged. But one has to wonder: What did Serrano think *would* happen? What else *could* happen? Is this not, as in the situation of Ofili's painting, the trickster at work, always compulsively stirring the pot?

In *Trickster Makes This World*, Hyde explores this issue of literally dirtying the sacred—returning the world again to its original fullness "before dirt's exclusion" in relationship to the U.S. flag.[6] We know that the elaborate rituals of folding the flag as it is removed from a flagpole are designed to keep the flag from touching the ground and thereby losing its purity. What upset people most about art student Scott Tyler's 1988 installation at the School of the Art Institute was not the photographic image of the line of coffins returned from the Vietnam War draped with U.S. flags. Rather, the controversy stemmed from the possibility that a flag placed on the gallery floor might be stepped on by viewers while they tried to write in the book provided for their comments and responses to the question posed by the title of the piece—*What Is the Proper Way to Display the U.S. Flag?*[7] In response, the gallery director at the school took the flag home each night to wash it in Woolite, in hopes of dispelling any sense that the school had intended to harm the flag or that a dirty flag would be on display. When the same piece was shown in Anchorage, Alaska, the local veterans' group picked the flag up off the gallery floor daily, leaving a check for $32.50 to cover the cost of replacing it, thus ensuring that for the run of the show a new flag would appear every day. This was truly the art object become performance event. The veterans' response in Alaska, although bizarre to many, seemed quite civilized compared with the mayhem that ensued in Chicago, where chaos threatened the physical safety of school and museum personnel as well as students, not to mention the museum's collection—all in the name of keeping the flag *off* the floor, to keep the sacred from mixing with the profane. When artists mess with what is sacred to others, there is always the risk that their work will trigger such results. But such incidents, whether anticipated before their occurrence or not, are rarely the concern of tricksters. They are simply doing their job, often to the exasperation of those left to manage the often unmanageable results.

For Hyde, tricksters are also those who "seek to change the face of shame," who refuse to accept the rules about what is shameful. Hence they are constantly attempting to commit what is deemed the shameful act to reduce its power, to make light of it, to raise the bar of acceptance. They are seismic dislocators, shifting the ground under our feet so we never stand in the same place for too long. In a puritanical society like that of the United States, already ambivalent about graven images, those who in any way compromise the reverent portrayal of images taken to be sacred are not greeted with appreciation for helping to renew the image and raise important questions about the sources of shame or for "lifting the shame covers";[8] rather, they are scorned and ostracized. But trouble is not what these artists fear. Being ignored would probably seem a worse fate to them. Remember Hermes, the trickster, is the god of "stealthy appropriation"—a thief by choice, and proud of it.

With the *Holy Virgin Mary*, Ofili was doubtless intending to be provocative. As a black artist in a predominantly white art world, he is aware that there is an expectation that his work will in some way reference blackness. He plays with this and takes it to an even farther point, back to the elephants of Africa, a place so primal and unexpected that either people accept the work as African and exotic, or they question why he insists on using dung everywhere, even to portray the Virgin Mary.

This type of provocation is difficult for those outside the art world to accept as a legitimate motivation for art-making. Because there has been an absence of a visible avant-garde tradition in the United States, one in which artists assume their right to expand the boundaries of both form and content and audiences assume their right to respond to such work— all in the name of civilization's evolution—a general audience is simply not used to accepting such acts of transgression as positive. This was certainly true of *Piss Christ*. It never occurred to those upset by the *idea* of the photograph, since so few even saw it, that Serrano was himself a Catholic. Or, if they did understand the way in which the artist was playing with these multiple meanings, they resented the sense of entitlement that allowed him to reinterpret an image that has been given meaning by millions of worshippers over centuries.

There is no doubt that the role of the artist is socially and historically constructed, as are the images they are able, willing, and determined to create. And the function these images serve has to be understood within its cultural context. Anthropologists, for example, talk about two different kinds of societies in their approach to dealing with troublemakers like the trickster. There are those societies that ingest or cannibalize what is other and potentially threatening. And there are those *anthropoemic* societies that vomit, eject, or isolate those who engage in troublemaking, put them in jail, relegate them to the wilderness, the margins, or, fearful of the

power of their otherness, destroy them. Obviously, says Hyde, it is to the advantage of any change agent to stay on the thresholds and points of entry, lest they find themselves excluded or, worse, obliterated.

PART III: WHAT IS TO BE LEARNED?

If dirt is a by-product of the creation of order, then a fight about dirt is always a fight about how we have shaped our world.

—Lewis Hyde[9]

Much of the media discussion around what happened at the Brooklyn Museum focused on the perception that the temple, or the "sacred precinct," as the American Association of Museum Directors referred to their institutions, had been sullied. Under what conditions was the work shown? Many believed that the art museum, by taking "dirty" money from Saatchi—the advertising executive, as he is often described—and enhancing the value of his collection, had put its reputation in jeopardy and, by association, that of all art museums. Some also expressed great anger that the museum had played into the public's insatiable appetite for entertainment by mixing high and low, by opening the gate; by installing sensational art at best, and bad art at worst, into the temple and, in so doing, legitimizing this work as having aesthetic and moral value. For them the whole incident had little to do with the place of art in society and everything to do with museum policy and practice, and with a betrayal of the public trust in these institutions to only select the best art for the purest reasons, to uphold certain values. Months after the "Sensation" vandalism incident had occurred, the American Association of Museum Directors held a meeting and put into effect a new set of guidelines on determining what gets shown in American museums and who pays for it. But even more important than the lessons about propriety learned from this confrontation are those concerning contemporary art, its function in the larger culture, and how the acceptance of controversial work can change the perception of what is acceptable.

In the last three hundred years, as artists grew more independent from the church in constructing their images, the power of artists to influence how the sacred was constructed diminished. Their work became less and less directly important to most people's spiritual lives or in the shaping of a collective iconography. Some of the work also became increasingly challenging, and even provocative, to those people not expert in the field; it developed, in effect, into its own religion with its own language, points of reference, and rituals. This has created a longstanding division between avant-garde artists and the general public. On the one hand, when a work

seems provocative, there are few forums though which conversation about its meaning can be convened. On the other hand, viewers can feel disempowered because if an image disturbs them, they appear to have no real recourse to move it out of public view. They may not even feel intellectually able to defend their at times unpopular objections, which they may also fear will seem provincial to art world sophisticates. They may believe they have no means of self-expression with which to respond to the work comparable to that available to artists. This sense of disempowerment can lead to anger, which for some results in aggression against the object. For their part, artists immediately rush to hide behind their right to freedom of expression, instead of trying to understand the response their work is eliciting. Perhaps this seeming impasse could be breached if a broad consensus could be reached on the myriad roles art can serve in a healthy society. Such a society may be defined as one that is not afraid of its own contradictions or those darker aspects of the self to be found in the *pro-fanum*.

As a writer and educator, I have never believed that my job has been to determine what art *should* be and do. What artists do is art; whether it is successful in communicating its intent effectively is another question. Art is often prophetic by speaking to us through the imagination. It is then up to us to determine whether it is true or false prophecy. In educating young artists at the School of the Art Institute, the faculty tries not to tell young artists *what* they should do or what art should be or should not be. In truth we cannot predict what art will look like in the future. While faculty may tell them what art has been, it is the next generation that will tell us what it *will* be. If professors disagree with the validity of the student's intention—if they see the art as badly conceived; as problematically racist, sexist, controversial for controversy's sake; or badly executed—they then work with the student, push him or her intellectually and artistically until the work gets stronger or the concept for the work becomes clearer. Instructors also need to help students talk about and contextualize their own work before others do it for them, such as writers and critics, who will have an open playing field for interpretation if artists are not clear about their intent. Critics, and not the artists, will then frame the conversation around the work, and artists will have no obvious tools of clarification. To educate in this way is to accept the idea that art, by its very nature, is always in transition, constantly evolving in form and content but also in its societal role.

As we approach the next generation of artists, thinkers, businesspeople, educators, intellectuals, and citizens, how do we want to present art to them? These are questions that must constantly be thought about and then rethought. To answer these types of questions adequately, one must look beyond art history to philosophy, literature, anthropology, history,

and theoretical writing across all these disciplines. We need to see art as it is—a sociological phenomenon, representative of human evolution and expression; a representation of society as it moves through the individual; a representation of individuals as they move through society; a link with our own collective unconscious and with our spiritual development as a species and our progress in developing a utopian sense of our own potential humanity. It is through such a process that one comes to understand how art functions in the society and how important it is to society's well-being. In this broader context, even art controversies are useful. If they are mined properly, they can tell us about the health of a society at a given moment—how tolerant, flexible, generous, and fearless it is; how in touch it really is with its own complexity and multiple publics.

Although controversial work is often rejected at first, as these incidents of art in the public realm demonstrate, they nonetheless change the perception of what art is and what it can be. Such incidents literally move art from the back section of "Arts and Leisure" to the front page and make it news. In so doing they broaden the scope of what a general audience comes to understand as art. The number of visitors to the Brooklyn "Sensation" show became outrageously large only after the controversy had been framed by Guiliani. Before that, the show was destined to remain cloistered within the small domain of the art world. Instead, seemingly half of Brooklyn's populace showed up to find out what all the fuss was about and, in the process, expanded their understanding of contemporary art and, in most cases, their tolerance for it. This show also prepared people for the next controversial work that might be transformed by public response from art into an event. Perhaps the next time art is about something provocative and difficult, it will be easier for those who saw this show to welcome it and ingest it with tolerance and even enthusiasm.

To want to hold back the new, to believe only in the tried and true and established is to mistrust the future and the creative forces that give rise to it. To fear the trickster or to try to suppress such a figure of change in society is only to encourage others to assume that role with a vengeance. Someone needs to be turning the world upside down, constantly, so that we don't die of boredom, weighed down by all the oppressive rules we construct to hold ourselves and each other back—mistrustful as we are of our own tendencies to spurts of creative lawlessness. Some force has to fight conformity, move the margins to the center, encourage us to play. Usually this is the role designated to artists, who often refuse to divide anything into dirty and clean, acceptable and unacceptable, black and white. We must applaud them for their inability to adhere to the letter of the law and for the ingeniousness with which they inevitably break it and demand its rethinking, freeing all of us to reimagine our world. And so we need to extend our gratitude to talented tricksters like Chris Ofili and

other equally playful, daring, and confrontational artists for, in Hyde's words, "keeping the joints of creation limber."[10]

NOTES

1. Lewis Hyde, *Trickster Makes This World: Mischief, Myth, and Art* (New York: North Point Press, 1998), 9.

2. For a long discussion of "dirt," see chapter 8, "Matter out of Place" in Hyde, *Trickster Makes This World*.

3. Hyde, *Trickster Makes This World*, 195.

4. Hyde, *Trickster Makes This World*, 79.

5. D. H. Lawrence, *Studies in Classic American Literature* (New York: Viking Press, 1951), 13.

6. Lawrence, *Studies*, 293.

7. For an extended discussion of this incident as well as those surrounding *Mirth and Girth*, see Carol Becker, *Zones of Contention: Essays on Art, Institutions, Gender, and Anxiety* (New York: SUNY Press, 1996).

8. Hyde, *Trickster Makes This World*, 311.

9. Hyde, *Trickster Makes This World*, 198.

10. For a thorough discussion of joints and joining see Hyde, *Trickster Makes This World*, 252–54.

5

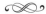

Betrayal

Ask about betrayal, and you will most likely hear recounted myriad devastations of failed romantic love. Push further, and you will be told sagas of cruel acts by family and friends. Continue, and there will be talk of falseness by colleagues in the workplace, deceptions by government, and, finally, global crimes humans have committed against each other in the name of civilization. At the core of each act of betrayal is trust that has been violated.

When individuals or societies maliciously, or even unconsciously, ignore, abuse, or unilaterally change the terms of deep commitments, there always exists the possibility of betrayal. Rarely will there be agreement on the part of the accused that betrayal has occurred, and rarer still are betrayers willing to admit their guilt, unless they are caught in the act. But the perception of being betrayed, whether justified or not, imagined or real, is experienced as a crime to the heart, creating a range of responses that include revenge, denial, despair, cynicism, paranoia, and, in rare instances, forgiveness and reconciliation. There are some betrayals felt with such magnitude that an individual or a society may never recover; the heart, or part of the heart, simply goes cold.

Once betrayal has occurred, all past equilibrium is shattered. This is why betrayal catalyzes the end of innocence, the fall into experience, as William Blake would have it. This is why it is at the center of tragedy: once the betrayal is revealed, that which was hidden becomes apparent, and the psychic world is thrown into catastrophe, never to be reconstituted in the same way again.

Out of the multitude of possible types of betrayal to explore I have chosen three: Mythic betrayals are those that have come out of and are resonated in

the collective unconscious, often because they have been re-presented in art, literature, or religion portraying human frailty large, against a cosmic landscape. Historical betrayals are usually understood only in retrospect as having provoked irrevocable changes in the outcome of worldly events, transforming the geographic and spiritual destiny of continents and nations but negotiated between individuals, something like the Hitler–Stalin pact. Last of the three are contemporary social betrayals, those happening right now, which may still be largely hidden from public consciousness and whose long-term effects are yet to be determined.

Among mythic betrayals is that of Medea. Shot by Cupid's arrow and willing to do anything to spare Jason's life, she betrays her father, kills her brother, and tells Jason the secret of the Golden Fleece. Ultimately she flees her "barbarian" point of origin, taking its dark secrets with her. When, many years later, Jason announces that he is going to marry a new, younger, more influential and civilized bride (i.e., a Greek citizen), exiling Medea and her children, *alea iacta est*—the die is cast. In the face of such opportunistic betrayal and Jason's unscrupulous want of feeling, what else could she do? As Simone Weil writes, "Betrayal begets betrayal." She poisons his bride-to-be with the gift of a dress steeped in poison and then plots to kill her own children. But Medea and the gods blame Jason's actions for hers: "O sons," she says, "your father's treachery cost you your lives."[1] Medea, already a betrayer, commits the most heinous betrayal, one that violates the trust between parent and child—she enacts the crime of filicide. Nonetheless she is redeemed—*deus ex machina.*

When Judas, whose name has been lent to all betrayers thereafter, betrays Christ, it is part of a divine orchestration. As Kazantzakis interpreted it, he is an actor in a predetermined drama. Harvey Keitel enacted it as such in Scorsese's adaptation, *The Last Temptation of Christ*, playing Judas as co-conspirator, a man off the streets, part of the plan, and therefore close to God. All betrayals start with trust, the most high and the most low. As Mafioso boss Sammy "the Bull" Gravano said to one of his own lieutenants before he knew he would testify against, and then betray, John Gotti and the Gambino family, "You must have trust before you can have betrayal."

Adam needs Eve to betray him in the garden so he can lose his innocence. Of this James Hillman writes, "God and the creation were not enough for Adam; Eve was required."[2] Nonetheless, it was a betrayal. In these gardens, these most holy, symbolic places—Eden, Gethsemene—a word of betrayal is spoken, a small action of betrayal taken, all part of a larger plan, and the consequences transform eternity. When Christ cries out, "Why hast thou forsaken me?" the universe quakes. There was an agreement, yet his words to God are those of the betrayed. As Christ's body is wracked with the crucifixion, the pain is too great, it obliterates all

memory. The body, like humanity, cannot transcend its physicality. The betrayal occurs in the inherent impurity and humanness—and therefore ambivalence—of the incarnation. His physical pain marks the originary betrayal, that of the spirit finally abandoned by the body in death.

Only the most innocent have never experienced betrayal. And however exalted is the justification for the betrayal, to be completely felt it must work through an individual or individuals. This is also true of historical betrayals. Emile Zola genuinely believed Dreyfus innocent. In his famous essay, "J'Accuse," he pleaded with fellow citizens and with the state to acknowledge their anti-Semitism. In Dreyfus's imprisonment, Zola saw the betrayal of all French values and of all French Jews; we see in hindsight a foreboding of the betrayal of all European Jews that was yet to come. The newspapers of the time wrote, "Could there possibly be an innocent Jew?" The Jew was constructed as the disease in the body politic, which had to be expurgated. Here we see how humiliation interfaces with betrayal. The betrayed still holds onto a set of beliefs, in this case his citizenship, the terms of which the betrayer has already rendered obsolete.[3]

In another historical betrayal, two American Jewish athletes, Marty Glickman and Sam Stoller, were benched in the 1936 Olympic Games in Berlin and replaced by African-American athletes Jesse Owens and Ralph Metcalfe (whom, after their victories, Hitler referred to as "Black Auxiliaries"). Glickman and Stoller believed the United States sought to spare Hitler the embarrassment of two Jewish winners. Their coach denied this allegation. But Stoller wrote in his diary at the time that this was "the most humiliating episode of [his] life."[4]

My first conscious memory of feeling a sense of social betrayal arose out of what I learned on the streets of Crown Heights about the Holocaust from children of survivors. It was then that I first understood that the social contract, or my child's understanding of what that might be, could be irrationally, brutally revoked.

These recent immigrants with whom I grew up were very anxious to become Americans. But none of us quite knew what that meant. We all strongly identified with the Brooklyn Dodgers and suspected that they were representative of it. When our team left us for Los Angeles, we felt betrayed. What made no sense to us then, in 1957, was that the owners did it for money—here betrayal obliterated all remaining vestiges of innocence.

Without the luxury of looking backwards from the future, we live mired in ongoing contemporary perceptions, actualities of betrayal transformed into cynicism and paranoia. "Hatewatch" lists hundreds of white supremacist groups on the Internet, all of whom feel betrayed: groups like the Ku Klux Klan, the National Association for the Advancement of White People, Aryan Angel's White Pride Links, Aryan Female Homestead.

There is even an Aryan dating page with read-outs like, "Are you white and proud? Are you sick of the multiculturalism that is being forced upon our children on the Jew tube in Amerika today? How about the race mixing that has become so popular in the monkey-infested cities?" I will spare you from reading more. These groups believe there is a liberal-communist (interchangeable to them) plot to destroy the white race. They quote Charles Manson. They feel betrayed by all whites who have given away any power to people of color and to Jews.

These perceived contemporary social betrayals, still to be confronted and addressed, are not unlike the confusions and delusions characteristic of certain right-wing Afrikaners. These South Africans had always supported apartheid and the National Party, but now have had to listen to the hidden secrets—those acts done in their names—as they are revealed by the Truth and Reconciliation Commission. One must ask: By what means *did* they think a minority could suppress a majority? But now they know not only that innocent people were tortured, poisoned, and murdered to sustain apartheid, but Afrikaner police at times burned the bodies of their victims and, while the bodies were slowly incinerating, had a *braii*, a traditional Afrikaner barbecue, where they drank beer and cooked their dinners in the funerary flames. Many right-wing Afrikaners did not know, or did not choose to know, that they were being represented by sociopaths and sadists. They now feel betrayed.

Ironically these hierarchies of betrayal around race share some similarities with my own sense of betrayal on this issue, although I come down on the opposite side of these polarizations. What I share with such extremists is rage about promises and assumptions that are now being violated. For me, the most demoralizing aspect of living in the United States is the recent demise of affirmative action. I believed that the nation had subscribed to a dream of integration and equality. I knew, we all knew, that staunch racists and segregationists were still living among us; nonetheless, a national moral commitment had been made to right a gigantic historical wrong. Affirmative action was the only chance the United States had to separate race from class, to rectify the effects of unequal education, and atone for hundreds of years of discrimination. It provided an opportunity to create a point from which everyone could start on a more equal footing. And it had been working. In California, where this redress has been eliminated, and ranks of students of color entering major public institutions, whose numbers had taken so long to build, are now plummeting. Fortunately these practices are under attack and have been resisted in other states.

Without betrayal there is no cataclysm sufficient to expose that which is hidden. Without the recognition of betrayal there can be no reconciliation. Race and class hatred have always been present in this country. The

United States was built on disenfranchisement. But the North American dream promoted a commitment to bring everyone into the center. That dream is no longer discussed. And groups from the far right militia movement, those from the far left, and many in between all feel that their versions of the United States are not represented in the social imaginary. And, all the while, the gap between who has and who can, who will succeed in an increasingly unabashedly class-serving system is ever widening.

I also feel betrayed that the United States seems to be relinquishing its commitment to good public education for everyone. What would it now mean to come from a lumpen, uneducated Brooklyn family, as I did, and try to get a really good education in New York City (as I did) without going to private school? Quality education for everyone, once viewed as a pivotal, national goal, has now become primarily a privilege of the upper class. Is this not a betrayal of democracy, which *must* create an educated citizenry to function equitably and effectively?

There no longer seems to be any dream to guide us as a nation. Or perhaps there is one, brought to us by the most advanced stages of voracious global capitalism, but we simply cannot concede its dominance, even to ourselves. There is certainly no public acknowledgement that there are many competing groups, all with conflicting assumed social contracts, commitments, and entitlements, and all of whom feel they are the *most* betrayed. The problem here, and one whose devastating consequences we have already experienced, is that betrayal generates extreme rage and self-righteousness. In its name all acts of vindication, however inhumane, horrific, or perverse, seem justified to those betrayed. The strength of this moment, however, is that as betrayal is acknowledged, its assumptions are made visible and, like all hidden, repressed thoughts once outed, these must then be confronted, their legitimacy and truthfulness finally assessed in the brightness of day.

NOTES

I wrote this piece in response to a request by Michael Brenson for a series he was doing on particular words for the Rockefeller Foundation. My word was *betrayal*, and once I began the process of thinking about this word, I realized how infinite might be my response. Fortunately, we were all restricted by the short time allotted us for our presentations.

1. Euripedes, *Medea and Other Plays*, trans. Philip Vellacott (Middlesex: Penguin, 1963), 59.

2. James Hillman, *A Blue Fire* (New York: Harper & Row, 1989), 277.

3. For a fascinating discussion of the Dreyfus Affair, see Sander Gilman, *Franz Kafka, The Jewish Patient* (New York: Routledge, 1995), 114–19.

4. For a discussion of the 1936 Olympics in relationship to Stoller and Glickman see Stan Cohen, *The Games of '36: A Pictorial History of the 1936 Olympics in Germany* (Missoula: Pictorial Histories Publishing, 1995), 97–99.

6

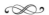

Trial by Fire: A Saga of Gender and Leadership

I never intended to be a dean. A writer, always, that was a childhood desire, but never a dean, and certainly not a dean of an art school, not *anything* at an art school. Had you asked me before I started teaching at the School of the Art Institute of Chicago what an art school was, I would have answered in the most rudimentary way, probably only able to imagine Cooper Union in New York or the Rhode Island School of Design (because I grew up on the East Coast), and even then having only a vague notion of what actually went on in such environments.

Now, twenty years after joining the school's faculty and serving as chair of the liberal arts department, chair of the graduate division, associate dean, and finally dean of faculty/vice president of academic affairs, I realize how these experiences have shaped my life. Not just my professional life, but my psychological, creative, and spiritual lives as well. To be honest about why and how I came to this state, and what it has meant, I need to start at the beginning, at the intersection of personal desire, gender identity, history, and psychic permission, combined with my own initial assumptions about place as a female raised in a 1950s world where men had the greatest authority, mothers were often homemakers even when they had jobs outside the home, and fathers wanted their daughters to be good.

I was most fortunate in that I was raised by a father who thought I was a son. He seemed not to have noticed that I was a girl, at least not until I reached adolescence, when he became jealous of the boys in my life and my interest in them, which he personalized as abandonment of him. But during my childhood we went everywhere together. At the age of five, I told him, "Now I know you well enough to call you by your first name." And

from then on I always called him George. My father was a gambler—cards and dice mostly. After World War II, and especially after my birth, he became a reformed gambler—an auctioneer. He was tough, Bogart-like, handsome, and I was his buddy. I accompanied him on business deals, met his friends and working companions, even served as a shill at his auctions, bidding from the floor, pretending no one noticed that I was a child, his daughter, and the only female in the place. He talked to me about money and future projects. He worried out loud about his failures and took me with him on summer nights to the favored delicatessens in Atlantic City, where he and his friends sat and kibitzed after the bars closed on the boardwalk at Point Pleasant. My father's friend Irving Block owned the Rip-Tide Bar, then the largest bar in New Jersey, which was packed all day and night with bathing suit–clad beer drinkers. My father ran the auction room and sold "Intercontinental Geneva" watches, which were not from Switzerland. Neither my father nor Irving drank, but they did wait out the bar's closing every night and carried paper bags of money with them into the delis of Asbury Park, not wanting to leave the cash and receipts in the car. I remember at least once when they forgot the bags in the booth where we'd been eating pastrami sandwiches at 2 a.m. We were halfway to Point Pleasant when we realized the loss and had to turn back, hopeful that the bags would still be sitting where Irving had stuck them between the wall and the Naugahyde. We rode back in silence. Miraculously the bags were still there on our return. I was probably eight at the time.

I must have loved to hear them wheel and deal into the late hours, arriving home to our beach bungalow in the middle of the night, getting up early to open the boardwalk shops. For many of my preadolescent summers, I had a job making fudge and as an employee got free rides on the Bubble Bounce and other carnival attractions. We all worked, stayed up late, tried to make a buck. In this context, we were equal.

At home in New York I was treated the same. My uncle, who was also my father's business partner, lived in our apartment building, and when they met after dinner to talk about business, I was always there. What I said, what I could have offered in such situations, I can't imagine. There is no doubt that I also learned a great deal from my mother and the aunts with whom I lived in that building in Brooklyn. They were tough, had lived through the war. They were confident, quick-tongued, and strong. They worked in Manhattan and rode every day back to Brooklyn on the subway. Their lessons to me were innumerable. But there is one aspect of my childhood that I intend to focus on here, which I attribute to my relationship with my father. It has to do with my perceptions about equality between women and men.

Something happened to me as a result of these times spent with my father, a configuration I might need years of therapy to unravel. The posi-

tive side of it I know well: I was raised to assume equality—my own equality. In this working-class or, more precisely, lumpen environment, I was not treated as a child or as a girl, but rather as their equal. The result is that I grew up assuming I was smart, that men wanted to listen to me and hear my opinion, that I had a right to be wherever they were. And this was a good thing, because to this day, thirty-odd years after the resurgence of the women's movement, I am convinced that the most transgressive act a woman can perform, at any age, is to walk into a room of men and unself-consciously, undramatically, unself-righteously assume her equality.

In an attempt to achieve such equality, many women, and many women artists, adopt the identity of "the bad girl." They flaunt their sexuality, dress in raunchy ways, make provocative and sexualized work, and act tough, all in order to claim their bodies as their own. Such performances are unsettling to men and to society, but often they are also pleasing to men. Women exhibiting behavior patterns that are predominantly male-defined are defiant of patriarchal oppression but are nonetheless marked by that oppression. Acting out on the father, against the father, yet never entirely free of the father, women are still caught in response to what society (read, codes of patriarchy) says they should or should not do. Because such behavior is also coded in sexual terms, it is often appealing to men. There are men who like scantily clad women grabbing their crotch, as Madonna has been known to do. They still perceive this behavior as somehow for them, unnerving but nonetheless titillating.

What many men have real difficulty with, however, and regard as a true threat, is a woman whose life is not lived *for* them, even if it is lived *with* them. A life simply defined for the female self, by herself, assumes equality. Acts of self-assertion become truly powerful when they are enacted by a person who behaves as an equal and does so from her deepest self. She becomes threatening to fragile egos because she is asking no one's permission to be.

I had no idea how powerful such self-possession could be until I dared to assume that I could be in a position of leadership, that in fact I deserved to be because I was qualified, could handle it, and was willing to do what it would take to fulfill the obligations of such a role.

When the former dean, a man, left the School of the Art Institute to go to another college, I was on holiday in Greece. Immediately I started to receive calls in Athens. Everyone in charge of the school at that time was in a state of panic: Who would be the dean? Who could be the dean? Would I serve as acting dean while a search began for the permanent dean? No one at this stage considered that I could be a possible viable candidate, even though I was already the associate dean and was being consulted as the "acting dean."

Instead of recounting the long, although not completely boring, narrative of how my colleagues finally saw my potential to fulfill this role, I will simply say that it was made apparent to some by how well I was doing the job in the acting position. But even while that recognition was taking place, people would come into my office—the dean's office, which I was inhabiting during my temporary appointment—and look straight at me and say: "God, do you think we could ever find *anyone* who can be the dean?" This happened more than once. Looking right through me (and in spite of the fact that the academic area was running just fine with me at the helm), they were expressing their anxiety that the person in the role of dad had left; how would we survive? Could a replacement be found before chaos ensued and before they, the children, became undone and the institution disassembled?

The potential for anarchy is always present in true patriarchal structures because there is a perception that no defining order exists; that no rules, no cohesion can be maintained without the father at the top. Such expressions of anxiety around the need for the return of the absented, abandoning father were true not only of male faculty members, but were even more true of several of the women faculty. They seemed to need dad in place in his authoritative role, so that they could continue to be the obedient or rebellious daughter. If they couldn't see themselves as empowered and adult—or should I say equal—to the father, how could they see that potential in me? If they needed to work under male authority, why didn't I? But when it became clear that the school continued to run and, in fact, ran very well without a male at the head of the academic area, and the word about all this got around—thanks to some wonderful colleagues who were quite vocal about my role in the school's success—the question then became: Would a woman ever be elected to the position, and a woman writer, not an artist, at that? The old guard liked to say, of course gender had never been an issue; why would it be now? To which I would respond that gender must have been some sort of unspoken issue, because in the 125-year history of the school, never before had there been a woman dean, even in an acting position.

While the institution grappled with the issue of gender and leadership, I faced a challenge as acting dean that demonstrated the kind of pressure such positions engender. This incident changed me, toughened me, and taught me about developing and sustaining a public self. It also made literal for me the expression "trial by fire."

I have written about various public episodes that occurred at the school in the past, incidents revolving around censorship, anger, and scorn for the School of the Art Institute, but never this one, not until now. It was too personally, painfully directed at me. But I think it constituted an impor-

tant series of causes and effects to consider because it raises many issues about responsibility, life without a father figure, and growing into one's leadership role.

Early on in my acting deanship, while the very public national search for the new dean was under way, an incident involving a photo student threatened to destroy my relationship with the student body and the faculty, and certainly any chance I had of being chosen as dean. A student had hung a series of photos in the photo cases of the school's main building outside the photo department, in the public corridors. The photos, cropped from the waist down, were of a woman stuffing various objects into her vagina. In one image it was a .45 caliber automatic gun, in another an egg beater, in another it looked as if the skin around the pubis had been punctured with a stapler. In some images the woman was spread-legged. They were all close-ups—large and graphic. I had received an alarmed phone call about these photos from someone in the art education department. That department had scheduled two hundred children to come for the opening of the school's Saturday children's session the next day. These children had to walk past these photos in order to get to the cafeteria for lunch. What should the art education department do? What were we in the administration going to do? We rushed over to take a look. After seeing the photos I knew we had a real problem. Parents dropped their children off and left them with us for the day. How could we explain these photos to the children (ages four to thirteen), or to their parents, for that matter? Why, the parents might ask, did these photos need to be in a public corridor when there are so many other possible exhibition venues in the school?

After going around and around with my colleagues about how to handle this, the administrative team, myself included, requested the chair of the department to speak with the student to ask if the student would move the photos from the cases in the public corridor to the cases right around the corner in the photo department. Through the intervention of the department chair, the student agreed to move the photos. But, as soon as she did so, she wrote all over the wall where the photos had been that she had been "censored" and had been forced to move the images, and that I had done it. Thus began an outcry focused specifically at me. There were "wanted posters" in all the school's buildings calling me a fascist, a Nazi. There were articles in local papers, discussions on Chicago radio talk shows focused on the issue, none of which accurately represented the thinking behind the request to relocate the photos several feet away. I was publicly slandered in Chicago and elsewhere for a year. Debates among the faculty took place, schisms between the faculty resulted, all while I was being considered for the deanship. It was a mess and a personally distressing mess. Everyone felt they could act out on me, however they

chose to; this was true of faculty and students alike. A close friend to whom I had not yet confided any of this came to the school's Film Center one night, saw the posters and damning graffiti addressed to me all over the school walls (in several of our buildings), and left this message on my answering machine without explanation: "Carol, this is Judy, I'm at the school; they can't pay you enough." I knew immediately what she meant.

Would such outrageous outbursts have been projected onto a male dean? Would the same accusations have been made? I'm not sure. I dare speculate, however, that students would be more fearful of the reprisals of a male dean—they probably would have more anxiety about unsettling the wrath of the father. What I did know for certain was that I had to rise to the occasion, become the leader, and I had to do it fast or be crushed by the sheer weight of humiliation hurled at me.

So what did I learn from all of this? I learned how to take the heat; to carry on with my job, no matter what; to avoid bowing to slander; to refrain from going on the defensive; to resist slandering back. I learned that the press will distort and sensationalize. Students will lie. Faculty will lie. And everyone believes you can take it and that you will take it, because it is your job to be the authority figure upon whom insults and abuses are hurled and upon whom even adults need to define their identities.

I had never before understood so clearly that to ask art students to consider the welfare of children was, for some, akin to receiving a request from Mars. Most acted as if *they* were the symbolic children and we were the symbolic parents. How, then, could we dare ask these student to care for real children? I had become the "monstrous mother," in Marina Warner's apt phrase. One poster in fact duplicated an image of my head sitting on one neck—a Janus-faced monster. In circles around this two-headed creature it read, "The Responsible Woman/ The Woman Responsible"—a take-off on a pamphlet I wrote about artists and social responsibility. At least they used a good picture.

I began to understand why deans are often paid more than faculty members, and I learned how to find a place inside myself that was tough enough, and simultaneously relaxed enough, to be able to sleep at night. I also understood why some rock and movie stars, as well as political heads of state (so much more visible and vulnerable than I was), probably want to commit suicide at times and occasionally do. I learned that no matter who you are, misrepresentations of reality and of your personal motivations do hurt. I learned to turn to the Tao Teh Ching at such times, to slow down, and to wait it out.

When this episode occurred I was completely unprepared for such public scrutiny, although I knew intellectually that it came with the terrain. I emerged from it more respected by some, simply for having held my ground. But it also irretrievably severed certain relationships with others who had quite different perceptions of the episode and how it should

have been handled. I am no longer sure whether my decision was right or wrong. There is a section in the student handbook that clearly states that the administration has the right to ask students to relocate work in the building if we believe the safety or well-being of the institution is at stake. But this did not matter to my critics. I had done the worst of all acts: I had asked a student to relocate a piece of artwork, and I would pay.

I also learned that in order for women to survive in such roles, they have to cultivate what I have come to think of as a public self—a way of being in the world that allows one to handle the complex issues that come one's way in the public sphere. This self involves being able to take the blows and the criticisms, being able to tackle difficult decisions, showing people at all times that these decisions are not easy but will nonetheless be made with great thoughtfulness, carefulness, and consideration—all the while knowing that people are watching and that if you reveal too much vulnerability, it will be perceived as weakness. For women, a key lesson is to accept that love from the people for whom one is responsible may not be forthcoming, but admiration and respect might. Men who take on such a public leadership role are often better prepared for it at a personal level than are women, who are generally socialized to cultivate personal characteristics such as kindness, compassion, and empathy; seldom are women trained to be as tough as they sometimes need to be in high-visibility positions. And they are certainly not trained to think about how their public behavior might be perceived or distorted, how their actions will be read or misread, how they might become the butt of rage and scorn.

For me these attacks about my actions were much more difficult to address than criticisms focused on my writings. Long before this event I had created a persona that could fight back in language, when necessary. But to stand up to such focused attacks against my person, in person, was a difficult challenge because it involved the possibility of face-to-face public humiliation. It made me feel much more vulnerable.

Artists and writers are allowed to manifest their inner selves as their outer selves, much more than people in other roles can. It is expected that they will dress in creative ways, speak from their emotions, not feel compelled to adhere to societal rules. Many male artists have used this mythos surrounding artists to their advantage, solidifying the illusion of eccentricity and otherworldliness, appearing to have great bravado when in fact they are often quite fragile and can even be abusive as a result of this fragility. Women are less likely to manifest such flamboyance, although from time to time they do. They are more likely to remain in the background.

It seems women have been raised to believe that their own authenticity is completely dependent on a permeable psyche and a vulnerability that must be present and preserved in all contexts. But what happens when one is actually out in the world? This contradiction becomes mortifying for

women artists, who often have to deal with gallery owners, producers, presenters, critics, foundations, journalists. How do women artists and writers keep the creative spirit alive and at the same time deal with the demands of a world that will judge them harshly and leave them out in the cold if they are not able to function as professionals—confident and with their emotions held in check? While there are many male artists who also have difficulty with all this, these are particularly daunting issues for women, who are not necessarily comfortable in the world of negotiations—whose rules have been established by men. This is why I've felt grateful for those long evenings in the Asbury Park delicatessens. None of the men I have encountered in my professional life has been as tough as my father. None has expressed his street-smartness and his willingness to stare you down when he wanted to win whatever volley of repartee in which we were engaged. It was good to recall his apparent fearlessness as I became involved in endless daily negotiations. Knowing that I could find a way to handle whatever came my way made me calmer and granted me the patience to wait for the correct response to the situation to emerge.

Now that women increasingly have access to higher levels of authority, the important issue then becomes, what can they do not only to empower themselves but also everyone who comes in contact with them to feel a greater sense of equality and involvement in the work situation? After surviving the abuses of others to obtain the position of dean, I became interested in the potential *use* of the position. What could I do that might be different from the efforts of male deans of the past? What might a woman's leadership in particular bring to this position and institution?

My first and most immediate goal was to create what I believed would be a healthy environment: one in which everyone felt they were treated justly, one in which everyone was expected to act in a mature and professional way. As part of this goal, I wanted all the women in the workplace to feel that they had the right to develop and assert themselves. To do this I had to demonstrate that I personally was not afraid of men, that I would stand up to any situation when called upon, and could take whatever consequences resulted. This became especially important to the young women working in my office, who were watching me daily, trying to see how I would handle situations. Would I be afraid, insecure, would I back down when men became angry with me? Would I try to appease their anger? And how would I deal with women who turned against me and acted out?

The second goal was to build a team-oriented workplace: to make everyone working close to me feel part of that team; to let everyone know, repeatedly and also publicly, that it was the team that was moving the institution forward, not any one individual; to turn the spotlight away from me and not appropriate the achievements of others as my

own, which was something I had seen men in leadership roles do for years. I was also careful not to blame those who worked for me when things went wrong, in order to save face in front of my colleagues, which I had also seen men in leadership positions do repeatedly. I wanted to communicate through my behavior that everyone was needed and that together we could probably make most anything happen. While I needed to build a sense of teamwork among my colleagues, I also needed to exemplify such cooperation myself. To that end, it was necessary to work on creating a cooperative, rather than a competitive, environment and to avoid competing with others myself, even when some individuals tried to compete with me. In doing so, I was attempting to break with a certain type of egotism that I have come to associate with male leadership, although there are, of course, men who are exemplary exceptions in all respects. Fortunately my colleagues liked to work together, collectively, so this goal was not especially challenging to achieve.

I felt it was also essential not to diminish my own authority. I had to own that certain decisions, for better or worse, rested with me, and I had to face them head-on. I could take advice from everyone around me, and should, but after that I would be alone with the final decisions and their consequences. While one should reflect on the thought process through which one comes to a decision, the agony and insecurity that often accompanies decision making should probably be kept to oneself. Appearing in control, in a human and humane way, is not always easy for anyone to maintain, and yet it is essential for good leadership and the mental well-being of the community. I felt it was important to project the image of a woman who was not afraid in these ways and to try to become such a woman in fact.

Finally, I learned to listen to those who worked with me: the students who answered the phones, the young women and men who did the work of running the office—those who were perceived as having little power. These staff members knew who was rude, bossy, and authoritative with them but nice to me. I learned to ask my assistants, if they did not offer it naturally, "What do you think of so and so?" And through such casual inquiries I learned a great deal about which colleagues were consistent and reliable, which ones were trapped in their own egos and sense of traditional hierarchies. I tried to transform a hierarchical organization into one where people at all levels and in all positions could feel heard and respected. This process is still under way.

With all of this I have also come to understand how easy it is to fall out of favor as a woman if you are just the slightest bit too aggressive, your humor or teasing a bit too edgy. Men get away with such behavior all the time, but women do not. For a woman to assume equality is attractive only to very particular men. Others are offended by this stance. Equality

is at times threatening to people of both genders, as all the battles against sex and race discrimination attest. And equality between men and women has been particularly absent in the art world.

The history of visual art, as it has been presented and taught in the West for most of this century, is the history of great white male geniuses—Michelangelo, Caravaggio, Picasso, and so forth. Only a few women have entered this exalted rank, and often they—except perhaps for Georgia O'Keeffe—are rarely known outside art circles. On the other side of many of these great men are the suffering women, the counterparts to the male geniuses, as profoundly articulated in Linda Nochlin's classic essay, "Why Have There Been No Great Women Artists?" Victorine Meurant (Monet's "Olympia") and Tina Modotti (Edward Weston's famous subject)—both models who became artists—or others like Frida Kahlo—a magnificent talent in her own right—were often overshadowed and tormented in their love lives by "great" male artists. The women's movement has done much to bring the lives of such women to popular consciousness, to save them from historical oblivion. But there is no doubt that these women suffered, their talent or psyches often atrophied, distorted, while they were forced to accommodate their impossible liaisons.

In my own experiences at the school I have witnessed the difficulty women artists face in trying to break through the barriers and hurdles presented to them by dealers, museum curators, critics. The obstacles are still formidable. Even the majority of women gallery owners prefer to represent male artists, at times carrying on vicarious romances with the moody, brooding male geniuses, who need their care, and basking in the odd glamour associated with such men. Few male collectors put their trust or their money into the work of women artists. And women often do not trust women or themselves in these ways either.

We all know the daily demands of being an artist and how few women have the structures in their personal lives to support them in such self-directed efforts. If they can do their work, it is often because they do not have their own families. If they have domestic lives, their careers often suffer. Rarely can women combine all these elements and be cared for and protected by a loving, loyal partner. Most women have to sacrifice parts of the self in order to assert the creative. This is just simply the way it is and always has been. There are women who are quite happy to stay home and raise children while their husbands write, paint, succeed in business, or develop their creative gifts. But I am always shocked, after all that has been said, all that has been written, to find young women who are still willing to give away their "daimon," as James Hillman calls it—their own quest and spirit—to project it out onto men or their children.

There have been individual women supported by men or other women in their talents, but these are the exceptions, even now. You can be assured

that the art world institution that supports a woman to be dean, president, a leader, or executive is also rare and difficult to find. The traditions of dominance must be transformed from the inside out.

I believe now that what is needed to break out of centuries of this resistant patriarchy are women taking positions of leadership, acting with a conscious awareness of the significance of their role. When they assume such roles, their presence provides new models of leadership, for everyone with whom they come in contact. For these new models to stand out, it is essential that women not be seduced or coerced into acting in these roles as if they were men. If women try to become more stereotypically male than men, then there will be little positive effect and, in fact, the stigma against women as leaders will intensify.

If instead women in such positions actively strive to achieve a healthy balance between their male and female selves, their public and private selves, their compassionate and assertive selves, this balance will foster personal growth as no other experience can. And it will create an unexpected, unpredictably subversive person at the helm who will affect how people relate to and understand power.

It shakes up the world, and the art world in particular, when *anyone* refuses to be competitive, petty, self-serving, self-indulgent, covert, narcissistic, or hierarchical. It redefines the notion of leadership when a leader is democratic, principled, inclusive, without rigidity, and not in need of ego boosting. This is true whatever gender a leader may be. It also gives all women in the environment courage and confidence to do whatever they desire and to do it in a principled way. Even though some women, threatened by the sister who becomes the mother, the mother who assumes the role of the father, will do everything they can to thwart her, it is my expectation that most healthy women and men would be proud to identify with, and be empowered by, women leaders expressing principled behavior and self-confidence.

Perhaps the greatest challenge leaders face is to bring the public self as close as one can to the private self and the private self as close as one can to the public. This aim is to cultivate a type of authenticity in one's behavior—not a posturing, but an integration that offers resilience and strength to all one's efforts. I believe that achieving this type of psychic health is a great and difficult undertaking. Even were one only to inch closer to this state, the effects would be contagious, rippling out to each individual and to the institution as a whole.

As a writer I have had to learn not to compartmentalize my various vocations: the work of writing—the building of community through ideas, the work of administration—the building of community through institutional structures, and the work of teaching—the building of community through developing continuity of thought while compassionately helping

students to find their identities creatively and intellectually. All of these efforts attempt to achieve a sense of collectivity, and each, in turn, is frustrating, exhilarating, and never-ending in its challenges. Brought together they reflect the desire for an integrated life, one that attempts to intersect meaningfully with those of others. Brought together, they attempt to challenge a fragmented and fragmenting society in need of mature models of leadership.

I never intended to be a dean. This is because I could not have known how much was to be learned from such a challenge, what growth I would experience struggling with my own ego and those of others. I didn't understand that I needed to learn to negotiate the reality principle—to comprehend how the world works. I also did not foresee the degree to which taking on that role would strengthen me, nor how far in practice it would take me from the boardwalk of Point Pleasant. And yet how surprisingly close in spirit that world of my father often still seems.

7

Reconciling Truth
in South Africa

I grew up in Crown Heights, Brooklyn, after World War II, a neighbor-hood that was home to many Jews who had suffered the profound indig-nities and losses of the Holocaust. As a child I was aware that the lives of several families who lived in our apartment building had been shattered by the war. Some were so psychically damaged that they never left their apartments, others so physically impaired that they could not easily go out on their own. We never directly asked about the experiences of these people. And they never talked to us about the tattooed numbers on their arms. As children we sang derogatory rhymes about Hitler, Goebbels, and Himmler, the import of which we did not understand. And we lived in the silence surrounding the suffering of their victims, the resonance of which obsessed me as a child and reverberates in my psyche even now. I am therefore deeply impressed with the degree to which South Africans have been willing to unleash the pain of their own histories, strengthened by the belief that there can be no truth without confession, no forgiveness without understanding, and no reconciliation without catharsis.

In order to reestablish the collective memory after the end of apartheid, the Republic of South Africa has undergone an unprecedented collective catharsis under the auspices of the Truth and Reconciliation Commission. Attempting to liberate itself from the weight of apartheid, South Africa shaped a process through which the truth could be told, forgiveness achieved, and the country finally freed to move into its future unencum-bered by the horrors of the past.

The questions South Africans asked—and the risks they took to articu-late them—may teach the world how to face one of the most pressing

global issues of our time, and one that has certainly followed us into this new century: reconciliation. There is a great deal to be learned from the enormity of their endeavor, both for countries like the United States that maintain democracy, often at the price of repression, and those that have been wracked by the nightmares of civil strife, such as Bosnia.

To this day, we in the United States have not grappled with the contradictions of our own beginnings—the destruction of vast Native American populations, the appropriation of land from Mexico, the nightmares of slavery, as well as the more recent wounds of the Vietnam War. We can only imagine the psychic weight that might be lifted if the truth were told, publicly, dramatically, under the scrutiny of a government-sanctioned body, and then used to rewrite the collective memory.

Across South Africa, thousands of stories have been told in public spaces—churches, meeting halls, colleges, and universities. Christine Buthelezi, mistaken for another person and shot in the spine during a police riot in 1976, is now paralyzed and asks for a wheelchair of her own. Doublas Nkwali, victim of a random attack by two Afrikaner Werstandsbeweging (AWB) supporters, tells how he was shot seven times and left for dead in the veld. A victim of the Sharpeville Massacre, in which 69 passbook protesters were killed and 186 wounded in front of the Sharpeville police station, relays to the commission how the police opened fire on the crowd. He was paid 88 Rand in compensation for his disabled leg. In Cape Town, the mother of Christopher Troter tells the commission that her sixteen-year-old son was killed by a bullet fired by Captain Albert Voskuil. Zubeida Jaffer, a journalist, recounts hours of police interrogation, sleep deprivation, beatings, threats of rape. She tells how she was drugged and almost lost the child she was carrying. Attorney Jan Wagener writes the commission on behalf of his police-officer clients, who are applying for amnesty. The list of crimes for which they have admitted guilt documents eighteen incidents, including the murder of Piet Ntuli in KwaNdebele in 1988, nine ANC members in Bophuthatswana in 1988, Joe Jele in 1986, Jeffrey Sibiya in 1987, and others.

Thando Kana, already sentenced to twenty-three years' imprisonment for his role in the abduction and necklacing (igniting rubber tires around the neck of victims) of four gang members, testifies during his amnesty appeal that he and others were forced by the police to eat bits of their victims' charred flesh. Janet Goldblatt, the daughter of Dr. Melville Epstein, who worked with disabled people in Soweto and was killed during a student uprising, wants to know why her father was murdered after years of service to that community and asks that a monument be erected in his name. In Johannesburg several parents beg Winnie Mandela to disclose the truth about the deaths of their sons—members of her "Football Club"—who disappeared after being called police spies. One of them,

Caroline Sono, says, "Before the world I plead with Mrs. Mandela to give us our son back, or his remains." Local doctors in Queenstown are accused of allowing people injured by police during the apartheid era to go untreated. In Kroonstad Maokina, an "ANC-aligned" group is accused of the deaths of twenty to twenty-five members of the "Three Million Gang" over a period of several years. Kwane Sebe, the son of a former Ciskei leader, and residents of Ciskei file an amnesty application confessing the necklacing of four alleged gang members. Walter Smiles, the self-confessed murderer of Manne Mokobe, asks the commission to arrange a meeting between him and Elizabeth Mokobe, Manne's mother; but, on the day of the meeting, Smiles does not appear.

Such stories were printed in the South African papers, televised, transmitted by international news services, and discussed on live radio throughout South Africa between 11 a.m. and 1 p.m. and between 2 p.m. and 4 p.m. each day. These narratives reveal the sadistic acts humans are capable of committing against each other once the spirit has been corrupted by an unjust system. What is astounding and unprecedented in the history of the twentieth century, and perhaps in human history, is the willingness of South Africans to engage in such disclosure openly, publicly, "transparently"—as described by Commission Vice Chair Dr. Alexander Boraine. Although nineteen such commissions have convened over the past twenty years in sixteen countries, there has never been another commission whose aim was so clearly to promote collective forgiveness. Not after World War I, not after Chile, not after Argentina, and not after the horrors of Bosnia have we seen a process that has been as committed to speaking the unspeakable within the public arena and making all that is said available to everyone through the use of open hearings and the media.

It is a tribute to the new leadership of South Africa that the tone of forgiveness was set for such a process. The government made a commitment to ensure that no one will forget what happened under apartheid so that it will not be repeated. There will be apartheid museums built around the country, with the motto "Never Again" linking them all. Simultaneously, there was a great desire to move South Africa beyond the past and into the future as one nation, reconciled with its own history.

For the most part, South Africans are not after their pound of flesh, although, given the horrific nature of the crimes revealed, many would seem to be deserving of severe punishment. Rather, they are concerned with the difficult challenge of reconstructing a very troubled society—not just economically or legislatively, but morally and spiritually. This emphasis on forgiveness derives from the influence of leaders like Nelson Mandela, Archbishop Desmond Tutu, Thabo Mbeki, Alexander Boraine—people whose generosity of spirit and well-earned wisdom are powerful enough to counter the national inclinations for vengeance, even in themselves. But

these worthy intentions notwithstanding, there are myriad difficult questions now facing South Africa. How can you bring people, whose lives have been destroyed, together with their destroyers and impel these people to work with each other to build South Africa for the future? How do you persuade those who have suffered so tremendously to put the needs of the society ahead of their own and help heal the sickness that has invaded the body politic? How can you rehabilitate those whose understanding of reality was so perverted by fear, hatred, ignorance, racism, or the deadly expediencies of war that they perpetrated inhumane crimes? Without powerful leadership able to keep the long-term interests of the country in the forefront, no one would dare even ask these questions.

The Truth and Reconciliation Commission came into existence as an act of Parliament under the Promotion of the National Unity and Reconciliation Bill of 1995. It was established by the South African government to create a public forum for, and a permanent record of, the crimes that were perpetrated under apartheid, circumscribed between the time period of 1 March 1960 (the Sharpeville Massacre) and 9 May 1995. The commission, comprising seventeen members and chaired by Archbishop Tutu, was divided into three distinct areas: (1) the Human Rights Violation Committee, (2) the Reparation and Rehabilitation Committee, and (3) the Amnesty Committee.

The commissioners were selected through a public forum in which people from many professions were encouraged to apply. The names of 299 applicants were received and, after a process that involved public hearings, the names of twenty-five nominees were sent to the president. Mandela, in consultation with his cabinet, then selected the seventeen commissioners (the number specified by the law). The commission's mandate expired eighteen months from its inception.

These appointments represented a cross-section of South African society and history. In addition to Archbishop Tutu, chair of the commission, they included such diverse participants as:

Vice Chair Dr. Alexander Boraine, former Executive Director of Justice in Transition;

Mrs. Mary M. Burton, Civil Society activist and Trustee of Black Sash;

The Right Reverend Bongaini B. Fin, president of Eastern Cape Provincial Council of Churches;

Dumisa B. Ntsebe, senior lecturer in Human Rights Law and Criminal Evidence, University of Transkei;

Glenda Widsc, chair of the Trauma Centre for Victims of Violence and Torture;

Dr. Wendy Orr, deputy registrar of Student Affairs, University of Cape Town; and

Chris de Jager, former member of Parliament for the Afrikaner Voksunie.

All South African citizens who so desired could apply to speak before the mobile commission, which relocated to various provinces of South Africa on specified dates. People who testified were sworn in, but because evidence before the commission was privileged, a person who unwittingly said something that was not true could not be charged with libel. If someone was accused or implicated during a hearing, the person could request to come before the commission, which was then obliged to listen. The commission was responsible for those human rights violations brought to them by victims, their families, or friends, while those who desired reparation could apply directly to the Reparation Committee, and those seeking amnesty could apply to the Amnesty Committee. To qualify for amnesty, persons had to prove that their actions had "political objectives," and that they were willing to make "full disclosure" of their motivations and the particularities of their crimes, including the whereabouts of bodies that had never been recovered. To date there have been two thousand amnesty applications, the vast majority of which were from people already in custody. Hearings were even held within a hall in a prison because the people being heard were already incarcerated.

Each day South Africans were able to hear the pleas of such victims and perpetrators and were made aware of all the heretofore hidden information inevitably revealed through their testimonies. With each disclosure the abscess at the core of the society was further drained, while the collective history of the country was being reconstructed, moving it that much closer to include the experiences of those oppressed within the apartheid system.

Sometimes confessions have emerged outside the formal commission process, demonstrating the sweeping influence the hearings had throughout the country. In July 1996, I attended a conference at the University of Cape Town that brought together artists, writers, and intellectuals around the world to discuss the issues of "remembering, recollecting, restructuring." At this "Fault Line" conference, a completely unexpected event took place involving Mark Behr, the then thirty-two-year-old Afrikaner writer who had just achieved great critical acclaim for his best-selling novel, *The Smell of Apples*—a semi-autobiographical account of the hatred, racism, and corruption inherent in certain powerful Afrikaner families. Behr had been asked to give the keynote address and, without forewarning, decided to use this public forum to offer a confession. He told the gathering that for almost four years, from the end of 1986 until 1990, he worked as a police agent, infiltrating student anti-apartheid groups on the campus of Stellenbosh University (a premiere Afrikaner institution). Recruited by a family member of high rank in the South African police force, he used the money received for these services to cover his college tuition and expenses. But once exposed to the many ethical people he met in the student

movement, his feelings about apartheid began to change. He then turned
double agent, supplying intelligence information to the police as well as
to the ANC in exile.

This personal truth-telling shocked the conference attendees and was
soon picked up by the international press. Some accused Behr of staging
his confession to gain media attention. But the nature of his speech to the
"Fault Line" meeting reveals that for a long time he had lived with a great
deal of guilt about his activities, and that it was this feeling, as well as the
nature of this moment in South African history, that motivated his con-
fession. Obviously distressed about betraying those who had participated
sincerely in the anti-apartheid struggle, he quoted Primo Levi, who, in
speaking of Nazism, said, "All those who in some way injure others are
guilty, not only of the evil they commit, but also of the perversion into
which they lead the spirit of the offended." One needn't understand the
psychology of Behr's actions. It is enough to say that he is a man who has
lived in many contradictions and who, through this confession, thought
he could begin to reconcile them and purify his conscience.

Perhaps it is by creating this environment, one in which the truth must
be told, that the commission has played its most valuable role. The dev-
astation to individuals and to society caused by the perversions and per-
mutations of apartheid could be externalized through these formal, ritu-
alized tellings. One hopes that the rage, pain, and suffering caused by
living under such inhumane and often absurd conditions finally began to
be defused against the larger historical context that was being created
daily. Because the time frame of the commission's work was circum-
scribed to eighteen months, this public exorcism, which could easily have
continued into the next century, inevitably came to an end.

On 26 July 1997, Thabo Mbeki, then South Africa's deputy president and
heir-apparent to Nelson Mandela, was interviewed on a Chicago radio sta-
tion. He was asked a question often posed inside South Africa: Can this
commission succeed when people who justify their acts of torture and mur-
der as legitimate parts of a political process are then given amnesty? How
can a society move to democracy when such confessed crimes and crimi-
nals go unpunished? Mbeki responded, "Truth is more important than re-
venge." He explained that the potential of the future must become more
present than the nightmares of the past—and the future cannot be compro-
mised with hidden facts. It is "practical," he said, to have a commission able
to award amnesty, otherwise criminals would never come forward as it
would not be to their advantage to tell the truth about what actually oc-
curred. The society then would never know who of the disappeared were
dead, and where the bodies were buried. The issue of reclaiming the bod-
ies of the dead is especially important within African society, where locat-
ing the remains of family members, understanding how they died, and

"fetching the spirit" from the place where they died serve as the beginning of the end of the mourning process. Valentina Matseletsele, testifying to the commission on behalf of her exiled son, who she was told had died in a car crash in Tanzania, explained that, "According to Sotho tradition, I don't believe my son is dead because I have not seen him."

Without a government-sanctioned, constitutionally based process, the conflicts between whites and blacks, ANC and non-ANC, Inkatha and non-Inkatha, PAC and non-PAC would have little chance of ever subsiding. The crimes and their political motivations would not be spoken aloud. There would be no way to progress as a nation—as one nation. This is very difficult for those of us raised in a Western democracy to accept. We imagine justice as punishment equal to the magnitude and spirit of the crime. Forgiveness is not part of our political or social landscape.

South Africans themselves debate the commission's efficacy. At the "Fault Line" conference, some attendees suggested that the commission should simply be called the Truth Commission because there will never be a real possibility for reconciliation. But others who spoke, like Nadine Gordimer, expressed the position that this process becomes powerful when those who have never been able to tell their stores are encouraged to do so publicly before a legally empowered body. Njabulo Ndebele, then vice-rector at the University of the North (now vice-chancellor at the University of Cape Town) and a leading South African writer and thinker, discussed the degree to which this telling of stories created a revitalized imaginative terrain for South Africa, a new narrative within which to contextualize the old. The theatrical setting of the hearings also provided a good stage for this much-needed exorcism of the nightmarish images and deeds of apartheid. Many feared that amnesty could simply perpetuate the old polarities of those who have power, those who do not, those who have paid dearly as victims, those who have been absolved. And there was, of course, the threat that once the truth was told, if government action was not taken, or not taken quickly enough, there might be those who would want to take the law into their own hands. It is understandable that Steve Biko's widow, unwilling to accept the final assessment that the amnesty given to his murderers would be upheld, went to the World Court seeking justice. But in The Hague the commission was deemed constitutional; the judges chose not to overturn its decision. This represented the final legal avenue of appeal.

South Africans studied the attempted reconciliation processes of other countries, especially those in Chile and Argentina, in order to devise what Dr. Alexander Boraine deemed the best process for truth telling that could be envisioned at the time. From analyzing the successes and failures of other such commissions, South Africans decided that there would be no general amnesty. Those seeking amnesty had to apply, and they were

evaluated on their willingness to speak their crimes publicly and on their ability to justify their actions politically. Once someone was given amnesty, he or she was no longer criminally or civilly libel. Some who told their stories would still be prosecuted. But if amnesty were denied, those involved could subsequently be prosecuted on the basis of their confessions at their amnesty trial. There needed to be additional evidence coming from other sources that could substantiate the charges.

Those who have been implicated in the testimonies of others but who have remained silent could be subpoenaed. The commission was given "teeth," to quote Bishop Tutu. It could do what was necessary to ensure truthful participation. The credibility of the process was enhanced by the fact that amnesty was not being granted by the same government responsible for the majority of the crimes. There was therefore less chance that the verdicts would be politically corrupt.

This process of truth and reconciliation has many layers and permutations. And it became clear in observing it that "an eye for an eye" in South Africa would blind too many people needed for the country's future. Such retribution would thrust the nation into internal political strife, while the very real necessities of reconstructing the economy and building trust in the political system would be hindered. Vice-Chair Boraine said: "Amnesty is the price we had to pay for stability." The possibility for amnesty was part of the early negotiations with the National Party, which led to the end of apartheid without civil war. It was probably also essential to the prevention of further violence and the cessation of a warlike mentality.

As one might imagine, the National Party was closely watching the commission to be sure that those crimes perpetrated in the name of the ANC were also tried fairly. But Mbeki and twenty-three other delegates representing the ANC—whose crimes were committed as they fought a war for liberation against a fascist state run by a small white minority—nonetheless were able to take the high road. They presented the 420 pages of documents on behalf of the ANC, acknowledging crimes committed by their party in its struggle against apartheid and disputing only the practices of necklacing and all acts against civilians, which had never been sanctioned ANC policy. De Klerk would have done well for his party had he been equally honest. By holding back so much of what South Africans already know to have been National Party practices, seemingly oblivious to the revelations that were made every day to the commission, he set himself and his party up for derision. Had he confessed to the sanctioned death squads, the covert direction of township violence, and the countless murders, tortures, and other serious human rights violations perpetrated by the National Party as they attempted to protect Afrikaner rule, he would have gained respect and proven himself to be sincerely motivated by the spirit of reconciliation.

While I was in Cape Town in 1997, the *Mail and Guardian* reported that a huge explosion, which had injured seventy people in 1987, blamed on the ANC at that time and called "a callous act committed by terrorists under the godless control of communists" by then-president P. W. Botha, was revealed in a letter, by a lawyer requesting amnesty for his police officer clients, to have been the work of the police. Whether the National Party was willing to admit to it or not, the truth *was* being revealed.

How will those who have committed such atrocious acts, but are nonetheless granted amnesty, continue to live with themselves and within their communities now that their deeds have been told and publicized? The crimes committed are too cruel to be forgotten—rape, torture, murder; random, gratuitous, sadistic violence that took the lives of so many, including those of countless youngsters and teenagers. Should the perpetrators leave the country? What do they tell their own children—the next generations—many of whom, although white, now study Zulu or Xhosa in integrated school settings? These young people grew up under black leadership with Nelson Mandela as the country's beloved president. They are learning to live within the logic of an integrated society and may never be able to justify their fathers' violence against fellow South Africans who, because they were black and the majority, threatened absolute white minority rule. These children might never comprehend, as the children and grandchildren of Nazis have not, how family members whom they loved, and who were kind to them, could have been so sadistic to others. Perhaps some of those who engaged in such violence will feel remorse. Few will probably be completely rehabilitated and free from all hatred. But the country finally has a shared recording of some of what occurred during those most violent apartheid years.

What was revealed daily in these open hearings is that nightmarish potential of the human heart to shut itself off to the humanity of others to such an extent that it creates an abyss within which all compassion is irretrievably lost. If South Africa is fortunate, we will also see that the human potential for generosity and forgiveness is equally great.

The world must watch the outcomes of this process carefully. There may never again be a government so courageously willing to face the truth with all the pain it brings, to do so without vengeance and, we can only hope, without the perpetuation of violence.

8

Memory and Monstrosity

These things at the limits of reason, nothing at the limits
of dream, the dream merely ends, by this we know it is the real

That we confront.

—George Oppen[1]

Two of the most complex and polarizing events of the twentieth century
have been the Vietnam War and South African apartheid. Both have
etched themselves into the collective psyches of their respective countries,
have mobilized international movements, and have demanded new, ritu-
alized performative expressions of exorcism to lift the weight of memories
that haunt both victims and perpetrators. In South Africa, the Truth and
Reconciliation Commission was established by the government to create
a process through which to confront the country's racist past. This trans-
parent South African process of reconstructing a collective memory, and
of speaking the truth, will take decades to complete. In the United States
there has been no comparable tribunal to deal with those barbarous acts
that characterized the American invasion of Vietnam. Yet, this war, fought
thousands of miles away from the United States, turned Americans
against each other, creating a rift in the collective consciousness that has
still not healed. There was no collective agreement about the rationale for
the war and, as a result, those who fought in the war have suffered im-
measurably, unable to organize and often justify the crimes they perpe-
trated in Vietnam. Because there has been no government-instigated
process to deal with the effects of the war on the Vietnamese, veterans
have had to find their own ways to survive the burden of remorse. In each

of these unique situations, the complexity of memory and the attempt to recollect an agreed-upon truth has been at the center of national pain.

Ritualized reenactments, and the telling of events as people experienced them, should result in some transformation of personal pain into collective accountability. Each attempt to heal past abuse should help us to understand how humans experience tragedy and then create rituals, both personal and collective, to live with and ideally transform its consequences.

PART I: REMNANTS OF WAR

In Ho Chi Minh City, the museum the Vietnamese have dedicated to the U.S.–Vietnam War has repeatedly changed its name: from the American Atrocities Museum, to the American War Crimes Museum, to the War Crimes Museum, and now to the Vietnam War Remnants Museum. These transformations reflect the evolution of the Vietnamese response to the American War, as they call it, which, for them, now appears to have passed from nightmare into memory. As a North American, my decision to visit this museum was a very small act of contrition, a willing confrontation with the devastation the United States caused Vietnam, both its land and its people—a gesture to allow the monstrous memory of the war to flood my consciousness once again. In preparation for this journey across the city, I imagined how many other Americans had steeled themselves for this same experience. Were they also uncertain what they might find, unclear how to respond in such a public space, concerned that they would be isolated in this situation, fearful of being overwhelmed by their own sorrow?

The museum resides in a series of three modest stucco structures. The first presents the history of imperialism in Vietnam, documenting, with photos and text in English, French, and Vietnamese, the narrative of this small country's ongoing colonization and battles with various world powers, up to and including the American war against the Vietnamese. Here I encountered, once again, many of those images through which I came to know and therefore oppose the war, thirty years ago. I began to weep when confronted with them once again: large blowups of massacred children piled in heaps of small legs and arms; a man dragged behind a U.S. Army truck, skin peeling away from his bones like pulp from an orange; a napalmed body, blackened, shriveled, reduced to cinders. And then the wall-text:

> Nearly three million Vietnamese were killed in the War. Four million others were injured, two million were affected by chemicals, 50,000 infants were born malformed, over 58,000 American army men were killed. More bombs

were dropped than in WWII, and 170,000 old people [get lonesome], as their children and relatives are killed in the war.

On the far wall are jars filled with deformed Vietnamese fetuses, perhaps affected by napalm, phosphorus, herbicides, or dioxin. Next to these are large, yellowing black-and-white photos of American families—mothers, GI fathers and, in the middle of each, a child born with deformities caused by Agent Orange.

In the third room the walls are covered with photos documenting protests against the war from Kent State to Paris, Jakarta to Auckland, placards in myriad languages—1968 around the world, youth mobilized against the war: a Vietnamese monk immolating himself, an American student performing the same act. I remember, for the first time in thirty years, a fellow student at the University of California who doused himself with kerosene and set himself ablaze early one Sunday morning on the campus plaza when no one was yet awake—leaving an ashen scar on the concrete. Later we learned he had left a note that said he could no longer bear the pain of the war.

Moving through this space I felt I had entered into the collective Vietnamese consciousness. I understood that this is how the Vietnamese chose to represent their experience of the war in a public setting, where both Vietnamese and foreigners might visit. Through text and imagery they represented the pain the war had caused at all levels, but amidst this suffering they presented the historical resistance to the war—their own and that of protesters from around the world. Here too the Vietnamese reflected their understanding that both countries were deeply affected by the war and are now joined by this horrific past in the present. What we share, primarily, is devastation. For the Vietnamese, this devastation was economic and extremely physical. Their land, their resources—human and other—were devastated. But, at an emotional level, they appear to have recovered from the war. For them it was a just war that they won in defense of their country. They have no guilt. They say the war is long over, done as of 1975. They repeat: "We have turned the page of the book, but we will never rip it out."[2] People still suffer economically, but not as they once did, and they have moved on. In contrast, many Americans still grieve at a deep personal psychic level, while the country, three decades later, continues to be polarized by the controversies that surrounded the war. There is for many a deep mistrust felt toward the U.S. government, generated in part by the foreign policies of that time. People who run for political office are still categorized as those who protested, those who "served," and those who didn't go. These designations continue to be utilized in America, which remains a nation lost in the pain of memory and the memory of pain.

To find a way to reconcile the complexity of this American response, a project to create a Vietnam War memorial was under way soon after the war's end. But, as most people know, the concept of the memorial from the start was, predictably, a very contentious subject. After much debate, a design by Maya Lin, then an unknown twenty-one-year-old Yale undergraduate student in architecture, was selected. But the fight over the concept that would finally come to represent the war had only just begun. There seemed to be no one representation that would satisfy the many different voices wanting to be heard. Those who objected to the design understood that how something is remembered—the image it is given in perpetuity—contributes to how it will be understood historically.

On Veterans' Day 1982, Lin's Vietnam Memorial Monument was dedicated. The money for the wall consisted of donations from veterans and some 275,000 other Americans. Lin's concept was simple, elegant, precise: a black granite wall cut into the earth, "polished like a geode," that would symbolize the American soldiers who died, rather than the war that killed them; a large V at a 125-degree angle "suggesting the pages of an open book,"[3] a running wall of names organized chronologically by the dates of their casualty, a glorious headstone for all who had lost their lives and a site of commemoration for all who remained. Expressed without figuration, the design thwarted the traditional expectation of heroic monumentality and instead plunged visitors down into the darkness and then up again (past 58,000 names of the American deceased), into the light. Many veterans understood and supported this design from the first. Others spoke against it, vehemently. Some veterans still felt that their war, "the forgotten and lost war," needed a heroic monument to give it legitimacy. And while response was divided, many understood that Lin's monument attempted to represent, in its severity, what had occurred: massive deaths, tragedy, sadness; twenty Vietnamese civilians killed for every one Vietcong; grenades randomly, thoughtlessly thrown into groups of children. Others experienced the wall as too abstract, too intellectual, "representing the art of the class that lost the least in the war."[4] Ultimately, the fight over the monument represented the nation's split over the meaning of the war itself. There seemed to be no one representation that could account for the complexity of public memory, interpretation, or mourning.

Many veterans were not satisfied with the wall and felt there needed to be a more traditional memorial to represent the heroism of those who died in the war. A second memorial was eventually built quite close to the first. In this traditional, representational memorial, three standing figures of indistinguishable ethnicity are posed, ready to engage in struggle. It is significant that this monument also has a flagpole flying a U.S. flag. It is a patriotic monument like so many that have come before. But it is Maya Lin's memorial, focused as it is on remembrance and sorrow, that has become a shrine—a site of ritualized remembrance, a destination of pilgrimage.

Performative gestures are made at this site daily. Against the wall, near the name of a particular deceased, offerings are left behind: a pack of cigarettes, a teddy bear, a rose, a letter, a photo of a child never seen by her father, a can of beer, an "Impeach Nixon" pin, a pair of boots, a bicycle—objects whose personal significance is shared by the mourner and the person remembered but whose meaning is often hidden from other visitors to the site. In traditional gestures, Jewish people leave stones on the grave, small stones usually found at the site, something to last for eternity, but most of the objects left at the wall signify temporality—good and sad times now gone. When the memorial was built, the expectation was that people would take something away, rubbings off the wall of the names of those remembered. It was never anticipated that people would also *leave* things at the wall. Perhaps no one could have imagined how desperately was needed a memorial space that afforded the possibility of ritualized acts. Men who had died so far away were brought home, remembered together, while those who served and survived make pilgrimages to Washington just to bear witness at the wall. Those in torment make the journey hoping to find relief. Veterans talk about long bus rides from their homes thousands of miles away, all the while preparing for the catharsis of coming to the wall. Some veterans and other visitors start to weep as soon as they are in sight of it. By now so many tears have been shed at the wall that it seems charged with sadness. Some veterans say the wall has an almost mystical aspect, able to conjure buried sorrow that can begin a process of personal healing. Part of the power is in "the sacralization"[5] of the 58,000 names—the names then conjured the objects as offerings. The Smithsonian Institution has collected these objects, which will soon generate a new museological site. This museum will be its own archive of sadness, a repository that creates a "heteroglossia"[6] of meaning, too layered and unknown ever to be truly understood. There is even a "moving wall"—a portable replica of the real wall that is transported and displayed around the country. In this way people who cannot travel to Washington can have a simulated experience of the monument. This concept resembles that of the AIDS quilt, commemorating the deaths of those who have died of AIDS. The quilt is now too large to exhibit in its entirety in one location, so it is shown in modules. Viewers can then attempt to visualize the breadth of the whole, the incomprehensible totality of the loss.

Chicago has its own monument to the pain occasioned by the war, which I visited a week after returning from my first trip to Vietnam. In a once-abandoned three-story building, now transformed by the labor of Vietnam veterans, there is a Vietnam Veterans Art Memorial Museum. On the lobby wall is stenciled an epigram taken from Taoist Monk Deng Ming Dao, written before the birth of Christ:

If you go personally to war, you cross the line yourself, you sacrifice Ideals for survival and the fury of killing that alters you forever. That is why no one

rushes to be a soldier. Think before you want to change so unalterably. The stakes are not merely one's life, but one's very humanity.

The founders of the museum wanted visitors to know, from the outset, that this is not a museum that glorifies war. Inside are two floors of art made by Vietnam veterans. These were men who fought and returned, often still believing in the war's necessity. Most were never trained as artists, some have since become artists. All have been compelled to re-create their experience of the war in painting, sculpture, installation, and photography. This space could be renamed the War Remnants Museum because here, on display, are the fragmented psyches of American youth, sent at seventeen, eighteen, nineteen to fight an irrational, psychotic war. Here, I began to weep again. These were the men we, in the anti-war movement, protested against in the 1960s and 1970s—those whose trains we tried to stop before they took the boats headed for Southeast Asia, those whose military recruiters we kicked off campuses from Brooklyn to San Diego, those we called murderers and tried to shame into refusing to serve. Surrounding the visitor here are the stories of those who were thrown into the massacres of fellow humans, of young soldiers who became perpetrators of atrocities from whose memory they cannot recover.

Not one veteran's work defends the war. All of it is unfiltered, unselfconscious, untutored—the raw representations of emotional pain. Here are the sagas of thousands of sons betrayed by the government-father that promised them glory, manhood, and moral correctness and, instead, brought them not only defeat but abandonment, leaving them to a weight of guilt many cannot and could not tolerate. Perhaps there is no one moment of recovery from the memories of such violations. There seems to be only the possibility of representation, repetition, and reenactment. All that is connected to the mourning of the war necessitates performative acts of contrition. Because they are unable to transform the guilt and pain, these veterans need to return to the issue of the war again and again in art-making.

The Vietnam Veterans Restoration Project, based in California, understands this need for ritualized return. This group of veterans has taken the notion of return literally. They organize pilgrimages that allow Vietnam veterans to return to Vietnam as humanitarians, helping to rebuild clinics and schools destroyed during the war or to build new homes for disabled and retired veterans. After decades, many veterans want their suffering, which has shaped so much of their adult lives, to end. In their film about the tragedy of Vietnam, the collective also cites statistics—the attempt to quantify the unquantifiable—but they add another amazing piece of data. Like the Vietnamese, they tell us that three million Americans served in the war, 58,000 died, and to this they add an unbelievable statistic of their own, which they insist is true: 200,000 veterans, they say, committed suicide after their return from the war. The veterans who organize these ritualized hu-

manitarian missions understand that, for some, only a productive return can lift the weight that has crushed others. The Greeks paid a *cathartes*, a fee, for this type of pilgrimage to the place of pain. They made the pilgrimage and the offering so they could find a "ritual relief from guilt."[7] The implication is that guilt, like memory, never ends, it is merely assuaged for a time.

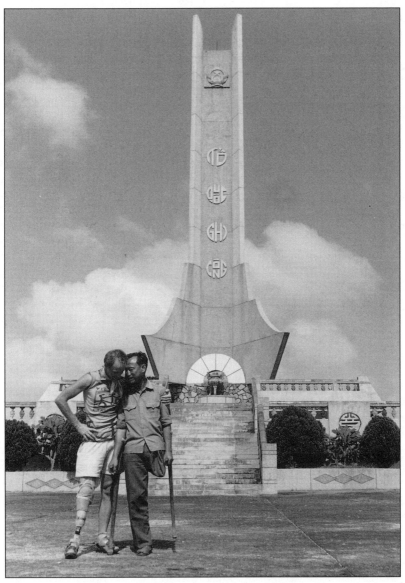

Vietnam Long Time Coming. Kartemquin Films, January 1998. Image courtesy of World T.E.A.M. Sports and the Vietnam Challenge.

The Kartemquin documentary, *A Long Time Coming*, released in 1998, documented an unusual pilgrimage of disabled American veterans and their Vietnamese counterparts, many using hand-driven bicycles because they had lost their legs in the war, setting out across the Vietnamese landscape. American veterans revisited the scenes of horrific tragedies where some had acted in the most brutal ways, as in the My Lai massacre, or where they had left behind an arm, a leg, an eye, a comrade, their innocence, or their mind.

On this journey of cyclists, many Americans repeatedly broke down, overflowing with tears. Such remorse, South African writer Anthony Holiday notes in his commentary about the Truth and Reconciliation Commission, might itself be understood as a "form of memory,"[8] perhaps the worst form of memory, the remembering of that which one desperately wishes to erase.

Freud writes about the site of complexity where contradictions, ambivalences, neuroses spin themselves into a mass—a "cathexis." This mass must then be unraveled, purged, cleansed, discharged, decathected if health is to be restored to the psyche. Wilhelm Reich went so far as to suggest that such emotional blockages could take on physical mass in the body. For Americans of certain generations, Vietnam, just the word, is the site of cathexis. It exists in memory and conjures monstrosity and the unbearable weight of guilt. Vietnam, many have written, must no longer be remembered as a war but, rather, as a country. Unfortunately, we cannot think of the country without remembering the war. Because the U.S. government continues to allow the blame for the war to rest on individuals, individuals must find a way to absolve themselves. Through self-designed, self-chosen, self-actualized performative rituals of absolution, veterans have chartered a way to personal reconciliation. To this day, the U.S. government seeks to justify its actions—not to understand nor truly to apologize for them. Were the government to ask forgiveness for the abuses of that time, they would have to admit that the principle and strategy behind the war had been wrong. And if these were wrong in Vietnam, perhaps they were also wrong in Chile, Guatemala, Nicaragua, El Salvador, Iraq, Cuba. Perhaps the entire premise of anti-communism, coupled with imperialism and the control of investments, has always been wrong, driven as it has been by the arrogance of economic power. But as long as this public denial persists, individuals can find no collective absolution and therefore are left to heal, if they can, by themselves.

PART II: RESTORATIVE JUSTICE

In the complex, almost unimaginable condition of post-apartheid South Africa, an imperfect but nonetheless profound model has evolved in the at-

tempt to uncover the complexity of truth, memory, guilt, and absolution, and to foster a culture of human rights. The process of the Truth and Reconciliation Commission (TRC) should be a far-reaching example for Americans because it is premised on the concept that speaking the entire truth, admitting one's torment, apologizing, condemning one's torturers, forgiving, and being forgiven in public is a formal, ritualized way to reconstitute the past and move into the future, for both individuals and the larger society.

These ideals of "restorative justice" and the reconstruction of collective memory are new and foreign concepts for the United States, which seems able neither to confront the truth, apologize, nor forgive. Perhaps this is why there has been so little interest in the commission in the United States, except at times when it has focused on those figures most known outside South Africa, such as F. W. de Klerk, Nelson Mandela, or Winnie Mandela.

Archbishop Tutu set the bar of forgiveness high. Most nations do not have leaders like Tutu or Mandela, whose personal integrity is indisputable. As the moral center of their country, they have insisted on an attempt at forgiveness coupled with the necessity for a reconstituted "moral universe." Tutu, in his role as head of the commission, wanted to raise the level of spiritual awareness for everyone present. The press, observers, families of those testifying all became the audience and beneficiaries for the lessons of the courtroom. They also became recipients of Tutu's wisdom and that of other commissioners. All were transformed, as one might have been in ancient Greece when the sins of Oedipus were uncovered on stage and the source of the plague that ravaged the city state of Thebes was finally revealed: the unspeakable was spoken. One imagines that the audience was affected in deep psychological and spiritual ways, as those present at the TRC hearings doubtless have been. By broadcasting the process on television and radio, by documenting it each day in the papers and on e-mail, South Africa enabled people outside the country to receive daily reports of the hearings. In order for the healing to be collective, the confessions could not have been kept confidential; in order for them to affect societies worldwide, they could not have remained confined within South Africa.

One of the attributes of the apartheid-era state, as in all fascist states, was its secrecy. Jeremy Gordin, in speaking of perpetrator Eugene de Kock, writes, "Covert operations are by definition illegal."[9] Certainly such was the case in South Africa, as people were carted off, their whereabouts unknown, and horrific deeds were enacted behind closed doors. The only historical antidote for such secrecy and its resultant perversities is an open truth-telling process. In South Africa, in public meeting places—schools, churches, courthouses, community centers, corporate buildings—in myriad locales, full disclosure was made. While the country was deconstruct-

ing its hidden history for the purpose of reinventing a collective memory, a new spoken and written history of the apartheid era told from multiple perspectives was slowly being constructed. At the personal and societal levels victims were able to "reinvent themselves through narrative," as Njabulo Ndebele writes.[10]

The transparent procedure of the Truth and Reconciliation Commission set a tone and created a model for a conversation about reconciliation that has influenced the world's attempts to prosecute Pinochet, Pol Pot, and the Khmer Rouge; to uncover Bosnian war crimes; to unearth Guatemalan killing fields; and, most recently, to spur on the conversation of reconciliation in Rwanda while escalating the collective calls for Holocaust reparations. The concept of truth and reconciliation has entered the global consciousness, even as horrors continued in Kosovo and hate crimes against gays, people of color, and immigrants continue and even increase in the United States, England, Germany, and Austria. At the southern tip of Africa, a process was developed that allows nations to deal with the memory of their own horrors and hatred in an astoundingly public way. The potential impact of the commission on global reconciliation could be enormous and, at this point, can only be imagined.

The numbers are staggering: seven thousand amnesty applications, twenty-three thousand victims interviewed. This overwhelming amount of information will take decades to assimilate. Those perpetrators who were called in for investigation, or those who made amnesty applications, are in a situation different from that of their victims, both from the point of view of their hope for the outcome of their confessions and from the point of view of the state. The times I have witnessed TRC hearings, I have been most struck by the dual lives lived by these perpetrators. Their sadism, denial, cruelty, perversities have often been hidden by their polite "god-fearing" affect. How could they have deceived their families to this extent, and saved their potential for unbounded cruelty for their "work" as interrogators or mercenaries? As they appealed for amnesty and provided the full details of their horrific crimes to the public and proved they were carrying out orders connected to a defined political organization, the particularities of what occurred became known to their victims, their communities, and to their own families. Some marriages have not survived such horrific revelations. Children cannot look at their fathers with trust ever again. Will those involved ever recover after these unveilings have occurred?

I have been fascinated by the particulars of this process, the actual orchestration of the hearings—the ritualized structures for listening and presenting, the care that was taken to create the most humane situations possible for victims who must face their torturers and their monstrous memories once again. There is a great deal to be learned from the hearing process, where, in designated public spaces, victims and victimizers often have had

to bear witness in close proximity to each other. In one of many analyses of these events, Jeffrey Sonis et al. discuss some elements of the process:

> During the hearing itself, the seating was arranged to ensure that the witness was at the same level as the Commissioners, whenever possible. Each witness has been invited to tell the story of the violation in his/her own words and was allowed as much time as necessary to relate events without interruption. Witnesses were not cross-examined, but each witness was assigned to one Commissioner who might ask questions to clarify a sequence of events or to find out more information about a victim. (The verification of facts and allegations took place during the investigative process, before and after the hearing.) Each witness would be accompanied during their testimony by their chosen support person and their counselor from the TRC. At the conclusion of the testimony, the witness, support person (and other family members, if so desired), would be immediately accompanied by the Briefer to a private room for a debriefing.
>
> About two weeks after the hearing the TRC team would return to the area to hold a follow-up meeting, to determine how witnesses and the community as a whole were coping with the aftermath of the hearing and, where necessary, to facilitate intervention.[11]

The subtlety and deliberateness of this orchestration of events demonstrated a great sensitivity to the pain engendered by such interrogations and provided a mechanism that can be adopted by other countries attempting similar investigations in the future.

It has seemed amazing to those outside the country that there are white South Africans who now claim that they knew nothing about the extent of these horrors. Many inside and outside South Africa see the absurdity of this self-declared ignorance. Still, it continues, and one would be hard-pressed now to find *anyone* who will admit to supporting the apartheid regime. How can they not have known that gross human rights abuses were taking place over decades? Yet this is not unlike white North Americans who refuse to acknowledge the racist tendencies of American society and then appear shocked when extreme incidents of police brutality receive media attention. For those in black communities, these abuses are daily occurrences. Immobilized by the depth of the problem, the white population takes note only when the abuses become so overt that they monopolize the media. At those moments it is as if everyone finally awakens to the same reality. But then the attention subsides, and those whose daily lives continue relatively unobstructed once again become oblivious to the many disparate realities that coexist in the United States.

For South Africa, the antidote to secrecy, silence, distortion, cover-ups, lies, manipulations, and denial—all familiar fascist tactics and tragically known to democracies as well—has been transparency. The memory of monstrosity must be awakened repeatedly and specifically, so that there

is little room for denial or dispute. How was anti-apartheid leader Steve Biko brutalized, for example? Where was he slammed against the wall and then left to die? Who was present and at what stage? His family denounced the amnesty process, but, as a result of the commission, at least they, and everyone else in the society, know more about *how* his death occurred and *who* was responsible than they did before.

The ongoing depth of humiliation, the terror-inducing behavior, the cruel experimentation with torture techniques, rat poisons, the *braii* (barbecue) that the police enjoyed, drinking beer and roasting their dinner in the same fires in which human bodies burned slowly—these are images of South Africa's past that reverberate as barbarism and cannibalism in the depths of the nation's psyche, actions we do not want to associate with civilization. They could be isolated as perverse acts by degenerate people. But as the commission heard thousands of victims speak, as those seeking amnesty had to reveal the complete truth, their memories and those of their victims many times may differ on motivation, but certain horrific events have now been corroborated and have become part of the agreed-upon collective archive.

PART III: RITUALIZED RETURN

Although many questions and contradictions will take decades to resolve, South Africa has deliberately attempted to uncover its nightmarish past. The United States, on the other hand, still fearful of its own truths, has not. Nonetheless, many in America cannot forget the horrors that occurred in Vietnam, because it is here, in these unconscionable acts, that we see the capacity of our fellow citizens not just to kill those they fear, but to slowly, coldly drain the life out of them, while attempting to take from them every vestige of humanity. In Vietnam we witnessed the result of a process of dehumanization that was premised on the same racism that flourished under apartheid and in Nazi Germany. In each case humans were transformed by propaganda into monsters, less than human, whether they were called racially inferior, gooks, or both. Aggressive tactics against blacks were justified by the minority government under apartheid because of the "threat of communism."

However monstrous these acts committed against the Vietnamese might have been, we need to ask, as South Africa has asked: What can be done to help those who have sunk to such levels of degeneracy to reformulate their sense of their own humanity, so that they might reenter the human community somehow transformed? Is there a ritualized way for them to return? Can the United States afford to allow its Vietnam veterans to suffer alone when their pain becomes the burden of those near them, those who are sadly affected by their drug and alcohol abuses, suicides, and attempted

murders? Some of these men, who are both victims and perpetrators, have become dangerous to themselves and to society. Many are seeking a process to transform alchemically the weight of memory into positive action.

South Africa faces an even more difficult challenge: What will become of those proven murderers and torturers who received amnesty? Can they be rehabilitated to reenter society? If they are not incarcerated, how can society be protected from their rage, despair, and desire for revenge? Going through the amnesty process probably has not thoroughly transformed their consciousness. If there is no longer a place or role for them in society, where might their destructive energies and abilities to enact covert operations lead them? Such are the questions of the future, resulting from the exhumations of truth from the past.

These events prompt questions about representation: How can the state of "humanness" be represented accurately? Have we denied these horrors so that we can continue to define humanity as inherently good and then label all horrific acts as inhuman? Are we unable to accept that such acts are in fact all too human? Must we say that, in fact, the species is deeply tainted and inevitably the struggle to overcome these catastrophes must become the *project* of civilization? To admit that what it is to be human is to be both capable of endless compassion and, for some, devastating cruelty, leaves us struggling to find a linguistic vocabulary to represent atrocity caused by humans to each other. Words like *abnormal, subnormal, inhuman, inhumane, uncivilized, barbaric* become meaningless. What *is* normal civilized human behavior? The Greeks had one way of explaining inexplicably horrific crimes. They called a sinner's state of mind *ate*—possession by demonic spirits, something not human that inhabits the human and then becomes the catalyst for the unimaginable. Everything bad was simply understood as the work of the angry *daemon*, that which is outside the human or is the Other. The possibility for an idealized notion of humanity thus remained intact.

But even the Greeks had guilt that could not be absolved. Oedipus's crimes of incest and patricide were too monumental, crimes neither "the earth nor the holy rain nor sunlight can accept."[12] And they resided in memory. Acts that obliterate societal taboos at the most primal level are the causes of catastrophe—the overturning, the denouement, the reversal of the action in Greek tragedy. The Vietnamese war was such a catastrophe. The guilt now sits on the shoulders of the three million men who served. Thus North Americans will return again and again to the memorial wall; to Vietnam, the country; and to the telling of the story of the war in film, fiction, documentation, while we attempt to relive and recontextualize its tragedy in the hope that some day it can be contained, absorbed, released.

In her book *Country of My Skull*, Antjie Krog recounts how a group of black South African youth filed a joint amnesty application. Their crime, they wrote, was "apathy."[13] They felt they had done nothing to end

apartheid and therefore were complicitous, even though it was their racial group that suffered most under National Party rule. Amnesty, she notes, has provided a public forum to say "I'm sorry."

The collective can only be reconstituted after the truth is told and agreed upon. Then, when memory and its interpretations have been collectivized, perhaps blame can be accepted by those responsible, and individuals can make a vow that heretofore they will actively "resist terror" and "illegitimate domination," in Hannah Arendt's terms, wherever and whenever they become manifest.[14] This type of agreement, as idealized as it may seem, is essential to secure this planet as a place fit for human habitation. Without such clarity of purpose, we, as a species, can never hope to devise a strategy that will protect us from the potential monstrousness in each other. And those who do become perpetrators acting out these ambivalences for society will continue to be bent under the weight of memory— at its best, remorse—forever caught in a ritualized cycle of self-destruction, guilt, attempts at expiation, or, at times, a parallel reaction of retribution.

NOTES

1. George Oppen, "Route," from *Collected Poems* (New York: New Directions Publishing, 1975).

2. Told to me by writer Grace Paley, who in 1969 went on a "peace mission" to Vietnam and was offered this thought.

3. Kristin Ann Hass, *Carried to the Wall: American Memory and the Vietnam Veterans' Memorial* (Berkeley: University of California Press, 1998). Many of my expressions used to describe the wall are inspired by Hass's intelligent imaging of the memorial.

4. Hass, *Carried to the Wall*, 15.

5. Hass, *Carried to the Wall*, 39.

6. Hass, *Carried to the Wall*, 39.

7. E. R. Dodds, *The Greeks and the Irrational* (Berkeley: University of California Press, 1951), 34.

8. Anthony Holiday, *Forgiving and Forgetting: The Truth and Reconciliation Commission* (Cape Town: Oxford University Press, 1998), 14.

9. Eugene de Kock with Jeremy Gordin, *A Long Night's Damage: Working for the Apartheid State* (Saxonwold, South Africa: Contra Press, 1998), 14.

10. Njabulo Ndebele, "Memory, Metaphor, and the Triumph of Metaphor," in *Negotiating the Past: The Making of Memory in South Africa*, ed. Sarah Nutall and Carli Coetzee (Cape Town: Oxford University Press, 1998), 27.

11. This paper, written by Jeffry Sonis, Wendy P. Orr, Mary Koss, Susan Hall, and James Pennebeker, was presented at the "Investigating and Combating Torture Conference," University of Chicago, The Human Rights Program, Center for International Studies, 4–7 March 1999.

12. Dodds, *The Greeks and the Irrational*, 36.

13. Antjie Krog, *Country of My Skull* (Johannesburg: Random House, 1998), 122.

14. As quoted in Forché, ed., *Against Forgetting*, 46.

9

⌘

The Second
Johannesburg Biennale

The first Johannesburg Biennale, "Africus," took place in 1995. It commemorated South Africa's political and cultural reentry into the world. The exhibition marked the country's first year of democracy, the election of Nelson Mandela in a fair and open process, and the awakening of a new era in South Africa—"The Rainbow Nation at peace with itself" (as co-curator Lorna Ferguson put it). Unfortunately that biennial was accompanied by a good deal of controversy. Many feared that South Africa was not ready for such an event, while others argued that it might not be the best use of the nation's modest economic resources. So much general agitation surrounded it that even the *New York Times* published a piece (written by a South African journalist) describing a fight between co-curators Christopher Till and Lorna Ferguson in which the latter allegedly struck the former and broke his nose. The planning of the event seemed to dissolve into such a degree of internal strife that the negative perceptions of the event appeared considerably to outweigh the positive outcomes, of which there were many.

Curators from many countries had been invited to participate in the biennial, with the added caveat that they curate South African artists into their national exhibitions. The result was a frenzy of activity in which international curators were whisked from the airport to various artists' studios throughout South Africa in the hope that they would find local work that might fit within the context of their country's pavilion. The final show had fabulous moments. On display was astonishing contemporary art from all over Africa that intrigued South Africans and other visitors, and also interesting juxtapositions of work from Africa and Europe,

Africa and Latin America, Africa and the United States. But for the most part the installations seemed to lack internal integrity, and the show was hard to grasp both visually and conceptually. Nonetheless, many who had never ventured to the tip of Africa before came to South Africa in 1995 to see art on a grand scale and, in doing so, inevitably observed what was magnificent and what was disastrous within the new South Africa.

The second Johannesburg Biennale, "Trade Routes: History and Geography," which opened in October 1997, had an entirely different feel. Under the artistic direction of Nigerian-born curator and art historian Okwui Enwezor, this exhibition was even more ambitious than the first, presenting works by more than 160 artists from sixty-three countries, including thirty-five Africans. Six additional curators were asked to curate exhibitions that took place in six sites spread across two cities, Johannesburg and Cape Town. Artists also created additional "projects," ranging from billboards, performances, Web sites, "collective-wear" pieces, and bus-shelter installations. While lacking in economic resources, which created logistical and installation challenges for the participating artists and curators, the exhibition was rich with intellectual sophistication.

The concepts for the show, as the title indicates and the catalogue explains, were structured to examine the "history of globalization by exploring how economic imperatives of the last five hundred years have produced resilient cultural fusions and disjunctions." One of Okwui Enwezor's goals, as articulated in his essay for the show, was to explain "how culture and space have been historically displaced through colonization, migration, and technology . . . and to emphasize how innovative practices have led to redefinitions and inventions of our notions of expression, with shifts in the language and discourses of art."

To achieve the breadth of these ambitious goals, the biennial also included a simultaneous conference organized by Nigerian-born, Florida-based art historian Olu Oguibe; a film series centered around independent films from Africa, Asia, Latin America, and Europe curated by New York–based Mahan Bonati; and a well-written, theoretically oriented catalogue with essays by Julia Kristeva, Francesco Bonami, Saskia Sassen, and others, addressing various aspects of these issues, and including statements by all seven curators—Okwui Enwezor, Octavio Zaya, Colin Richards, Gerardo Mosquera, Kellie Jones, Hou Hanru, and Yu Yeon Kim. Because of the weight of the discourse, the sophistication of both artists and curators, the quality of speakers invited to the conference, the reputation of curator Okwui Enwezor, and the exoticism of the locale, many artists and curators from around the world gladly participated in these events and came in time to celebrate the biennial's opening and attend the adjoining conference. When performance artist Robyn Orlin—a falling balletic Icarus with an attitude—flew across the space of the Electric

Workshop in Johannesburg (the main biennial site), wearing metal harnesses, a motorcycle helmet, pink tutu, and ten pairs of toe shoes, while smashing light bulbs against the cement, an international assemblage of curators, art historians, writers, artists mingled with their South African counterparts to create a sense of international excitement and mass, all gathered for this opening event.

I had personally hoped that President Mandela would open the proceedings, but he did not. Nor did Thabo Mbeki (at that time deputy president) or anyone else of high governmental stature. For those guests who had never before been to South Africa, it would have been a powerful statement to see Mandela acknowledge the importance of art and culture to the African National Congress (ANC) agenda, and it would have alerted the country to the biennial's existence and significance in marking how far South Africa had come in lifting its isolation and becoming an international player at all levels. I was hoping for some kind of direct link between the biennial and contemporary South Africa itself, because there were aspects of the exhibition and the conference that already concerned me. I was looking for something dramatic, something monumental to erase the ambivalence I was feeling.

At the core of my ambivalence was a concern that this biennial—brilliant, at times gorgeous, at times moving—was in truth isolated from, perhaps even ultimately irrelevant *to*, the political and social realities in South Africa at that time. Or, if the issues did overlap, as they did at times, then it was the form or, rather, the accessibility of the form that was problematic. The show and the conference were focused largely on the diasporic citizens of the world and issues of cultural displacement, but the intellectual framework of this focus drew largely on discourses originating in international urban centers of the West. And many of the artists whose work appeared in the exhibition, although impressively diverse in their points of origin, were residing in New York, London, or Paris. In many ways the emphasis did not seem to reflect the conversation South Africa was having with itself. As journalist Ivor Powell wrote in the *Mail and Guardian* during that opening week, the biennial perhaps seemed "stuck within the problematics of the colonial" instead of exploring post-apartheid South Africa. The issues of post-apartheid South Africa are multifarious—economic, political, and social.

South Africa, which had never experienced true nationhood, which is desperately trying to reconstruct a way that its inhabitants can begin to think about themselves in relationship to a totality, was not in the same place as those artists and intellectuals at the biennial, who move around the world relatively freely, responding to their new locales with the ever-evolving language of postcolonialsim and diasporic cultural studies. Those who move through space and time in these ways are, in some sense,

postnational, because their efforts are directed to linking local concerns with global issues, through art and art-making in an international arena. And there are some South African artists who are immersed in these questions. But most of South Africa is not yet there. How could it be, when it is in the process of working through its own desperate emotional and physical problems—attempting to create equality at all levels, perhaps for the first time—as a nation? From working to meet the most basic needs like running water and housing to the profound interrogation of its past through the nightmarish but hopeful process of the Truth and Reconciliation Commission, South Africa is grappling with the legacy of apartheid. Those who were once in prison as "insurrectionists" are now heading the country, trying to build confidence in the government's ability to bring stability to relations among all races. In comparison with its more pressing needs, debates around postnationality seemed abstract, remote.

As the biennial proceeded, the tensions in the larger society were everywhere apparent. During the opening days of the biennial, the Truth and Reconciliation Commission was meeting only blocks from the Electric Workshop. In a medium-size room in the Sanlam Center, filled predominantly with journalists but open to the public, South Africa's apartheid past was on trial. Relof (Pik) Botha (former Minister of Foreign Affairs) and Adriaan Vlok (Minister of Law and Order from 1986 to 1991) were making their amnesty testimonies. Here, those who grotesquely divided the populace, who had given the orders to "eliminate," "neutralize," "take out, " and "destroy" individuals thought to be a threat to the apartheid government, were explaining to an incredulous audience and group of commissioners that they never intended these orders to mean "murder." But Bishop Tutu, in a tone of pure sarcasm, insisted that someone must have thought these words meant "to kill" because, in fact, "many had been killed." But they each insisted, in their own way, that they were only trying to forestall "civil war," and now they were asking forgiveness and amnesty from those they had imprisoned and tortured. Mandela said about such denials: "They claim they don't know, and expect South Africa and the world to believe them" (28 April 1997). But no one in the audience did believe them on that day. Photographers snapped pictures as Pik Botha apologized to Bishop Tutu and to God, while many snickered when Vlok did not apologize and instead pronounced to all of us in the hearing room: "We are all victims of the conflicts of the past."

Into this complex process, filled with the pain and seriousness of South Africa's past, and into Johannesburg—a culturally rich but very different city wrought with crime and uncertainty, suffering from the importation of drugs and a degree of poverty shocking even to those familiar with harsh urban areas—comes the second Johannesburg Biennale, positioned

against the nationalistic tone of the first in its attempt to present South Africa as an international player in the arts.

These jarring juxtapositions were made more conspicuous when the international art world arrived. Hundreds of visitors, dressed in art-world black and funky chic, wandered around the biennial site, some wondering out loud if it was possible to create a transnational biennial in a country not yet a nation. This group was joined in the second week of October by an impressive array of curators from some of the most important venues in America. Brought to the biennial by the Norton Family Foundation, they were encouraged to step outside their own often Eurocentric and American worldview to experience Africa, while discussing what that experience might bring to their own curatorial decision making. In many ways this biennial was heavy with the presence of curators and the curatorial hand—the "curator's moment," as critic Michael Brenson has called it, marking the emergence of the curator as the framer and articulator of art's meaning in global history at this time.

Added to this group of international and South African artists and curators was an impressive lineup of conference participants—many of whom, like Gayatri Spivak and Andreas Huyssen, came originally from disparate points of origin but are now based in New York. It seemed like the "Who's Who" of the art and theory world, all taking in the biennial.

The most dramatic of all six biennial sites was the Electric Workshop. Built in 1929 to house a power generating station, the space was reconfigured for the 1995 biennial. Moveable walls allowed the curators to maximize its gigantic ceiling heights and industrial attributes. South Africa spent millions to transform this building into a multipurpose art building for cultural events, leaving insufficient funds available for the actual biennials themselves.

Outside the site of the Electric Workshop were two very important and successful installations, both of which related directly to the historical situation of South Africa today. Up against the building, Hans Haacke presented the closure of his trilogy, *The Vindication of Dulcie September*. An ANC member working in the party's office in France, Dulcie September was murdered in Paris in 1988. (It is sadly ironic that Pik Botha was quizzed about this assassination in his trial taking place only blocks away from Haacke's piece on the opening day of the biennial.) Haacke saw this piece as the culmination of two previous installations. The first presented the old apartheid flag; the second, the ANC flag and the old apartheid flag tied together. In this, the third, the large post-apartheid flag flies with smaller flags of the previous installation, the ripped flag of apartheid separated from the flag of the ANC. The piece is complete now that there is a flag for the new nation of South Africa.

Across from Haacke's piece and also in front of the Electric Workshop but facing into the rest of the biennial was a work by South African Andries

Botha, titled *Home*. Here, a small-prefabricated wooden shed or house (often used for security guards) had been installed. Its windows were covered with white lace curtains, and Astroturf and a short, white picket fence surrounded it. The open door invited the viewer inside, where the temperature was kept coldly air-conditioned. There was no furniture, no place to rest, only hand-engraved metal texts that covered the walls. The texts were excerpts from the testimonies given to the Truth and Reconciliation Commission by apartheid victims during 1996. The effect was chilling in several ways, the juxtaposition of inside and outside both powerful and devastating. There was no "home" here to be found, only horror; there is probably no safe place in all of South Africa at this time. The piece touches on a very important issue, central to South Africa, that concerns personal security, land, and what Andries Botha refers to as "emotional geography"—the violation of space that once was home. On the wall, among dozens of other quotes from the hearings, was one from Mrs. Caroline Sono, mother of Lono, last seen in the company of Mrs. Winnie Mandela: "Sometimes I hear a knock on the door and I think Lono has come home. At night I see him flying and think he is coming home and I open my eyes and say, 'Welcome my son, Welcome Home.'"

In keeping with this theme of lost home, disenfranchised home, disturbed home was the installation *Saturn's Table* by Cuban-born artist Ernesto Pujol. The walls of the darkened room were covered with cow excrement, the heavy nineteenth-century Afrikaner table and chairs sat stolidly on the dank earthen floor. A place was set for the worst of all monstrous patriarchs, the one who grotesquely abused his power—Saturn, who ate his own children.

Also in "Alternating Currents," the name given to this part of the exhibition, curated by Okwui Enwezor and Octavio Zaya, which dealt with lost and damaged home movement and migration, was Penny Siopis's small "art theater" installation designed to show her magical film *My Lovely Day*, taken from old faded footage of her Greek family's early life in Cape Town. Showing them arriving from Smyrna, unable to return home because of the Greek Civil War, the archival footage (shot by her mother, to which Siopis added her own text) grapples with childhood and the memory of displacement, juxtaposed to the reality of assimilation into the land of the Other.

Across from the Electric Workshop is the famous Market Theater, where Barney Simon (now deceased) staged some of the first mixed-racial productions that defied the laws of apartheid. Hundreds of township youth attended his laboratories and were trained as actors. Some of Simon's close friends, those well-known white activists Joe Solve, Ruth First, and Nadine Gordimer, first came here to see the original productions of South Africa's most famous playwright, Athol Fugard. In this space also was to

be found the Rembrandt van Rijn Gallery, where curator Hu Hanru's exhibition, "Hong Kong etc.," was mounted.

The whole enclave of space extending from the Electric Workshop to the Market Theater Complex is filled with the history of the anti-apartheid movement, yet now it is a place to be feared at night. Street violence is a topic with which everyone is concerned and cannot avoid—visitors and Johannesburg residents alike. None of us could simply roam freely, and it was very frustrating to all biennial visitors that they could not know this city as directly as they would have liked. I think of curator Catherine David's statement that audiences come to Documenta in Kassel to shop in extravagant stores; certainly this was not the case in Johannesburg.

The Museum Africa, topped by Stephen Bakehol's two African figures from the last biennial, donated to the city by the artist and silhouetted against the Johannesburg sky, exhibited another part of this second biennial—the show titled "Transversions," curated by Yu Yeon Kim. Museum Africa was once an old produce market; it has since been renovated to house various collections that reflect the history of both Johannesburg and the region. It also displays exhibitions on the history of the mining industry in Johannesburg and recently hosted a remarkable exhibition about the "Treason Trials." It is for certain that nothing as high-tech as the show curated by Yu Yeon Kim had ever appeared in this space. In it were video installations by Dennis Oppenheim; a fabulous piece by Diller and Skofidio, *Pageant*, comprising dissolving corporate logos—of South African Airlines, Playboy, Exxon, BMW, Shell, GM, Samsung, Honda, VW, Gucci, Mickey Mouse—all morphing together and projected onto a large circle of a dark room, altogether making a clever and terrifying statement about homogenization and globalization. Here too was a dramatic piece by Alfredo Jaar, *The Eyes of Guetete Emerita*, about the ten weeks of genocide that ensued after Rwandan president Juvenal Habyarimama was shot down above Kigali, the capital of Rwanda—a catastrophe Jaar clearly feels the world chose to ignore. There were drawings by William Kentridge from *The Trials of Ubu* and *Ubu and the Truth Commission*. These drawings were used in the animation projected as part of the play *Ubu and the Truth Commission*, written by William Kentridge and Jane Taylor, and performed by a cast of actors as well as the Hand-Spring Puppets. This humorous, damning production, based on *Ubu Roi*, with its eccentric, engaging movements choreographed by Robyn Orlin, used real actors as well as animation and puppet theater to present its complex vision of post-apartheid South Africa. All these pieces were installed in a space that has been traditionally used for exhibitions that one might find in a museum of natural and cultural history.

Steven Pusy, who set up the technological installations for "Transversions," said that the young people from Soweto who came to act as

facilitators for the exhibition, and who had no prior training in this area, learned quickly how to keep the computers up and running. He speculated that perhaps they were accustomed to an oral and visual culture that allowed them to hold such information easily in their heads.

The fourth Johannesburg site was the Johannesburg Art Gallery, a large museum housing a European collection as well as contemporary African art. Right in the heart of the downtown area, where many small vans moving people from the townships converge, sits the museum, protected like a fortress. Heavy metal gates are juxtaposed to the many sleeping people stretched across the lawns surrounding the building, some of whom are coming from work, others of whom are homeless. The installation "Important and Exportant," curated by Gerardo Mosquera, was mounted here. As part of the exhibition, South African artist Willem Boshoff displayed a piece called *The Writing on the Wall*. Boshoff's statement alludes to "fourteen stations of an imperious cross," which "testify to the failed bid for the soul of South Africa." Fragments with words like *truth*, *order*, *destiny*, *identity*, *progress*, and *principle* appear to have fallen off small pillars placed in the gallery space. These words, signifying concepts that have fallen in stature and meaning, are reified here in the languages of the colonizers—French, Dutch, English, Portuguese, and Spanish. It is implied that within their chaotic assortment, resembling words that have fallen out of a Scrabble box, lies the history of Africa and its colonized past. But it would appear that such moral platitudes can no longer be reassembled. Also exhibited were photos of German reconstruction by Sophie Calle documenting places that once housed monuments now removed and vacant—evolved into spaces of memory. Sophie Calle has recorded their history, as interpreted by people who have experienced these locations directly.

An installation created by Brazilian artist Cildo Meireles consisted of a wooden pier standing across illusory water made of blue paper-covered books that, together, resembled the sea. It was a pier you could walk out onto, the illusion of water amplified by sound—the word *water* spoken in an infinite number of languages. In my attempt to understand whether the control of the volume of this sound was related to how close one moved to the end of the pier, I nearly fell into the imaginary sea of books, the sea of imaginary books.

In Johannesburg the challenge was to take in the entire breadth of the work while also attending the conference, which competed with the exhibition for the viewer's time. Olu Oguibe had assembled a remarkable group of scholars and intellectuals for the event. The concept was to put artists in dialogue with critics, to create what James Clifford refers to as a "contact zone," and to reflect the degree to which artists, curators, and theorists are often focusing on the same questions. Panels were structured

around topics such as "Home and Exile," "Funding and Culture in the 21st Century," "Speaking of Others," "Cultures in Diaspora," "The Politics of Mega-Exhibitions," "Cinema and Globalization," "Culture and Rupture in the Digital Age." Among the discussions were debates on issues unresolved in the United States being replayed a continent away. Howardina Pindell continued her ongoing criticism of artists like Michael Ray Charles and Kara Walker for what she perceives as their anti-black, racially stereotyped image making, which, she charges, appeals to the intrinsic racism of the United States, capitalizes on it, and then succeeds in the white-dominated art world as a result. Not all African Americans present agreed with her position; many who spoke after her, including art historian Richard Powell, used this forum to clarify their disagreements with her position.

Also evident at the conference were serious tensions surrounding the meanings of racism and sexism in both Africa and the United States, which kept manifesting themselves. These points of contention, which would have proven truly interesting if debated, were not addressed directly; however, this resistance to structuring an intercontinental debate might have resulted from the specificity of racism and sexism to each locality, such that each issue needs to be framed and positioned quite particularly within each society in order to be discussed. But it seemed a missed opportunity to avoid exploring these differences in an organized way.

In one glaring instance of such a missed opportunity, Salem Mekuria offered a critique of *The Sexual Binding of Women*, Alice Walker's film about female genital mutilation in Africa. Clips of the film, shown in this African context, seemed truly lacking in a thorough understanding of this practice. Walker's all-too-eager willingness to draw a parallel between having been blinded in one eye when she was a child and this type of mutilation made the film seem outrageously odd, patronizing, and naïve. In this context, where both African Americans and white Americans are often humbled by how little they, as Westerners, truly understand Africa's cultural complexities, it often becomes especially painful for African American artists and thinkers to realize that they, too, are in fact dislocated when visiting this continent, with its multifarious cultures to which they are historically connected but from which they are diasporically removed. Walker posed and imposed her own problematic on an African dilemma and then attempted to solve it within the terms she created. The results were disastrous. It would have been wonderful to hear Africans comment on these clips of Walker's film, but the occasion to do so was not offered.

The intensity of looking and talking moved to Cape Town, where the exhibition continued at the Castle of Good Hope, a structure built in 1666 as a fortress to protect the first colonial settlement in the cape by the Dutch East India Company (VOC in Afrikaans). These letters were

hauntingly illuminated in Wayne Barker's *The World Is Flat*, a massive map laid out in the South African National Gallery consisting of one hundred green bottles and three thousand army fatigues. Also in Cape Town, Kellie Jones's exhibition, "Life's Little Necessities," featured works by women artists, from U.S. artist Pat Ward Williams to Nigerian artist Fatimah Tuggar. Various technological problems seemed to trouble this show, and a rumor was circulating that Jones's effort had not been sufficiently supported, and that she therefore had been hampered in her attempts to create a successful exhibition.

At the South African National Gallery in Cape Town, Colin Richards had curated "Graft"—an exhibition of South African artists in which he attempted to intercept the historical moment by using a word with multiple meanings. Graft means "hard work" in South African slang; it also means bribery, and of course it also is used to describe a process that brings disparate elements together in an imperfect fit to create hybridity. The show, an amalgam of these definitions, featured a wonderful piece by Moshekewa Langa, titled *Temporal Distance (with a criminal intent). You Will Find Us in the Best Places*, in which toy cars and large spools of thread situated on the floor created a cartography of distance and a sense of movement—a reflection on the passage of all postnationalists who migrate from city to city. Using name-brand empty whisky bottles to show points of national origin, this clever and strange miniaturized map looped across the gallery floor. And between all locations little plastic rats were placed, perhaps to show that there is some commonality among all urban locations.

But almost nothing in "Graft" had the power of the very first image guests saw when entering the National Gallery space—Jane Alexander's *Butcher Boys* from 1988. This piece was not part of the biennial, but it is owned by the National Gallery and was not moved for the exhibition. It was made even more dramatic when set in relief by Siemon Allen's installation *La Jetée*, which was part of the biennial exhibition. Walls made of recycled VHS tape that cannot be accessed without technology inadvertently lent a dramatic backdrop to the twisted, gnarled souls of the *Butcher Boys*, a representational piece that reifies the sickness of apartheid. In Alexander's well-known installation, three life-size male figures—half-human, half-animal—sit on a bench as if waiting for something to happen. Their bodies are muscular and lean, their heads deformed—a combination human and ram with curved horns—their eyes dark and glassy. Images conjured from dreams and nightmares, they serve as a reminder of the fierceness of so much anti-apartheid art making that exploded out of the repression experienced during the dark ages of National Party rule.

The conference also continued in Cape Town, where the sun and sea competed with these darkened galleries and lecture halls for attendees'

attention. I was scheduled to speak on the last panel of the day. By then many tensions had developed from what had not been said. South Africa itself, and its issues, seemed largely to have been ignored. Knowing the intensity of South African artists and intellectuals, I should have expected what happened next, but, anxious to give my own paper and hopeful for the discussion that might follow, I did not. We were all frustrated by this point. Everyone had been far too polite. The conversation had been too abstract. Nothing had been said that brought us back to South Africa directly, and no attempt had been made to summarize the ideas presented, to formulate any type of theoretical model around which to think about transnationalism and its multifarious complexities. Ideally the first day of the conference should have been focused entirely around our host country. Perhaps the last day should have been structured to allow some theoretical postulations to be made. In any case, there was a palpable accumulated restlessness that needed to be addressed, as well as internal South African art world debates begging for disclosure. But the conference had not been structured in this way.

Andreas Huyssen began the morning of the last day with a fascinating analysis of the dehistoricization of the city of Berlin—the way in which it has lost its relationship to its local inhabitants. Corporate architecture, he demonstrated, colonizing the city into an indistinguishable international center, has caused an erasure of history. Huyssen visually juxtaposed most of the new and, unfortunately, unsuccessful Berlin building ventures with architect Daniel Liebeskind's Jewish Museum Project, which he finds of great interest. The talk, although specific to place, nonetheless powerfully presented the notion of the global city as "progress" run amok, deflating, for a time, any romance associated with globalization. It would have made great sense to follow his analysis with a similar one by a South African architect or art historian focusing on the city of Johannesburg.

By the afternoon the hidden agenda for the day started to emerge. My panel was called "Speaking of Others," a reference to the problematization of otherness; it was to be moderated by Sallah Hassan (originally from Sudan but now teaching at Cornell University). The panelists were asked to discuss what constitutes otherness at the end of the century; I had constructed a piece in which I proposed that the United States had become "other to itself"—no longer certain of its goals or identity. But right before the panel was to begin, I could hear conversations building around me. Some expressed anger that there had not been enough discussion about South Africa and that this, the very last panel, should therefore devote itself to South Africa. Unbeknownst to those of us on the panel, the moderator had agreed with this suggestion. He announced that all the panelists would speak briefly (although I refused to budge on our agreed-upon allotment of twenty minutes), that we would focus on South Africa, and that

we would specifically engage a discussion—already heated in South Africa—that concerned the representation of otherness activated by an essay Okwui Enwezor had written for a show of South African art in Oslo. In this essay he attacked certain South African white women artists (most of whom did not have work in the Oslo show) for appropriating the images of black African women's bodies in their work. This essay had caused tremendous controversy in South Africa.

When called upon, I began by saying that I had already written an essay about this debate, which was soon to appear in a book published in South Africa called *Grey Matters*, edited by Brenda Atkinson, and that I had not intended to discuss these issues of representation today, especially because we were also speaking to an international audience unfamiliar with the issues or the work around which the debate was focused. I then read my paper. Francesco Bonami, then editor of *Flash Art* and a writer for the catalogue, spoke next; he was followed by Colin Richards, South African artist, writer, curator. None of us had come prepared to address South Africa specifically or the Okwui Enwezor debate. When we had finished speaking the attacks began.

I was criticized for not giving my paper (written for *Grey Matters*) on the issue of representation and race at this conference, for not focusing on South Africa, and then for the one allusion I had made to the transformation that had occurred in South Africa. (I had juxtaposed South Africa's admission of racism to the absence of such admission in America, where those with social consciousness are still feeling isolated, waiting and hoping to see change in their lifetime.) By then I felt myself an honorary South African because I was the only foreigner attacked in an otherwise too-polite conference that had failed to address South Africa's ongoing debates—an omission for which we were now paying.

Then a young South African addressed Colin Richards. He requested that all artists who had benefited under apartheid please stand up. Colin asked if he meant all white artists; he said yes. Many white artists did stand, including Colin, who then asked something like, "Now what do we do?" Of course, there was nothing to do. The point had been made. Later, when I described this series of events to artist Andries Botha, he remarked, "At the point at which Colin was asked to stand, Colin should have said, 'Will all those South Africans *not* damaged by apartheid please stand up.'" But only a South African could have pursued that line of inquiry with another South African.

Then a heated debate among Okwui Enwezor, Olu Oguibe, and several women artists, particularly Penny Siopis, ensued. I was somewhat shocked to hear such a sophisticated diasporic man as Olu Oguibe insisting that when white women used images of his "sisters'" naked bodies in their artistic work ("without his sisters' consent"), he wanted "to stran-

gle" the white women artists, even *if* the intent of their work was to expose sexism, pornography, or colonial violence. The paternalism in these statements was astounding, and the scorn for white feminists painfully obvious. It seemed we were only steps away from the type of argument that might lead to a decision, by black African men, that all black African women should wear the chador "for their own protection."

Accusations were flying, and everyone was waiting for the black South African women present to take the lead. When they did not, African American women and diasporic women from other parts of Africa and now living in New York spoke up only to say that they hoped African women would speak for themselves. Only the limits of time put an end to it. The tensions in the South African art world, politely contained all week, had exploded. The argument ended in true South African fashion; after it was over, we all moved to the lobby for tea and biscuits. This was something I had also witnessed with amazement at the Truth and Reconciliation Commission: certain rituals, colonial ones at that, were used to reestablish civility when there was nowhere else to turn.

Afterwards, it was clear that it was too easy for the Americans present to extrapolate from their own "identity-politics" debates of the 1980s and assume that the South Africans were referring to the same issues of appropriation. But when race is discussed in South Africa, so much is still measured by the past, with questions focused on where people stood in the struggle against apartheid. Some of the women artists whom Okwui Enwezor questioned about their use of images of black women's bodies were artists who had been important for the anti-apartheid struggle internationally; they had used their images to build support from foreign countries for the cultural boycott. To attack these white artists now is a complicated matter, especially for a non-South African. But there was neither time nor inclination to fully engage the complexities of these debates—so much by then had been personalized and, in the process, depoliticized.

We were shocked, dismayed, and brought immediately back to the reality principle when, on the first day of the conference, we heard that a soldier had been killed by ETA (the Basque separatist movement) while guarding the new Guggenheim Museum in Bilbao. Suddenly all the biennial debates about identity, postnationalism, and postcolonialism could be seen as connected to an intense reality. All of the biennial curators were clearly shaken. But questions about the significance of recontextualizing art at this moment of globalization went largely unanswered. What *does* it mean in practice to decontextualize our creative work and ourselves, and what would it mean to recontextualize all our efforts, on a global scale, beyond nationhood and personal identity? We had only just begun to imagine. The pitfalls seemed enormous.

POSTSCRIPT

Upon my return to the States I began receiving frantic e-mail messages that the biennial was in danger. By mid-December it had closed but was soon reopened after Okwui Enwezor, Bongi Dhlomo, and other key players in the biennial intervened. The ambivalence on the part of the Johannesburg City Council was apparent: they wanted to close the show because of its considerable daily operating costs and used the low attendance numbers as further justification. Such a shaky outcome to the tremendous efforts of all those who brought this biennial into being was terrifically upsetting, foreboding badly for the future. One is left with some very serious and fundamental questions about how to measure the success of such an event, on both a global and local level, in terms of superstructure and base. How well can anyone, however clever, position a transnational event in a society in turmoil, one still attempting to become a nation?

It is impossible not to speculate what the reception to the show might have been had it been positioned around a topic like truth and reconciliation, and had it featured South African artists and artists from around the globe addressing this issue in terms of the historical moment. Had the conference participants positioned South Africa as a leader constructing a transparent process to accomplish reconciliation, perhaps the exhibition might have generated more local interest. Perhaps its presence might have been more easily justified, its themes more organically contextualized. But these are speculations. It is true that South Africa is a society in transition, as thousands of immigrants from the rest of Africa fill its cities. If these migratory patterns had been featured, for example, maybe the show would also have been more fully contextualized.

International visitors came to South Africa hoping for an entirely new experience. For that to have occurred it would have required a show whose roots went deep into the local dialogue and spread out to touch upon international concerns and South Africa's position in the international debate, thereby projecting the sense that it could have happened nowhere but South Africa. It might have also required a large parallel exhibition, perhaps at the Johannesburg Art Gallery, offering international viewers a chance to see the diverse spectrum of South African art. But this focus on South African art was never Okwui Enwezor's goal. Still, without such a stated purpose, we are forced to ask, whom was this biennial for? If the show was for the international art world, then it was a success—it was smart, sophisticated, conceptually ahead of its time. If the show was also for South Africa, then perhaps it needed to consider its local audience much more closely—not with the sense of where South Africa *should* be but with a realistic sense about where it *is* and where it wants to be. Without a general

audience who will come to see the biennial, any biennial, after the hoopla of the opening is over, how can one justify the enormous expense of such an event, especially when the pedagogical purpose for the local community is not clear? Perhaps Okwui Enwezor would have to admit that the fabulous show he created really did need more mediation, filled as it was with work from artists whose points of origin were vast, whose concerns were complex and often conceptual in execution. He might have to concede that South Africa does not as yet have a critical mass of viewers able, interested in, and prepared to engage with work of this nature. In attempting to bring the world to South Africa, South Africans were inadvertently left out. What seemed most left out of all were the great insights South Africa itself has to offer the international community about postcolonialism and the relationship between art and politics.

I have been traveling to South Africa since 1992 to engage in debates about the place of art in a democratic society. With each visit I have been struck by the sophistication of the debate among artists and art activists (as arts administrators often call themselves in South Africa). The complexity of thinking that South Africa itself has to bring to the world at this time around race, reconciliation, art-making in societal contexts felt overlooked in this biennial. To me, this was a great loss.

The debate in the Johannesburg City Council about the importance of the show is significant. Apartheid ravaged people at so many levels. The healing process will be long and complicated, and there is no doubt that culture can play an essential role. It is unfortunate that the biennial, positioned in concept to help South Africa take its place in the international arena as a major player, was not able effectively to build greater visual literacy in South Africa quickly enough, or to enchant the local population deeply enough so that large numbers of people came to *own* the biennial, and therefore to protect it as best they might have, from the exigencies of the politics of transition. The conversations around the second Johannesburg Biennale will continue for some time because they crystallize the issues of what biennials are and could be for the future. It forces us to evaluate such events, especially in nations such as South Africa, whose own immediate problems demand that such exhibitions justify themselves in relationship to the pressing needs of the host country from which they take their sustenance, and ultimately their meaning, as art events within a social and historical context.

NOTE

When this essay was first published in *Art Journal,* Summer 1998, it was accompanied by an interview with curator Okwui Enwezor in Johannesburg. At that time we discussed his rationale for the Biennale in depth.

10

The Romance of Nomadism

The second Johannesburg Biennale, "Trade Routes: History and Geography," raised important issues about the role of artists and curators who function as global citizens and about those of us who are art travelers and become part of their peripatetic audience. Mounted in 1997, this huge and spectacular biennial brought 160 artists from sixty-three countries to the tip of Africa and staged a conference convening cultural workers from around the world to address the issues of transnationalism, itinerancy, and diasporic art production. Because the exhibition was held in downtown Johannesburg and its immediate adjacencies were burned-out buildings and crime-ridden streets, this inquiry inevitably turned on itself. The intent and significance of international art exhibitions and how they position themselves in relationship to their geographic and historical contexts inevitably came into question.

The Guggenheim Bilbao also presents interesting incongruities: U.S.-curated exhibitions presented in a museum whose mission has little to do with art-making in Spain, and even less to do with the political situation of the Basques, ETA—their separatist movement—and its ongoing struggles with the Spanish government. This fabulous new building brings an international audience to Bilbao but stands apart from its cultural locality.

What occurs when travelers see the world through art, and artists attempt to transcend their own point of origin and engage in conversations across national boundaries? What is the significance of artists who hail from all over the world but currently reside in New York, London, or other Western metropolises, positioning themselves as transnational or postnational, and being selected by curators to represent their point

of origin in such contexts as international biennials? What about those artists who have never left their homelands?

As the concept of the "global citizen" and the romance surrounding it takes hold, one might ask: Who is entitled to this appellation? How does one achieve such citizenship? In what location does it exist, in what time, in whose history? Has the international art world become its own entity, its own nation, with its own citizenry and its own rules? What happens to art production when the Other is implicitly understood as those outside of the art world?

These questions took on an ironic literality on my return trip from the Johannesburg Biennale and its postnationalist aesthetic. Several artists, curators, and I were en route to New York when our South African Airlines flight announced it would make a fuel stop at Ihla do Sal (Island of Salt), a small island off the coast of Africa. The simulated miniature airplane on the map in front of us had been laboriously inching its way up through the vast, indeterminable Kalahari desert for hours. It was dark when our plane finally landed. None of us knew what date, time, or day it was. We weren't sure if Ihla do Sal was part of Cape Verde or owned by South Africa. And we didn't know what language the islanders spoke or what commerce they engaged in. Having been given the option of leaving the plane or remaining on board, most chose to disembark; we were ushered into an airport waiting room with instructions to stay there, because we had not gone through customs and therefore had not officially entered the country. Surprisingly, in this large room we found groups of Russians smoking cigarettes and drinking coffee. Why were *they* here? Had they been working in Angola? Trapped in a room filled with smokers and unable to step outside, the non-smokers among us were feeling sick and becoming angry. Caught midway between New York and Johannesburg, we were a group of displaced biennialists turning lavender in the florescent light.

Having just engaged in discussions on postnational theory, perhaps we should have felt liberated by this out-of-nation experience. Had we been better able to imagine where we were, we might have felt free. But that was not our reaction. No longer travelers involved in a process of recognition, we had become passengers in transit between two points, inhabiting the nonorganic space of travel—mind out of time, time out of mind, as Edgar Allan Poe liked to say. We were in a postmodern moment unable to locate ourselves in cultural space. We were in a postnational moment unable to locate ourselves in geographic-political space. And, however philosophically attuned to such abstractions we were, our physical response to these particular uncertainties was disorientation.

In another instance of art world dislocation, the Guggenheim Bilbao sits like a landed spaceship in one of the former industrial parts of the city. This once great steel empire, one of the richest in Europe, has taken on the

challenge of postindustrialism, using art and architecture to reinvent itself as an international cultural center. Bilbao has emerged as a point of destination for the art world. Most Basques are pleased about all this and affectionately refer to Frank Gehry's achievement as the "Gugen." There are even local jokes about the building. One goes like this: "Have you seen the Puppy?" (referring to the Jeff Koons's dog stuffed with petunias that towers in front of the museum); "Yes," says the other enthusiastically, "but have you seen his house?"

The new Guggenheim is golden at night and silver in the day, industrial titanium transformed into a skin so light one imagines the entire mass could float away, all defining points of finality rounded. There are no edges. This sphericity separates it by a century from all adjacent structures. The building itself *is* the attraction, the reason for the trip. Gehry's creation daily brings masses of tourists and their money to this once very prosperous city, one that more recently has sunk under the weight of unemployment and drug trafficking. Everywhere is the sense of the ghost of industry, one notices the stark contrast with the Calatrava Bridge up the river. The blue-colored wall to the left of the entrance makes reference to the multihued shipping containers stacked next to cranes that you can see from the Guggenheim, ready to be loaded for transport. The titanium itself is a reimagined industrial material given new purpose. Everything there is about light and volume spiraling over a void.

It is one of the first true structures of the twenty-first century—a building unbuildable, Gehry insists, without the use of the computer as a design tool. This building recognizes what postindustrialism means—that even bricks and mortar, here titanium and rivets—can be transformed into light and movement. The mandate for the next century is that even matter is to be morphed by illusion, and even gravity is to be defied.

Inside the museum, the major point of reference is New York. Not really a contact zone in James Clifford's sense, not a place where colonial and autochthonous cultures interact, or where cultures interweave to create something decidedly new; rather, this is a U.S. museum in Spain. Visitors from all over the world come to see works by Judd, Stella, Morris, Rauschenberg, Rosenquist, Warhol, Andre, Dine, Holzer, Oldenburg, Serra, as well as exhibitions on the Guggenheim curatorial circuit. Gargantuan sculptures by the biggest U.S. art stars appear as the toys of giants in the main hall's voluminous space, all built for a cost that can only be imagined—22,000 million pesetas, approximately $150 million.

But what does it mean to have this museum in a location that, for Spaniards, is not unlike any nondescript U.S. industrial city? The Basques, who have resisted Spanish domination, do not seem concerned about the cultural invasion of U.S. art and curatorial decision making. Then again, the museum was their idea. The North Americans came on their invitation,

money, and business savvy. "The Basques," Gehry says, always referring to them as a nation, "spared no expense." From the point of view of governments, culture works.

When I first heard that a Guggenheim guard was killed by Basque separatists, I was in Johannesburg at the 1997 biennial's conference. I thought that perhaps the murder was ETA's response to the building of a U.S. museum in a Basque province, but I was naïve. The guard was killed by mistake; the bomb was targeted for the Spanish king, who had come to attend the opening. On the contrary, the museum is loved by the Basques, not for what is inside, or even particularly for the building itself, because many local people we spoke with had not visited the museum, but rather for the prestige it has brought Bilbao, as well as the revenue, way beyond their wildest imagination. The phenomenon fits the Basque country's image of itself as autonomous, as *Euskadi*, an international region that could secede from Spain.

On the evening we stayed in Bilbao, the city was overrun by youth representing ETA. Hooded and violent, they broke windows and trashed the city wherever they could. The riot police were called out. It was summer in Spain, where people go to dinner at midnight, so these events explained why the night streets were so empty at the time. But what of all this do most art world tourists know or care to know? The art traveler's word on Bilbao is: "See the museum, eat. You can do it in a day, two at the most." I've heard it said more than once. For most, it is just another Guggenheim added to those in New York and Venice.

During the Johannesburg Biennale, the atmosphere was heavy and gravity was omnipresent. The Truth and Reconciliation Commission was in session, and the weight of the past sat on a city fighting its own potential anarchy. As each day revealed another horrific truth of betrayal and sadism, South Africa struggled to reconcile itself with its history and move beyond apartheid. The biennial positioned itself beyond the concept of nationhood and, in so doing, created a fascinating subject matter, but it remained outside the prevailing debate of its geographic context. Certainly Okwui Enwezor's intention was never to leap over the contemporary South African debate but rather to position South Africa as an international player in the art-curatorial arena. But perhaps the timing was unfortunate given South Africa's pressing economic demands and the tremendous efforts necessary to reconstitute itself after thirty devastating years of apartheid.

Like the Guggenheim Bilbao, the biennial was a monument to nomadism—a tribute, a celebration of a longed-for time when national boundaries will be dissolved, when the currency, the vehicle of communication for this transformation out of the past, even outside of history, will be images and art itself.

There are many artists who now present their work as international and global, recognizing that the conversation in which they are engaged crosses national boundaries. Such work deals with diasporic, postcolonial situations and, like the work of Alfredo Jaar or Ernesto Pujol, is often quite political in its concern with specific historical conditions. A good deal of the work in the biennial fits this description. Although the work was largely familiar in form to those moving between biennials and large urban centers, it was not familiar to many South Africans, who had never seen such work and had little or no experience with the predominantly Western aesthetic and, perhaps most significant, had been cut off from the international contemporary art world because of the nation's cultural boycott for too many years.

It is as if, in this era of postnationality, the international art world has become a place of origination itself, imagined into being by its curators in what Michael Brenson has termed the "curator's moment."[1] But just when it seems that all this curatorial emphasis on globalism should have made the world bigger, in fact it all seems to have become smaller. Of those artists represented in these international biennials who have left their point of origin—Africa, South East Asia, Eastern Europe, Latin America—to enter into the New York art world, what languages are they now actually speaking once their own hybridity is complete, once their individual points of view are sifted through the sieve of the New York aesthetic? What has happened to local conversations in this translocal, transregional debate? How can the local permeate the global when, even in art-making, it may speak different discourses, represent different constituencies, classes, and forms, ones that the art world often excludes? From where does work take its aura if it no longer exists in relationship to a physical locality but rather to a series of global ideas? If its concerns are social, where is its imagined point of impact? And, if these questions are asked of diasporic artists, why are they also not asked of North American artists?

I add to this set of concerns one pertaining to responsibility. To whom are we as artists, writers, and curators responsible when attempting to exist in relation to no *one* individual society? If the political issues in question are global, to whom do we express these concerns? How do individuals outside corporations operate as transnationals? Some who move through such an elite world of art, culture, writing, production, and exhibition seem only to answer to the art world. Even though the work appears to be socially motivated, the only real consequence of such critical effort is the degree to which the work is found acceptable, unacceptable, or exceptional by the art world, measured by the reviews it receives—the quality of the paper trail it generates—and the sales it ultimately accomplishes. This state of affairs is not pleasing to those artists who want to

have an impact on society but who are rendered impotent by their lack of currency in the debates around globalization.

Unfortunately, the world now seems divided between what Jacques Attali calls the rich and poor nomads: the nomadic elite who travel at will, expanding their world, and the disenfranchised poor who travel because they are desperate to improve their living conditions.[2] To whatever degree artists may sometimes be indigent, we in the art world are very distinct from those migratory laborers who cross borders illegally, return again and again, live on the margins, negotiate cultures because there is no other way to earn a living. These people move at constant risk to their lives and without the romance of travel or the delirium of adventure. Migrant workers who cross the Mexico–U.S. border every day in search of work don't always survive the INS.

There is a great difference between the migrant workers' experience of borders and that of art school students, for example, some of whom come from all over the world to study art in the United States and receive a level of education they cannot find in their own country—whether it be Ireland, Korea, Thailand, Brazil, Israel, Pakistan, South Africa, or Norway. In the process of becoming educated, they also inadvertently become multinational and postnational. And although they might have few economic resources, they ultimately do very well in this global art world, living on the boundaries of culture, versed in several languages and discourses, constructing and deconstructing their identities at every turn. They are the future, and the future of the art world. But often their own self-chosen immigration becomes expatriation, as more and more they are formed and informed by the West and therefore less able to return "home." Many live in political limbo when in the United States and usually, although not always, only truly engage with the local when they return to their homeland, bringing their new hybridity back into their own culture, challenging, forming, engaging, and often transforming local debates. Many of these artists and writers, those who make work or write about the transnational experience, are the ones chosen to be included in international exhibitions, because their work talks about the process of crossing over and has been formed within the Western aesthetic. But what does it mean to come from Asia, Latin America, Africa, or rural regions of the United States and become part of this international discourse? As these artists' work becomes more and more about the complexity of their relationship to their multiple realities, and as they speak more and more from the centers of capitalism, where is their point of connection to those who never left places that may now be on the economic periphery or, worse, beyond the measurable parameters of the global market altogether?

Surrounding this theoretical transmigration there is romance. Perhaps it is a convenient relief to imagine transnationality as a new ideal. Now

that we have seen the end of the hope of Marxism and socialism, as well as broad acceptance, with remarkably little resistance, of global capitalism, the aura of U.S. audiovisual production is everywhere imperialistic but remains unchallenged. In what other social systems could we now believe? Perhaps the abstraction of transnationalism is especially attractive at this dystopian moment, a time when it seems less and less viable to transform societies in the particular or the general. Isn't it easier to think of oneself as a citizen of the world than as a citizen of one's own neighborhood, where gang violence, unemployment, pollution, racism, and a defunct educational system may prevail and seem so immediate and overwhelming? Aren't these ideas of globalism just abstract enough to counter the need for any real local involvement or praxis—the integration of theory with meaningful social action? Or is nomadism in the Deleuzian sense a truly superior reality—one that transcends the apparatus of the state?[3] At its best, such thinking could be understood, Roland Robertson suggests, as the "particularization of the universal and the universalization of the particular."[4] But what does this mean in a political sense? It would seem that all such activity fits quite nicely within the directions already chartered by global capitalism. If there is resistance in international art exhibitions, where is it? What ideologies are actually contested?

It is true that exhibitions ultimately make their own context. That is their strength, but it is also at the heart of their contradictions. The context for such events is not always formed in organic space. Augé refers to space where no "organic social life is possible" as "non-place."[5] We have experienced such space—the white walls of the gallery, the categorized chambers of the museum, the formal spaces designed not to interfere with art. These are spaces in which very few people feel comfortable. The more we live in non-place the less we understand the discomfort such space presents to others.

In the extreme, non-place can appear as blank space—shopping malls, suburbs, airports. But increasingly such space has become ideological. Everywhere we are bombarded by the CNN loop. No longer alone with our thoughts, our books, our work, no longer allowed to have private space in the public arena, everything is now sold, even the possibility of silence. In U.S. airports the news has become packaged, homogenized. CNN news loops may no longer report the local. We read the *New York Times* in almost any small city in the United States and the *Wall Street Journal* in all its myriad European and Asian manifestations. Those who shop in duty-free airport malls while traveling are able to buy the same products from New York to Singapore, disposable items for those with disposable incomes. In these forays, we "experience the world vicariously and safely," as Attali writes.[6] Even when the historical environment is not safe, the nomadic elite is. Deleuze tells us that in nomadic thought, "the dwelling is

not tied to a territory but rather to an itinerary."[7] Nomads traditionally are preurban or nonurban, but this new breed of nomads is posturban, dwelling for much of their experience in airports—shelters of transport—all over the world, living within a series of temporary nonengagements, almost always able to bypass the local, yet connected to those not present though nomadic objects—cell phones, laptops. We engage best with what is not there. Where are we at any one moment? From where is creative work now made? From whose point of origin is it formed? To which nation or nations do we owe our expertise, allegiance, energy? With whom is the conversation being held? In what timeless, spaceless, nationless location are these extravaganzas shown? What audience do they reach? In what interstitial spaces should they be viewed? Through what or whose prism of value should their success be measured? And who is being left behind? What classes, which races, which artists? What types of art are exiled from the conversation? What aspects of this delocalized itinerancy are progressive? Which are not?

Such questions haunted my thoughts as we landed in Kennedy Airport after the sixteen-hour journey from the tip of Africa. We, the recently returned biennialists, were in a state of dislocation. At the baggage claim I felt a bit uneasy, as I often do at such transitional-transnational moments when I am about to leave my simulated nomadic tribe and enter the world of domesticated locality. Some of us were home. I wasn't. Having grown up in New York, I always feel that JFK Airport is the non-space of my psychic point of origin, the "almost home," but I still have to go to my actual place of residency and employment—Chicago. We all seemed stunned to be back in the United States, but, in true nomadic fashion, even at 6 a.m. and with only a few minutes to spare between flight connections, the tribe began to put down its virtual tents and get on with the business of rhizogenic, global connection. Several of us were already on the phones calling Brooklyn, the Bronx, counting back to Chicago, Los Angeles, Seoul, Bangkok, or ahead to Johannesburg, Berlin. One person had sat down, plugged in her nomadic object of navigation, and began surfing the Net. Someone else was responding to e-mail, others were checking voice mail. All of us, it seemed, were once again on the move in virtual space. Intellectual-artist travelers as we are, could not let any grass grow under our feet. Even had we a piece of land on which to grow some grass and could we admit such retro domestic desires as those for organic cultivation, anything we did plant would certainly die; we'd never be there, anywhere, long enough to water it. Anyway, as Bruce Chatwin notes, nomads are grazers, not planters. Restless, they take the best from each location and move on. (Not unlike the art world.)[8]

While waving good-bye, we expressed the hope that we'd meet again in São Paulo, Venice, Berlin, Kwangju, Cuba, Sydney, Taipei, Kassel. We

seemed like transnational executives living in airports across the globe. But unlike them we did not possess the VIP/Red Carpet Lounge cards with which to access the inner sanctum of non-space. We doubtless made considerably less money than our corporate counterparts and, even more unfortunately, exerted none of their political influence.

NOTES

1. Michael Brenson, "The Curator's Moment," *Art Journal* 57, no. 4 (Winter 1997): 14–27.

2. Jacques Attali, *Millennium: Winners and Losers in the Coming World Order* (New York: Random House, 1991).

3. Giles Deleuze and Felix Guattari, *Nomadology: The War Machine*, trans. Biran Massumi (New York: Semiotext[e], 1986).

4. Quoted in Fredric Jameson, preface to *The Culture of Globalization* (Durham, N.C.: Duke University Press, 1998), xi.

5. Marc Augé, *Non-Places: Introduction to an Anthropology of Supermodernity*, trans. John Howe (London: Verso, 1997).

6. Attali, *Millennium*, 105.

7. As quoted in Deleuze and Guattari, *Nomadology*, 132, from Amy Milovanoff, "La second peau du nomade," *Novell Litteraires*, no. 2646 (27 July 1978), 18.

8. Bruce Chatwin, *Anatomy of Restlessness: Selected Writings 1969–1989*, ed. Jan Borm and Matthew Graves (New York: Penguin, 1996).

11

Art and Ecology

From an old word of the sacred tongue, which signified stain and profanation, insult, violation, and dishonor, we call the breakdown of this equipollence pollution. How have divine landscapes, the saintly mountain and the sea with innumerable smiles of the gods, how have they been transformed into sewage farms or horrifying dumping grounds for corpses?

—Michel Serres[1]

Art and ecology—two philosophical and physical forces struggling to survive within U.S. society. In examining these struggles, one can identify similarities between these seemingly divergent areas of inquiry. Society's resistance to embracing art fully parallels a similar cultural inability to accept the need for a universally recognized ecological consciousness.

On the subject of ecology a reasonable person might ask questions such as these: Why hasn't Western civilization grasped that what is toxic to the natural world is also toxic to the human body? That what strips the planet of its trees, destroying its ability to breathe, also diminishes oxygen for humans? That those chemicals that kill fish in the water are probably also slowly killing us, and that the fumes and noise of cars, so noxious to all living things, have rendered most major cities in the world unfit for human habitation?

One can sit in a traffic jam in Tokyo, Athens, Mexico City, Manhattan, Los Angeles, or Chicago and experience the same feelings: anger, immobilization, and frustration while breathing in pollution—sick from the fumes, even gasping for breath. Yet as a species we continue to obsess

about our cars—how they look, how fast they run—instead of building decent public transportation systems or developing and marketing reasonably priced vehicles that are independent of fossil fuels.

One might attribute these apparent contradictions in our behavior to one of capitalism's excesses: its obsession with personal freedom at the expense of the collective good. But capitalism is a system that only reflects and manifests human values, inclinations, and priorities. It intrinsically does not concern itself with the larger societal unity, nor does it promote the truism that humans are only one species among millions to exist on this planet; or that we should attempt to cohabit, not just with each other, but with all creatures of the natural world—many of which we depend upon to serve as our food and to provide us with the oxygen necessary for our breath.

Because we refuse to look upon the environment—the ecosystem—as an interwoven series of relationships, of cause and effect, we are willing to overdevelop one element of that system for profit, unmindful of the consequences. We want to breed shrimp, for example, so we haphazardly cut down the mangrove trees that have created the complex conditions in which shrimp and other sea creatures thrive. Humans act as if we are in it only for this life, for the short haul, abusing the world around us for our immediate gratification, personal comfort, and sense of power and freedom. We even abuse our own bodies in this way, assuming we can work all the time, without rest, and that youth will be a permanent condition. We treat our spirits as if they will continue to thrive even though we permit no play, and our lives become a series of quantifiable negotiations. It would seem that nature once seemed fierce to humans—something to fear—but now it seems compromised, spoiled, and fragile.

As the post-communist world scrambles to adopt capitalism and a market economy as its main goal entering the twenty-first century, we need to examine closely the values we have so successfully exported. The primary one of these is the equation of democracy with product development: one is only as free as the range of choices with which one is presented in the supermarket or on the Internet. Running in parallel with the acquisition of things is the obsession with the acquisition of money, at no matter the cost to oneself or to the environment. In U.S. society monetary wealth is the prime motivator, even though Freud warned us that money can never make us happy because it's not a childhood desire; even though we know that money cannot buy peace, love, happiness, or meaningful work, unless one has already cultivated the capacity for these in oneself and in the world. Money also cannot buy back our health when we are smitten with a terminal disease, and yet it is the acquisition of money that is continually offered as the prize.

Acting on these values has cost this country dearly, with ongoing pollution, threats of global warming, and loss of undeveloped open space. I

do not believe, however, that these observable, destructive impulses represent Thanatos, what Freud calls the death instinct. Perhaps they more closely represent the polarities between love and discord presented by Empedocles—the conflicts between the unifying principles of order embodied in love and its contrary, which seek disunity, such as the child who joyfully builds a toy-brick house but then finds even greater satisfaction in knocking it down. In the child the literal enacting of these forces usually represents play, but in the adult such behavior can result in devastating destruction.

It seems clear that some serious questions need to be asked: What is important to this society? What keeps us from doing the best for ourselves, and what contradictions must we confront if we are to survive as a species? What is hidden and what is visible? Who is allowed to ask these questions, and how are the answers best communicated to the rest of the population? It is here that the work of artists becomes essential.

Many artists and indigenous peoples, often alone in U.S. society, have shared the knowledge that we are of this planet, made of its stuff—earth, fire, air, water—and, like all that surrounds us, we too are elemental and infused with an inexplicable life force. But, as far as we know, we are unlike the rest of the natural world in that we were given a self-reflexive consciousness with which to understand, and hopefully improve upon, our condition and that of the other species with whom we cohabit. With this self-reflexivity we have made art, written books, engineered our environment, designed our universe, and then commented upon all our achievements. But we have also used this consciousness to deny our animalness and the fragile condition of inhabiting a physical form.

Artists alert us to these present dangers in perception. They let us know when we have gone too far, put our own physical and psychic well being in danger, lost touch with our own fragility, or when we are approaching a new paradigm, either having lost what was most valuable from the past or having ignored what is most problematic in the present. Artists often make us aware of these contradictions through their use of the physical body. In the name of all women Karen Finley abuses her own body in simulated acts of aggression and humiliation. Andres Serrano photographs grotesque moments of death taken from unidentified bodies in the public morgue. He reminds us that U.S. society has never faced death head on, and that bodies can go unclaimed, unloved and unmourned—casualties of urban warfare. Magalena Abrakanowicz creates hundreds of hollow yet convex life-size figures marching we don't know where, propelled from within by an unknown force, a collectivity marching towards its death or perhaps away from death to life. Through alchemical acts, these artists take what is inside and give it an external form, and take what is outside and give it an internal form, in order to comment on the society

around them and its intersection with the individual. But they are often misunderstood as they move between the individual and the collective, serving as public intellectuals, bringing difficult issues into a social forum. At times such work is labeled difficult, obscure, unsettling, blasphemous, pornographic, obscene, while they intend it to be political and confrontational to a positive end; many artists believe that there is a usefulness in collective psychic upheaveal. Many want "to open the doors of perception," as Blake says, and create dialogue, but too often their work is only met with resistance, fear, and empty silence.

A root cause of this misunderstanding is the lack of consensus about the real value of art to American society. Its role and importance never having been articulated, art faces many challenges, such as people advocating the elimination of all public funding for the arts and for art education in the public schools. In a society that equates worth with price, the value of art has not yet been calculated because it cannot be easily quantified, nor can it be explicated within a sixty-second sound bite.

Yet people's actions often belie what appears to be a silent acceptance of public anti-policy towards art. In their hearts, many people do seem to understand the value of art. A million people, for example, flocked to the Monet exhibition at the Art Institute of Chicago several years ago. For weeks they lined up around the block to see nine rooms of paintings, and they confronted impenetrable crowds once inside. What did they want? Why did they bother? What was the show's impact? In a city mostly known for the Bears and the Bulls, it was art, and not sports, that generated substantial revenue for the city. Various analyses have shown that professional sports teams do not contribute significant revenue to the city; rather, these teams create only marginal, seasonal jobs. They do not bring people into hotels, do not encourage them to rent cars, to eat in expensive restaurants, or take in other cultural events available in the city. The Monet show brought $393 million in associated revenues to Chicago. It also presented Chicago to the world as a city of culture. No one could have imagined how successful it would be.

The show was hyped in a fabulously effective advertising campaign funded by Ameritech, which conveyed a sense that one should not miss the largest Monet show to date, that it was a must-see cultural event. But much of the love for these paintings is undoubtedly derived from a deep need and desire for the sumptuousness and beauty that viewers find in them. There is a collective longing for the idyllic life that is portrayed in these images, for a life that was, for all but the bourgeoisie, only a fantasy even in Monet's time. In this sense, the strong interest in these paintings demonstrates that there is longing for joy, pleasure, coherence, for an integrated relationship to the natural environment. Such emotions—simulated by art—can serve as a creative catalyst moving the world forward.

I was fortunate enough to see the Vermeer show when it was at the National Gallery of Art in Washington—twenty-one perfect paintings. The respectful silence of the audience surrounding these paintings was an imitation of the silence within the paintings themselves—a meditativeness that slows the world down enough to capture the often-unexperienced sense that life is truly lived moment to moment. The paintings allow us to observe an instance of time and to study its enigmatic unraveling without intrusion.

In the United States there is almost no quiet left. Silence can now only be found in true wilderness, in houses of religion, books, or in art that requires a psychic connection between the audience and the work. But our culture does not seem to believe in silence, does not embrace the merits of contemplation. Noise has become one of the greatest pollutants to the physical environment as well as to the human psyche and body. But the making of art, and the viewing of art, requires concentration. Therefore art itself becomes a possible site of silence and a vehicle with which to reconstitute the self.

How many people have an image from nature pinned to their bulletin board—a card from Alaska, the beaches of the Caribbean, or the mountains of California? How many have an image from works by Van Gogh, Brancusi, Edward Weston, Mary Cassatt? These are the images of dreams, of what people choose as healing and inspiring to themselves, and they offer images of silence and contemplation from nature and art. What are we looking for as we glance over to our own portable galleries during the day? We rarely examine this need to integrate what is not apparently of the self but which reflects something deep inside the self. Art sends the viewer into the recesses of his or her unconscious, and it is from there—these deepest layers—that we can then reach out and find the relationship between dreams and reality, the child and the adult, the individual and the collective, inner and outer, human and nature. If we deny ourselves access to these deeper psychic states, we will never understand the interrelatedness of all aspects of the universe, grasp the magnitude of our place within it, or recognize that we too are of nature, that it is not an entity only outside the self. Without such understanding, we will find no rest from the anxiety such loneliness causes.

In cultures like many in Africa and Asia that easily recognize the subtle relationship between various parts of the self, as well as the sacred in the profane, the spiritual need for art and art-making is clearly valued, and money is organically poured into art and sometimes given to artists in recognition of their importance to the society. In such worlds the making of art and the sites designated for the making of art are supported. Artists and writers, those who make the objects connected with such radical ideas, beauty, or spiritual meaning, are given prominence. Their work is not always understood, but it is most always valued.

Several years ago I took part in an international symposium in Japan with a group of Japanese artists, playwrights, and architects. The chair of the symposium asked each of us to respond to these questions: What will be the place of art in postindustrial society? Were there more leisure time and everyone were to use this time to become artists, what might that look like?

How truly subversive it would be, to the very foundations of U.S. society, if a general population were to be trained to think as artists, to prioritize as artists, to work as artists, and to do so from an early age. As interesting as that idea seems, I anticipate a series of problems that would be caused by this transformation. Art is what makes society a civilization, yet most of it is not sold or is not saleable, and therefore has no quantifiable exchange value. This fact alone would make it difficult for many to give themselves over to art-making. If they became artists, they would have to learn how to measure the value of their labor, to themselves and to society, to see its creation as a productive use of their resources and time, without the expectation of external reward. Because there is no simple way to measure the "success" of artists' work, and because there is vast disagreement about what constitutes artistic success, it can be anxiety-producing for most people, most of whom need some objective or quantifiable measurement of their achievements.

It would be wonderful if values could change in such a way that the making of art was validated as essential to everyone's growth and development, not just as part of the education of children, but as an ongoing challenge to adults. One of the key aspects of the type of thinking that artists, writers, and intellectuals are trained to do is to keep reality at a certain distance, to examine or study it. This examination moves day-to-day reality into a form of abstract thought, and it creates a symbolic representational universe that exists in a tangential relationship to what we term reality. In practice this means that, although art may have a direct impact on the world, it also affects thought and emotion at a symbolic level—it shifts the psychic terrain. Instead of acting out dramatic gestures, artists represent them and imagine their consequences. Greek mythology and tragedy were based on such psychic displacements. One could simulate the experience of killing one's father, sleeping with one's mother, plucking out one's eyes in retribution. The audience could watch Oedipus go through his torment, imagine it, look at the horror, observe how such acts destroy the fabric of social interaction, and then move away, having learned something profound about the resonance of such emotions. Having observed a dramatization of such pain, audiences recognize that a desire to act out these dramas represents an unconscious need that has no place within the reality principle and should be played out and resolved *only* in a symbolic universe. *Catharsis*, the Greeks called it, a cleansing of

the collective psyche, but it is a term whose origins refer as much to the purgation of the physical body as the psychical.

Imagine if an entire society were to have the capacity to act out its most horrific feelings, thoughts, and hatreds representationally. We might then have symbolic war, violence, patricide, usurpations of power; there might be great art and little actual violence. In the same vein, were people to paint landscapes, perhaps they could no longer tolerate the decimation of the natural world. Were they to focus on the city and draw on its images, they might be moved to alleviate the economic and visual poverty and despair they could not avoid observing. They would have to really *see* and study what is around them. To live on such an art planet would be a great gift. If the Buddhists are right and a nation is really a collective of people who share similar illusions or who construct, as Homi Bhabha says, a common narrative, then were everyone making art, were everyone trying to represent their version of reality, the nature of the reality principle itself could be transformed. We might all find ourselves living in the pleasure principle, where people's desires are actualized within the aesthetic dimension. One of the primary struggles of society would then be determining how to develop the collective imagination, so that we could reimagine the entire society. Humans make wars, create imbalances of power, destroy the physical environment, terrorize and discriminate against each other. If people's dreams, both positive and negative, could be fulfilled in symbolic ways, perhaps we could then let each other and the environment *be*.

I present this as an idea, yet, as utopian as it sounds, it is a vision that hearkens back to other civilizations that were able to make art a more integrated part of their people's lives, which were able to live out their dreams and nightmares collectively. In Latin American, African, Native American societies, art and life, and art and nature, as we categorize them in the West, have interacted at many more levels, and the collectivity participates in these intersections to a greater extent. But our advanced industrialized society has lost the coherence of the personal and the collective, the mundane and the spiritual. The United States has become a desouled society, and now we frantically seek to reclaim a lost spirituality.

In our new high-tech world some look to the computer as a source of salvation. But this is terrifically problematic. When I see the term *community* used to describe the disembodied interactions that cross the electronic universe, I wonder where we are headed. It seems that, once again, we are caught in the illusion that advances in technology will solve the problem of the relationship of self to other, and of humans to their environment. We want to believe that inventions outside ourselves will free us from ourselves. We once held this hope and expectation about the automobile. But most of us would agree that there has been a tremendous price for the

freedom of mobility we have gained as a result of that invention. The television was going to revolutionize education and family life, and so it did, but now we can more easily quantify its myriad negative effects than its positive influences.

I recognize that I am not a child of this electronic age; I still love actual, not virtual, human interaction and am rarely satisfied with simulacra. While I am impressed with the efficiency, mobility, and access to information computers provide, I fear for the well-being of the natural world as generations might emerge who no longer feel they need face-to-face human interaction or a physical relationship with the environment to experience themselves as complete. We in the United States now live in a global universe, speaking as easily to South Africa as to Manhattan, rarely taking the time to remember the historical and cultural distances being crossed. I fear that as virtual travel becomes easier and easier, we will lose the concept of the time that has actually passed, the geographical space that has been traversed, and that with the push of a button and within one synchronic moment, history, cause, effect, difference, distance will all too easily be obliterated.

As we continue to make our offices electronic, working from home, airplanes, or from wherever we may be, will that mean that all space will become work space, and there will be no free zones within which to be silent or to dream? Americans are already congregating in smaller and smaller units of social organization because fewer people belong to labor unions, participate in other civic organizations, or attend religious services. A few years ago now, we experienced our first "CyberSeder." Will one's own private computer terminal replace the workplace for shared common experience, goals, and orientation to society? But what can replace the workplace for interaction of gender, race, and class? Not just the talking between these groups, but the actual bonding that results from shared daily life, labor, goals, struggles, achievements, and experiences, of learning to admire people because of their work ethic and moral ethics within a context that we share.

If my fear of the homogeneity of cultures globally is justified, then more than ever we must support that which focuses on the creative individual and the place where the individual intersects with the collective. We need to believe in the education of artists and the important place art-making should take in an educational curriculum. Imagine if a general population were trained to trust their creative selves and that their imaginations were nurtured, developed, and integrated into their adult lives. To recast society's focus in this way, a number of things must occur: the collective must take seriously the potential role of the artist in society as a purveyor of particular wisdom, recognize the important place that art occupies within society, validate the work that artists do as *work* and find ways to reward

it, while acknowledging that the making of art is as essential to the well-being of society as the transactions of business, government, or education.

But this transformation will not come easily. As long as people deny the deepest needs of the soul—to be rooted, to be part of family and community, to be able to represent all elements of their identities and their complex range of emotions—we will inevitably deny as well the need for a clean and protected environment in which to live, to breathe, and to dream. And as long as this society refuses to acknowledge the relationship between the individual and the collective or the need to have this relationship represented symbolically, then the work that artists do will still not be seen as important work and will continue to be condemned as self-indulgent and irrelevant to the problems society faces.

What motivates creativity—the need for play, diversity, multiplicity, repetition, pattern, design, unpredictability, beauty, drama, upheaval, transformation, and risk—are all reflected again and again in the natural world. Perhaps now, at the beginning of the twenty-first century, we can acknowledge that the fragility of this multifarious physical world, which is subject to mindless human destruction, is not unlike the fragility of the creative spirit in each of us. These entities can no longer be ignored or abandoned as we try to run from nature—within and without. In effect those in the art world have always been environmentalists, seeking to protect from extinction the creative will that enlivens and motivates the work they do, including their ability to envision a future that does not as yet exist. Were this drive to create—the active imagination that propels society forward manifesting in nature as infinite variety and adaptability—to become extinct, were we to live in a world that no longer was inspired to create or no longer inspired a creative response in us, and we, in turn, no longer aspired to a more perfected future, then that which is the life force in each individual, and that which drives the will of the entire species, would soon wither and die.

NOTE

1. Michel Serres, *The Natural Contract*, trans. Elizabeth MacArthur and William Paulson (Ann Arbor: University of Michigan, 1995), 24.

12

GFP Bunny and the
Plight of the Posthuman

When it was first proven that Dolly, the cloned sheep, had a genetic makeup the age of her host, it threatened to end the fascination with cloning as a viable method of reproduction. (Why would a member of any species want to start out old?) But in April 2000, when scientists at Advanced Cell Technologies in Worcester, Massachusetts, announced that their cloned cows "possessed cells with clocks that are set like newborns," this was a revelation.[1] It would seem that, finally, humans had found the fountain of youth. Now able to replicate other species (and someday ourselves) ad infinitum, they (we) could always remain young.

The Human Genome Project, cloning, and the field of biotechnology appear to be driven by a desperate desire to find "the secret of life" and to foil the most fearsome elements of our genetic programming—the inevitability of imperfection, deterioration, disease, and death. Perhaps the conversation about the "posthuman" is fundamentally about our desire to flee from human vulnerability, mortality, and our subjective awareness of these conditions. And if such experimentation and theorizing is a personal, ontogenetic attempt to defy death, it is also a phylogenetic effort to continue to evolve as a species when it would appear that all dramatic "natural" evolutions of the physical body have come to completion. Simultaneous with this interest in immortalizing the physical body is an attempt to create a new virtual body, unencumbered by gravity. One day we might decant our old "self" or core into a cybernetic shell stored on some version of a floppy disk from which our singular and collective identities could be eternally retrieved (but hopefully not erased). These complex motivations are often couched in the discourses of transcendence and liberation.

If, in the art world, the theorizing of the 1980s and 1990s was about is-
sues of identity—the mining of the nuance of one's historical self, con-
ceptualized in society, or *what one is*—then perhaps this new era will be
characterized by discourses about *what one is not*, and focus on the incor-
poration of otherness: the recombination of the natural and the fabricated;
the physical and the virtual; the breakdown of distinctions between art
and science; the site of visual experimentation now become the actual,
material body, no longer merely its representation; the interrogation of the
permeable parameters of species differentiation—new hybridities—as
well as the cyborgization and robotization of the human body, and the hu-
manization of the machine. Perhaps we are now enamored with the no-
tion of the posthuman precisely because we perceive humanity as an out-
dated Enlightenment construct impossible to obtain. Dystopian—unable
to imagine the transformation of society and social structures—we have
become fascinated with something pre-social: the source of life and all its
differentiations as manifested in the Human Genome Project. Is our focus
now shifted to the origins of being in order to deflect us from the question
of being *in society*? Or is this the issue of identity taken to even more ba-
sic levels: What is human? What is animal? Where do the two come to-
gether? How can we truly gain mastery of the code that makes us human
and differentiates us from the 98 percent of our makeup that is genetically
similar to that of apes? Are we nostalgic for our placement in the world of
animals (the 98 percent), or are we committed to leaving such categoriza-
tions behind once and for all (the 2 percent), through our ability to control
how all animals, including ourselves, evolve? Or are we simply bored,
fearful that our apparently intransigent relationships between mind and
body, sentient and nonsentient will remain unchanged for eternity? Into
this wildly unpredictable, potentially dangerous, philosophically rich
field of experimentation, one marked by a lack of examination of motiva-
tion and potential consequence, enter artists, many of whom love to cre-
ate in such spaces of metaphor, ambiguity, virtuality, multiplicity, artifi-
ciality, utopianism, risk, and chaos.

Eduardo Kac is such an artist; he has navigated these new geographies
for some time. Kac believes, "If we leave technology behind in art, if we
don't question how technology affects our lives, if we don't use these me-
dia to raise questions about contemporary life, who is going to do that?"[2]
He has used each of his art pieces and spectacles to attract media attention
and thereby encourage public dialogue about the social issues his interac-
tions and interventions address, often transforming scientific projects into
social interactions. Among many other projects, Kac has grown a single
seed in a gallery in New Orleans through light sent by individuals around
the world via the Internet (*Teleporting an Unknown State*). He has implanted
a chip in his own leg, registering himself as both animal and owner on a

Posters from the "GFP Bunny—Paris Intervention" series, Eduardo Kac, December 2000 (top). Eduardo Kac placing the "Religion" poster in front of the Sacré-Coeur cathedral, Montmartre, Paris, December 2000 (bottom). Courtesy Julia Friedman Gallery, Chicago.

Web-based animal identification database (*Time Capsule*). And he has created a performance where a robotic device designed to aerate his own extracted blood was then able to use it to ignite a flame (*A-Positive*).

In his most recent piece, Kac has collaborated with geneticist Louis-Marie Houdebine to create a "GFP rabbit"—a transgenic albino bunny whose genetic makeup was altered with a gene obtained from a Pacific Northwest jellyfish that contains GFP, green fluorescent protein. Scientists have previously used this substance to track genetic changes in frogs and mice. Kac had originally wanted to create a "GFPK-9"—a dog that would turn fluorescent under a blue light or glow green in the dark, like the rabbit. But the technology was not yet advanced enough to permit bringing the fluorescence into the coat of a dog. Hence Alba, the albino bunny. But Kac insists that Alba alone is not the art project. Rather, according to Kac, "It is one gesture—the creation, social integration, and response" that constitutes the actual piece.

Eduardo Kac will live with Alba (now several months old) in a gallery context in Avignon, France (as part of AVIGNONumerique), where he will attempt to "normalize" his relationship with her, constructing a domestic space where he and Alba will cohabit over the course of two weeks. There, visitors will be able to see the rabbit and to observe her glow under a blue light. As a result of the weeks in Avignon and the conference framed around the multifarious issues this piece will generate, Kac hopes to "displace the discourse of a transgenic animal from a scientific model into that of a social subject." Kac will then return to Chicago with Alba, where she will become a "member of his family." He is interested in finding the place of public dialogue beyond the obvious polarizations—the utopianism that can surround bioengineering as well as the fear that often accompanies its potential outcomes. He is also interested in how the issues around such transgenic (cross-species genetic transplanting) art are discussed in the public arena and how Alba's existence, and his response to it, might, in his words, "introduce much-needed subtlety and ambiguity" into the debate.

Here the artist has assumed the role of educator, researcher, scientist, social critic, inventor, and co-creator of life. His struggle as an artist is no longer to interrogate his own "hybridity" to register his own "agency," but rather to be part of creating a visually and genetically new transgenic creature, and then focus on *her* integration into society, *her* agency, individuality, and potential designation as "other."

In the universe of the posthuman it would appear that the human species will now not only fuse with machines to determine their destiny and how human they will become, but also, no longer the victim of nature ourselves, will become even more the choreographers, curators, and programmers of all other existent and yet-to-be-imagined species. As Kac

says, "I'm interested in science and technology because they allow me to intervene in reality in a way that has a sense of immediacy."

Had we done better as humans in relationship to each other and the natural world, perhaps we could be more optimistic about what to expect from such posthuman interventions in the realm of the "real." But there is no turning back. Such work to expand the notion of self/other, sentient/nonsentient—visually and conceptually—will inevitably continue. Many scientists and artists will be seduced by the challenges, and also the imagined good, that certain types of research might achieve. Some will also be attracted to the glamour, power, and money connected with creating "the first of its kind." What should be done is as Kac has proposed: create forums where conversations about "consensual domain" between ourselves and other creatures can take place;[3] interrogate the motivations behind such projects; develop ethical discourses to help honestly evaluate the effects of such experiments and art endeavors on those other humans, part-humans, posthumans, and nonhumans with whom we cohabit and whom we will increasingly seek to perfect and control.

NOTES

1. Tim Friend, "Clones May Hold Secrets to Youth," *USA Today*, 28–30 April 2000, A1.

2. All the quotes attributed to Eduardo Kac are taken from an interview with the author, May 2000, in Chicago.

3. This term *consensual domain* is very important to Kac and repeatedly arose during our conversation.

13

Surpassing the Spectacle

Marxism is not a philosophy of history; it is the philosophy of history
and to renounce it is to dig the grave of Reason in history. After that
there can be no more dreams or adventures.

—Merleau-Ponty[1]

As long as there was a philosophical alternative to capitalism that held the
promise of greater equity, even if it had not succeeded as many had imag-
ined, even if it had disappointed its greatest supporters, its existence al-
lowed for the possibility that a new economic organization of society might
someday evolve, one taking the best from several systems and securing the
intent of society to provide for and protect its citizens. Within this dream
was a vision of a society that might appreciate cultural work that dares
challenge its premises, offers dissenting opinions, encourages serious de-
bate, and makes inherent contradictions apparent. Such was the dream of
various artists, writers, cultural workers, and critics during the 1990s as
they monitored social and political trends—plumbing whatever hidden
radical implications they could find and reporting on evolving states of
consciousness in the United States, always with the hope that through the
chinks in the armor might be found the possibility of change, whether these
were glimpsed through labor struggles, battles against globalization and
the World Trade Organization, or students organized in protest against
Nike's exploitation of workers in developing countries. All such forms of
resistance might be used as goal posts if one could find even the general lo-
cation of the goal. But at this time in history, most would agree that paths
to change remain remarkably uncharted.

Even when these various resistances do find their way into popular consciousness and, one hopes, into government policy, there is no longer any one image for change that might radically transform basic economic structures and create greater social and economic equity. That goal, at least for now, seems to have been obliterated from any future progressive agenda for the United States. Perhaps this is a good thing; perhaps this will allow for new creative solutions to emerge. But for many this is an anxious and at times demoralizing time.

Without such located dream spinning, or the glimmer of a utopian vision, it is now difficult to imagine how the dominance of advanced capitalism will change radically any time soon. Or, if it were changing, how would we ever recognize any progress, wrapped as we are in the most impenetrable spectacle of them all—the ongoing barrage of information and visual stimuli disseminated by the media, which absorb the attention of U.S. citizens every day, but which do not necessarily help anyone to see and understand their situation in relationship to society with clarity. This spectacle successfully overstimulates, distracts, and diverts people from the reality of their condition, often obscuring the real needs for community, meaningful work, respect of difference, and an equitable distribution of wealth by promoting an insatiable desire to consume.

While many artists, writers, and cultural critics continue to hold out for any movement that indicates a shift in the general public consciousness, U.S. society appears to have become increasingly polarized, as the 2000 election so undeniably demonstrated. Traumatized by issues of race, choice, class, difference, and economic inequity, the United States has split down the middle, its assumed values and sense of national cohesion severely challenged. Gestures of inclusion have been token at best, and even they have been slowly eroded. All aspects of the welfare state are being quickly dismantled. California has marked the end of affirmative action, while government agencies demand proof of citizenship before helping people address their most basic needs. States debate how to provide health care to needy undocumented children while refusing such aid to their parents. Yet, as dire as these realities are, no *one* issue in the United States has received as much sensationalized press, with so little understanding of the depths of issues actually involved, as the debates around public funding for the arts. These discussions, which originally pivoted around the National Endowment for the Arts (NEA) and its threatened obliteration, have marked a barbarous period when battles over who is an American, what images can represent U.S. society, and even whether there will *be* a society or merely a gaggle of geopolitical fiefdoms are waged daily.

Central to the debate over which images are acceptable for a general audience, i.e., which images should be financed by public support, are the categories of otherness that polarize U.S. society—categories like African

American/Asian/Latino/white, urban/rural, popular/intellectual, underclass/working class/middle class/elite, heterosexual/gay, and a polarization harder to categorize but nonetheless powerful in its implications: those who believe in the value of taking the world apart to reconstitute it in art and those who assume that art should elevate, entertain, or soothe. Although it would seem that this separation surrounding art might be determined in large part by education or economic status in America, often it is not. Rather, at times it has to do with what Guattari calls "the politics of passive acceptance of the world such as it is."[2] What does it mean really to believe that a critical approach to one's society is the greatest form of respect for one's role in that society? This is not a popular position in the United States, where entertainment, whether through sports, television, or film, is the national pastime. Probably what separates intellectual pursuit from popular culture most is its commitment to serious interrogation of the world as it is and the imagining of what it might become, over and beyond the accumulation of capital.

But because public funding for the arts is now equated with the funding of such social criticism, which has been termed "un-American" by some because it often results in progressive ideas of tolerance, the backlash to such interrogations has become increasingly intense. Those who argue against funding the National Endowment for the Arts talk about "family values," while the rest ask, Whose family? What values? Reactionary forces that want to censor controversial work align with those who believe in free enterprise and small government to insist that art should not be government-subsidized at all; together they form a strong lobbying force intent on destroying government support for the arts. Those who object to these so-called confrontational works of art do not primarily represent the ruling or dominant classes protecting their own interests. The power of right-wing oppositional forces in America is not directly economic. Often it is moral, religious, and then *becomes* political, holding sway over the House of Representatives and the Senate because of the numbers of people the far right is able to mobilize. But in the United States many continue to ask this question: Why does anyone want to take the world apart, to live outside the parameters of what is conventional? And the answer is still the same. Those who challenge the prevailing ideology do so because their lived experience differs so dramatically from the projected version of reality that defines America. There are always those—artists, cultural critics, writers, along with groups demanding social change of all types—who are compelled to articulate what is hidden. Art generates fearful debate because it is, as Adorno notes, "the negative knowledge of the actual world."[3] And those who fear the unstated, unexamined realities that dominate most people's lives also come to fear the power of creative work to unveil and make available such knowledge.

While artists and writers attempt to present the complexity of America to itself accurately through images in theater, literature, and art, hoping to transcend the spectacle, at times they appear doomed (in Guy Debord's sense) at best to transform "ideas about the spectacle."[4] A great deal of art-making in the 1980s in particular took on issues about the illusions of society, but this work did not succeed in giving enough people real tools to move beyond these illusions or pose alternative cultural models for a world we might dream into being. Such work reflected upon the condition in elaborate, at times entertaining, and often hermetic ways.

On 14 August 1997, several articles relating to these issues appeared on the front page of the *New York Times*. Although of disparate concerns, together they exemplified the contradictions around otherness and difference in an America at war with itself and with the image of itself. The first involved so-called controversial art. The headline read: "Across U.S. Brush Fires Over Money for the Arts." The skirmishes to which the piece alluded—the images conveyed in the reportage were warlike—largely surrounded Tony Kushner's two-part drama *Angels in America*, a play about the AIDS virus, gay lifestyle, and the complexity of identity in contemporary American society. This epic, performed all over the United States, is arguably one of the greatest theatrical hits of the century and undoubtedly only rivaled by Maya Lin's Vietnam memorial as a popular vehicle for collective mourning. The theatrical community has awarded it numerous distinctions. And although the general perception is that such layered works are produced only in cities for sophisticated urban audiences, the massiveness of Kushner's achievement is that *Angels in America* has played to full houses in small towns from North Carolina to Alaska.

The play is grand in scale, gorgeously written and staged, but it is not by any means avant-garde theater. The work adheres to traditional theatrical structures; only its content is provocative. For many, Tony Kushner is a hero. Yet when *Angels in America* was performed in upstate New York and at the Arkansas Repertory, these theaters printed statements intended to protect themselves from public protests by indicating that the play was produced "without public arts funds." This infuriated Tony Kushner, who said, "Theaters weaken themselves with such disclaimers . . . this is not a fascist state. . . . This is not a theocracy."

The Charlotte North Carolina Repertory Theater staged *Six Degrees of Separation*, a play in which one character is gay. As a result, the County Commission decided by a five-to-four vote to withhold the state Arts and Science Council's entire $2.5 million grant. This meant that science museums and all public cultural institutions, previously free to residents, were suddenly forced to charge entrance fees for children and adults. Truly astounding is that those who seek to defeat the NEA would sacrifice all the

cultural events that move and educate millions of Americans of every race, ethnic group, and age just to protect their vision of the United States from plays like Kushner's, and, what's worse, the federal government has taken similar positions.

These attacks justify the feeling of many artists that when the NEA renounced grants to cutting-edge performance artists several years ago, because they were seen by some as controversial, in effect the NEA was turning its back on part of its mission and on all its grantees. There was real concern that once one segment of the population forces a national agency to reverse peer-panel decisions and label them "mistakes," then the right wing could hit the next tier of controversy, until it attempts to censor everything that does not meet its narrowly circumscribed specifications.

The second article on the *New York Times* front page that day reported a horrific case of police brutality that has received a great deal of national attention and protest. The headline read, "Police Say an Officer Will Face Criminal Charges in Torture Case." Arrested outside a nightclub, taken to police headquarters, and mistaken for another Haitian man who had tried to punch an officer, Abner Louima, though innocent, was almost fatally beaten and then sodomized with a bathroom plunger by two white male police officers. He was in critical condition with punctured internal organs by the time someone tipped off the officers in charge that there was an arrested man who might die in his cell. Other New York police on duty tried to cover up the incident. The Police Benevolent Association appointed a lawyer to defend the police officers charged and then said: "We stand behind the police officers, who deny any wrongdoing." The monstrousness of this event, reminiscent of the worst atrocities of South African apartheid and of testimony by victims at the Truth and Reconciliation Commission hearings, completely astonished most Americans. And a week later ten thousand people—a mix of Haitian-born, African American, and others—marched across the Brooklyn Bridge, plungers in hand, to protest New York City's infamous record of police brutality. Abner Louima's condition continued to be very serious, and a FBI investigation did lead to the conviction of the police officer who committed the act. But the grotesque and sadistic nature of this incident still haunts many.

At such moments, those in the art world might justifiably ask this question: Where are right-wing groups like the Christian Action Network now, concerned as they are with "family and American values," when the most un-Christian, unfamilial, supposedly anti-American acts imaginable are occurring every day? Unfortunately, the hidden text is that the same groups that protest what they consider "art from the gutter," as Jesse Helms called "controversial art" funded by the NEA, are in fact unconcerned with such brutalities because these groups are often also deeply racist, wanting to turn the United States back to some imagined racial purity.

The same day on the *Times* front page, positioned under this last hor-rific story, but of a completely different and seemingly benign nature, was a photo of a barren, snow-covered dark highway. A lone man, his back to the photographer, was walking towards a very small, garishly lit structure, with a disproportionately large neon marquee that read, "Espresso." This third headline read: "Alaska Revels in Frontier Image Though Frontier Slips Away." The photo caption explained: "At the pit stop Espresso booth in Palmer, Alaska, Jeremiah Odorn does not feel he is living a frontier life." In the middle of the wilderness, civilization has appeared—European civilization, identified by the availability of good coffee. The United States, in its myth of itself to itself, has always taken pride in its ruralness and lowest-common-denominator frontier mental-ity, a myth that remains intact in such remote regions. This is where the stronghold of America resides, and such locations are decidedly not Eu-ropean. But this recent article implies that all of America has become civ-ilized. Or, we might say, all the wilderness outposts have become subur-banized—each mall housing the equivalent of a Starbucks—the European-style coffee house, which was once Other to mainstream America but now has become closely associated with gentrification and an upward mobility of taste adopted by large segments of the popula-tion, even in the outback of Alaska. Without the uniqueness of the un-hampered American rural experience, there can no longer *be* a frontier. Without a frontier, the collective American psyche—which from its in-ception has defined itself against Europe in part by its wilderness and the populist, anti-intellectual politics that accompanied it—now lives with only the illusion of its presence. Like expensive Jeeps that allude to wilderness owned by inner-city investment bankers dwelling in safe high-rise buildings, the myth of the great outdoors can still be used to sell products to weekend adventurers, even though there are few Amer-icans left who live true to the ways of the frontier or even want to.

Between the interstices of these three stories one can construct a glimpse of how little the projected and exported images of America mir-ror its actuality. America's popular myths about itself include these: it is a true democracy, committed to freedom of expression; it abhors cen-sorship and keeps a firm division between church and state; it is not racist or arbitrarily brutal to its population; it welcomes new immi-grants; and somewhere it is still a rugged frontier society. Add to these misperceptions the constantly changing immigrant populations and their effects on the projection of America as a predominantly white so-ciety, and you can understand why the United States has become Other to itself.

When I was a child in New York in the 1950s, Crown Heights, Brook-lyn, my old neighborhood, comprised Hasidic Jews, reformed Jews, and

African Americans who lived in extremely close proximity. There was always conflict. It is still Hasidic and African American and, unfortunately, the conflicts have not ceased. But the mix now includes West Indians, Lebanese, and Egyptians. In the last decade it has increasingly also housed exiled leaders representing various international fundamentalist movements. There are strong ties with ultra-Zionist groups like those who raised large sums to defend Rabin's murderer, or the Egyptian fundamentalists who planted explosives in the World Trade Center, and those recent Lebanese immigrants who planned to bomb the busy Atlantic Avenue subway stop at rush hour and were caught building bombs in their apartment. America now is the site of international terrorist politics as it never could have imagined itself to be. Its barriers of isolation and protection from the political struggles of other nations, its sense of security and impunity have come to an end. But this very real vulnerability has still not crept into America's public image of itself.

The media have also not seriously acknowledged the danger of America's own home-grown rural terrorist and anarchist movements, which became startlingly apparent in the Oklahoma bombing; the Amtrak derailment; and in the mobilization of militia movements in Michigan, Montana, Idaho, and Texas; not to mention the Unabomber's letter bombs to scientists and mathematicians. The roots of these vigilante tendencies appear to be of a nature different from those of the international groups, yet they are motivated by similar perceptions, justified or not, that there is no possibility for inclusion of themselves or their beliefs within their originary native societies.

Having reached this point of complexity, how can the cultural forces of the United States talk to each other? It has been the goal of many artists to bridge these polarizations, to construct their work on liminal lines of identity as African Americans, Asian Americans, gays, immigrants—documented and undocumented. Through interventions into the status quo and reclamation of what has been lost in our understanding of our collective situation, artists have performed acts of "reparative cultural symbolizations," as Leo Barsani calls them.[5] Certainly Tony Kushner's epic fits this description. It became a symbolic touchstone for many stricken with AIDS and their families. But less accessible witness-bearing attempts to tell the truths about America's realities have often met with limited success, in part because the intentions behind the work have not been understood. Such has often been the case of artists whose focus was around issues of race and gender.

When we encounter art, writing, and music where the point of intersection of self and other, of imaginary and real is similar enough to our own that we can experience the work directly (and this can occur for some as powerfully with a Jackson Hlungwane throne from South Africa as

with a Vermeer painting), then we have experienced what art can do, which is to address the "loneliness of the self"—a loneliness that Adorno insists is always "socially mediated and so possesses a significant historical content."[6] But in defense of this work, how do we communicate this process of identification, as well as its importance to the reintegration of the individual with the society, in a sixty-second sound bite on national television?

When America was truly a frontier society the lines were drawn—at least in the myth. Culture was something imported from Europe, made by Europeans, which is partially why great nineteenth-century American writers like Melville and Poe were so undervalued. Barbarity and civilization were divided by race, with white people holding the position of civilization and Native Americans and Africans that of the Other. The frontier separated organization from chaos, civilization from wilderness, the tamed from the untamed. And the populace was a rough, raucous, anti-intellectual, and politically conservative bunch. But the best American thinkers and writers of the nineteenth century, from Hawthorne to W. E. B. Dubois, understood the complexity of American society even then and were never confused about the spiritual turmoil at the core of the spectacle of democracy. The only analysis done was exegesis of text—the one text, the scripture. There was supposedly only one truth needed for this complex society. But none of these contradictions was lost on Melville, Poe, or Whitman, all of whom were concerned with democracy, race, class, the multiplicity of meaning and the decentered subject, as well as with what was indigenous to America. A century later, the obfuscations and simplifications that tormented them continue to dominate collective thought, and the language of art—the questions it raises, the complexity it presents—is often seen as the work of the devil—the ultimate otherness—corrupting values, morals, and "the good." Thus, as the United States becomes more complex in every way, its racial and class divisions, instead of being rigorously exposed, explored, and analyzed, are repressed almost to the point of explosion. But instead of an explosion that could propel us forward, we experience further denial and sanitization.

An interesting turn of events has occurred that presents a lighter, but nonetheless chilling, sense of what those with consciousness about such issues in the United States are up against. The image of Mickey Mouse is now looming large over New York, stamped on mugs and sweatshirts. Disney stores have opened. Parades have been held with Mickey at the head. New York, once the center of high art and culture, if there ever was one center in America, has been Hollywoodized, "Disneyfied," to the horror of many. New York—the last consciously articulated stronghold of otherness, inhabited by artists, Jews, minorities, newly arrived immi-

grants from Haiti to Russia—has been theme-parked. If there had ever be-fore been an animal that one associated with New York it was King Kong, trapped in various film versions on top of the Empire State Building: he was, in Edward Lewine's description, "an immigrant." New York seems to have traded this true suffering foreigner of depth and pathos for some-thing as "placid" as a "cartoon mouse from California."[7] Why would any-one fund art that highlights difference, raises issues of race, class, gender, the failures of society, and the breakdown of democracy when they could drift away in this prefabricated, predifferentiated, undifferenced, albeit nonhuman fantasia of Mickey and Minnie? Simply, why would anyone choose art when they could have entertainment? For too many, the an-swer would be why, indeed?

The dream of Marxism allowed the notion of social justice and equality to be imagined, affirming that those who worked would get their due, that society would be constructed to recognize real human needs—both material and spiritual—that theory would combine with praxis, that con-tradictions would be addressed, that art and culture would play a key role. Without the dream of the dream, or the possibility of another dream, how do we imagine our humanness into the future in the face of human-to-human unconscionable brutality? How do we protect and promote work that attempts to penetrate the spectacle? This is the point of inquiry on which America—its writers, artists, curators, and cultural critics—are now all precariously balanced.

About such conditions, Vivian Gornick has posed the challenge that those of us engaged in critical discourse as writers or as artists in the United States need to try to keep "decently alive between periods of pub-lic urgency."[8] Or, as Guy Debord writes, "A critique capable of surpassing the spectacle must know how to bide its time."[9]

NOTES

1. Maurice Merleau-Ponty, *Humanism and Terror*, trans. John O'Neill (Boston: Beacon Press, 1969), 153.

2. Felix Guattari, *Soft Subversions*, ed. Sylvère Lotinger, trans. David L. Sweet and Chet Wiener (New York: Semiotext[e], 1996), 153.

3. Theodor Adorno, "Reconciliation Under Duress" in *Aesthetics and Politics: Theodor Adorno, Walter Benjamin, Ernst Bloch, Bertolt Brecht, Georg Lukacs*, trans. Ronald Taylor (London: Verso, 1977), 160.

4. Guy Debord, *The Society of the Spectacle*, trans. Donald Nicolson-Smith (New York: Zone Books, 1994), 143.

5. Leo Barsani, *The Culture of Redemption* (Boston: Harvard University Press, 1990), 108.

6. Adorno, "Reconciliation," 159.

7. Edward Lewine, "Who Is He? Mickey: He's Here to Stay. Finding a Way to Live With Him," *The New York Times*, 11 August 1997, Living Arts Section, 1.
8. Vivian Gornick, "Criticizing Critic," *The Nation* (22 September 1997), 35.
9. Quoted in Lewine, "Who Is He?" 1.

Index

Bold page numbers indicate artwork.

Abrakanowicz, Magalena, 129
Act-Up, 24
Adorno, Theodor, 27
affirmative action, 62
African National Congress, 78–79,
 82–85, 103
"Africus." *See* first Johannesburg
 Biennale
AIDS, 16, 24; quilt, 91
Alexander, Jane: *Butcher Boys*, 110
Allen, Siemon: *La Jetée*, 110
"Alternating Currents." *See* second
 Johannesburg Biennale
amateur intellectuals, 14
America. *See* United States
American Association of Museum
 Directors, 55
amnesty. *See* Truth and Reconciliation
 Commission
ANC. *See* African National Congress
Angels in America (Kushner), 33, 146–147
anthropoemic societies, 54–55
apartheid, 62, 80, 82, 84, 87, 95, 97–98,
 147. *See also* Truth and
 Reconciliation Commission

A-Positive (Kac), 140
Archeworks, 30
art, 18, 127, 133–135, 145, 149; as a
 political target, 36; as
 entertainment, 45–46; as otherness,
 150; in the public sphere, 18–19;
 Marcuse's discourse on; of
 testimony, 37; postmodern, 23–24;
 public funding of, 24–25, 144–147;
 radical, 40; role of, 27–28, 47, 131;
 role of in U.S. society, 18–19, 25, 39,
 48–49, 130; socially engaged, 23–24,
 26–27, 31; the sacred in, 52, 55;
 transgenic, 140; value of in the U.S.,
 130, 132. *See also* artists; artwork; art
 world; avant-garde
art critics: right-wing, 17
art education. *See* School of the Art
 Institute of Chicago; artists,
 education of
Art Institute of Chicago. *See* Monet,
 Claude
artists, 6–7, 71, 129, 131–132;
 ambivalence toward, 12; as
 environmentalists, 135; as

intellectuals, 13; as public
intellectuals, 13, 19, 130;
contemporary, 17; diasporic, 121;
education of, 12–13, 19–20, 30–33;
images of in U.S. society, 11–12, 38;
infantilization of, 30–31;
marginalization of, 5–6;
misunderstanding between
audiences and, 25; organic, 15, 17;
postnational, 117; responsibility of,
121; role of, 18, 23, 32, 36, 54, 57,
134; socially engaged, 23–24, 26–27;
subversiveness of; transnational,
117, 121–122; working
environments of, 5. *See also* male
artists; women artists
art museums: financial practices of, 47;
funding of in U.S., 45–46. *See also*
Brooklyn Museum
Artist's Space, 24
art schools, 31; role of, 7–8
art students, 19–20, 27; as nomads,
122; socially engaged, 28. *See also*
"The Art of Crossing the Street";
Archeworks
artwork: social effects of, 5
art world, 48; homogenization of, 6; in
era of postnationalism, 121; New
York, 121; response to "Sensation"
of, 47; theorizing of in 1980s and
1990s, 138; theorizing of in era to
come, 138
ate, 99
Athey, Ron, 16, 40
avant-garde, 25, 54; audience
responses to, 55–56; role of, 21–22,
48; totalitarian critiques of, 21

Barker, Wayne: *The World Is Flat*, 110
Basques, 117, 119–120
Bausch, Pina, 40
Behr, Mark, 81–82; *The Smell of Apples*,
81
betrayal, 59, 63; around race, 61–62;
historical, 60–61; in South Africa,
62; mythic, 59–60; social, 60–62
Biko, Steve, 98

Bilbao, 117–120
biotechnology, 22, 137
Blake, William, 39, 59
Boraine, Alexander, 79–80, 83
Boshoff, William: *The Writing on the
Wall*, 108
Botha, Andries, 30, 112; *Home*, 105–106
Botha, Relof (Pik), 104–105
Bowie, David, 45, 48
Brooklyn, 43, 45, 48
Brooklyn Dodgers, 61
Brooklyn Museum, 43, 47, 55;
"Sensation," 44, 52, 57
Bush, George W., 2
Butcher Boys (Alexander), 110

Calle, Sophie, 108
capitalism, 22, 29, 38, 63; dream of
alternatives to, 143; global, 123;
values fostered by, 128
Cape Town, 109–110
Castle of Good Hope. *See* second
Johannesburg Biennale
Catharsis, 132–133
cathexis, 94
Charles, Michael Ray, 109
Chicago, 130
Christian Action Network, 147
Civilization and Its Discontents (Freud),
35–36
cloning, 137
Columbine High School, 4
computers, 133; human relationships
and, 134; effects on workplace of,
134
cosmopolitanism, 3–4
Country of My Skull (Krog), 99
creativity: motivations of, 135
Crown Heights, Brooklyn, New York,
77, 148–149

de Klerk, F. W., 84
Debord, Guy, 2; *Society of the Spectacle*, 1
democracy, 36, 63: effects of the
spectacle on, 2
de Montebello, Philippe, 47
difference, 4–5

Diller and Skofidio; *Pageant,* 107
Dubois, W. E. B., 150

Eagleton, Terry, 3, 8, 36
ecology, 127
ecosystem. *See* environment
Electric Workshop. *See* second
 Johannesburg Biennale
Empedocles, 129
environment, 128, 131
Enwezor, Okwui, 102, 106, 112–115,
 120
Eros, 35
ETA, 113, 117, 120
Eyes of Guetete Emerita, The (Jaar), 107

F. *See* School of the Art Institute of
 Chicago
"Fault Line" conference (University of
 Cape Town, 1996), 81–83
Ferguson, Lorna, 101
Finley, Karen, 24, 129
first Johannesburg Biennale, 101–102
Freud, Sigmund, 94, 128–129;
 Civilization and Its Discontents,
 35–36
fundamentalism, 3

Gehry, Frank: Guggenheim Museum,
 Bilbao, 118–119
GFP rabbit (Kac and Houbine), 140
Gingrich, Newt, 16
Glickman, Marty, 61
globalism. *See* globalization
globalization, 3, 5, 121, 123
Goat Island, 40
Goldin, Nan: "I'll Be Your Mirror,"
 37
Gomez-Peña, Guillermo, 26
Gordimer, Nadine, 83
Gore, Al, 2
"Graft." *See* second Johannesburg
 Biennale
Gramsci, Antonio: amateur
 intellectuals, 14; organic
 intellectuals, 14, 24; *Prison
 Notebooks,* 13–14; professional

intellectuals, 14; public
 intellectuals, 14
Gravano, Sammy, 60
Guernica (Picasso), 18, 39
Guggenheim Museum, Bilbao, 113,
 117–120
Guiliani, Rudolph, 47, 57; response to
 "Sensation" of, 46, 48, 52

Haacke, Hans: *Vindication of Dulcie
 September, The,* 105
HaHa, 26
Harvey, Marcus, 44
Hawthorne, Nathaniel, 150
Heiner, Dennis, 43, 48
Helms, Jesse, 147
Hermes, 50–51, 54
high technology, 22
Hitler, Adolf, 35
Hlungwane, Jackson, 149
Holy Virgin Mary, The (Ofili), 43, 45; art
 world response to, 47; as evidence
 of the trickster at work, 52; media
 response to, 46; iconography of, 46,
 51–52, 54
Home (Botha), 106
Houdebine, Louis-Marie, 140
Human Genome Project, 137–138
humanness, 99, 138
Huyssen, Andreas, 105, 111
Hyde, Lewis, 50–51, 54–55; *Trickster
 Makes This World: Mischief, Myth,
 and Art,* 49, 53

Ihla do Sal, 118
I'll Be Your Mirror" (Goldin), 37
"Important and Exportant." *See*
 second Johannesburg Biennale
intellectuals, 7, 16; amateur, 14;
 function of, 13–14; organic, 14, 24;
 private, 14, 19; public, 13–14, 19, 48;
 right-wing, 17
In the Penal Colony (Kafka), 16

Jaar, Alfredo, 121; *Eyes of Guetete
 Emerita, The,* 107
Jason, 60

Jesus Christ, 60–61
Johannesburg, 104
Johannesburg Art Gallery. *See* second
 Johannesburg Biennale
Johannesburg City Council, 114–115
Jones, Kellie, 102; "Life's Little
 Necessities," 110
Judas, 60

Kac, Eduardo, 141; *A-Positive*, 140;
 GFP rabbit, 140; "Paris
 Intervention" series, **139**; *Teleporting
 An Unknown State*, 138; *Time
 Capsule*, 138, 140; transgenic art, 140
Kafka, Franz: *In the Penal Colony*, 16
Kahlo, Frida, 74
Kartemquin: *A Long Time Coming*, **93**,
 94
Kentridge, William, and Taylor, Jane:
 Ubo and the Truth Commission, 107
Kim, Yu Yeon, 107
King Kong, 151
Koons, Jeff, 119
Krog, Antje: *Country of My Skull*, 99
Kushner, Tony: *Angels in America*, 33,
 146–147, 149

Lacy, Suzanne, 26, 40
La Jetée (Allen), 110
Langa, Moshekewa: *Temporal Distance
 (with a criminal intent). You Will Find
 Us in the Best Places*, 110
Last Temptation of Christ, The (Scorcese),
 60
Lawrence, D. H., 51Lehman, Arnold,
 44–45
Leung, Simon: *Surf Vietnam*, 33
"Life's Little Necessities" (Jones), 110
Lin, Maya: Vietnam Memorial
 Monument, 33, 90–91, 146
Long Time Coming, A (Kartemquin), **93**,
 94
Louima, Abner, 147
Luna, James, 40
Lyotard, Francois, 23

Maddox, Eva, 30

Madonna, 67
male artists, 71, 74
Mandela, Nelson, 79–80, 85, 95, 103
Mandela, Winnie, 106
Marcuse, Herbert, 29
Market Theater. *See* second
 Johannesburg Biennale
Martinez, Danny, 33
Marxism, 151
mass media, 37–38;
Mbeki, Thabo, 79, 82
Medea, 60
Meireles, Cildo, 108
Melville, Herman, 150
memory, 99–100
Metropolitan Museum of Art, 47–48
Meurant, Victorine, 74
Mickey Mouse, 150–151
Mirth and Girth (Nelson), 43
modernism, 21–22
modernity. *See* modernism
Modotti, Tina, 74
Monet, Claude: exhibition at the Art
 Institute of Chicago, 130
Mosquera, Gerardo, 102, 108
Museum Africa. *See* second
 Johannesburg Biennale
My Lovely Day (Siopis), 106

nation, 133
National Artists' Coalition (South
 Africa), 30
nationalism, 3
National Endowment for the Arts,
 15–16, 19, 36–37, 40, 144, 146–147;
 budget for, 25; debates
 surrounding, 145, 147
National Endowment for the
 Humanities, 36
National Gallery of Art. *See* Vermeer,
 Jan
National Party (Republic of South
 Africa), 84–85, 100
Ndebele, Njabulo, 83
NEA. *See* National Endowment for the
 Arts
Nelson, David, 48; *Mirth and Girth*, 43

New Criterion, 17
New York City, 119, 121, 147, 150–151
New York Times, 46, 146–148
Nine Mile Run Greenway Project, 26–27
Nochlin, Linda: "Why Have There Been No Great Women Artists?" 74
nomadism, 120, 123
nomads, 124
"non-place," 123–125

Oedipus, 132
Ofili, Chris: as trickster, 52, 57–58; *The Holy Virgin Mary,* 43, 45–46, 51–52, 54
Oguibe, Olu, 102, 108, 112
organic intellectuals, 14, 24
Orlin, Robyn, 102, 107
Osorio, Pepon, 26, 33
"other," the (or Other), 118, 150
otherness, 5, 138, 144–145, 150

Pageant (Diller and Skofidio), 107
"Paris Intervention" series (Kac), **139**
patriarchal structures, 68
Peterman, Dan, 30
Picasso, Pablo: *Guernica,* 18, 39
Pindell, Howardina, 109
Piss Christ (Serrano), 53–54
pleasure principle, 133
Poe, Edgar Allan, 51, 118, 150
"posthuman," 137–138, 140–141
postindustrialism, 119
postmodernism, 23–25, 37; legacy of, 28
postnationalism, 121
post-postmodernism, 26, 28
presidential election (2000), 2–3, 5
Prison Notebooks (Gramsci), 13–14
pro fanum, 50
professional intellectuals, 14
public funding of art. *See* art, public funding of
public intellectuals, 13–14, 19, 48; education of, 19–20
public self, 71, 75
Pujol, Ernesto, 121; *Saturn's Table,* 106
Pusy, Steven, 107

reality principle, 132–133
reconciliation, 77–78
Reith Lectures, 13
Representations of the Intellectual (Said), 13
Richards, Colin, 102, 110, 112
Rosenthal, Rachel, 40
Royal Academy of London, 44

Saatchi, Charles, 45, 48
Said, Edward, 16–19; categories of intellectuals, 15; organic intellectuals, 14; *Representations of the Intellectual,* 13. *See also* Gramsci, Antonio
Saturn's Table (Pujol), 106
School of the Art Institute of Chicago, 48, 53, 68–69; "Art and Politics in the New Southern Africa," 32; art education at, 56; students leaders at, 31; F, 31; "The Art of Crossing the Street," 29–30
Scorcese, Martin: *Last Temptation of Christ, The,* 60
second Johannesburg Biennale, 102, 112–113, 117, 120–121; "Alternating Currents," 106; Castle of Good Hope, 109; connections to South Africa of, 103–104, 111, 114–115; Electric Workshop, 102, 105–107; "Graft," 110; "Important and Exportant," 108; Johannesburg Art Gallery, 108; "Life's Little Necessities" (Jones), 110; Market Theater, 106–107; Museum Africa, 107; South African National Gallery, 110; "Transversions," 107
Sennett, Richard: *The Uses of Disorder,* 4–5
"Sensation," 44, 52, 57; financing of, 45, 48, 55; New York museum directors' response to, 47–48; response of American Association of Museum Directors to, 55. *See also* Guiliani, Rudolph; Ofili, Chris; Saatchi, Charles
September, Dulcie, 105

Serrano, Andres, 129; *Piss Christ*, 24, 43, 53–54
Sexual Binding of Women, The (Walker), 109
Sharpeville Massacre, 78, 80
Simon, Barney, 106
Siopis, Penny, 112; *My Lovely Day*, 106
Six Degrees of Separation, 146
Smell of Apples, The (Behr), 81
Smithsonian Institution, 91
socialist realism, 50
Society of the Spectacle (Debord)
South Africa, 32, 39, 77, 79–80, 82, 85, 94–95, 97–99, 101, 106, 111–115, 120; post-apartheid, 103–104. *See also* apartheid; Truth and Reconciliation Commission
South African National Gallery. *See* second Johannesburg Biennale
Spain, 120
spectacle, 9, 146, 151; description of, 1, 144; effective responses to, 5; effects on democracy of, 2; possible responses to, 7; role of information overload in, 7; role of media in, 6–7
Stoller, Sam, 61
Street Level Video, 26
Studio for Creative Inquiry, Carnegie Mellon University, 26
suburbia, 4
Surf Vietnam (Leung), 33

talk-show mentality, 17
technology, 7, 22
Teleporting an Unknown State (Kac), 138
television, 134
temenos, 50
Temporal Distance (with a criminal intent). You Will Find Us in the Best Places (Langa), 110
Thanatos, 35, 129
Third Reich, 35
Tigerman, Stanley, 30
Till, Christopher, 101
Time Capsule (Kac), 138, 140
totalitarianism, 50; critiques of the avant-garde in, 21

"Trade Routes: History and Geography." *See* second Johannesburg Biennale
transnationalism, 122–123. *See also* artists, transnational
transnationality. *See* transnationalism
"Transversions." *See* second Johannesburg Biennale
TRC. *See* Truth and Reconciliation Commission
trickster, 49, 52–54, 57–58; as liar, 51; Hermes as, 50–51, 54; Mercury as, 50
Trickster Makes This World: Mischief, Myth, and Art (Hyde), 49, 53
Truth and Reconciliation Commission, 8, 62, 77, 82–85, 87, 104, 113, 120, 147; amnesty policies of, 81–84; commissioners of, 80; establishment of, 80
transparency of, 95–97; procedures of, 81, 97; testimonies at, 78–79, 83, 96, 106
Tutu, Desmond, 79–80, 95, 104
Tyler, Scott: *What Is the Proper Way to Display the U.S. Flag?* 53

Ubo and the Truth Commission (Kentridge and Taylor), 107
Unabomber, 149
United States, 38–39, 143–146, 151; as Other to itself, 148; denial of racism in, 97; frontier myth of, 148, 150; popular myths of, 148; terrorist threats in, 149. *See also* U.S. flag; U.S. society
uses of disorder, 5
Uses of Disorder, The (Sennett), 4–5
U.S. flag, 53
U.S. society: adolescence of, 38; ambivalence toward artists in, 12; denial of difference in, 4; images of artists in, 11–12; isolation in, 4; otherness in, 144–145; polarization of, 144–145

Vermeer, Jan, 150; National Gallery of Art exhibition of works by, 131

Vietnam, 88, 92, 94

Vietnam Memorial Monument (Lin), 33, 90–91, 146

Vietnam Veterans Art Memorial Museum (Chicago), 91–92

Vietnam Veterans Restoration Project, 92–93

Vietnam War, 87, 99; aftereffects of in the U.S., 89, 94, 98–99; casualty statistics from, 88–89, 92

Vietnam War Remnants Museum (Ho Chi Minh City), 88–89

Vindication of Dulcie September, The (Haacke), 105

Virgin Mary, 51–52

Vlok, Adriaan, 104

Walker, Alice: *The Sexual Binding of Women*, 109

Walker, Kara, 109

Warhol, Andy, 38–39

Western painting, 23

What Is the Proper Way to Display the U.S. Flag? (Tyler), 53

Whitman, Walt, 150

Whitney Museum of American Art: Biennial Exhibition (1993), 39; "I'll Be Your Mirror" (Goldin), 37

"Why Have There Been No Great Women Artists?" (Nochlin), 74

Wilson, Fred, 40

women: as leaders, 75; as "the bad girl," 67; public self of, 71

women artists: challenges faced by, 71–72, 74

World Is Flat, The (Barker), 110

World Trade Organization, 7

Woynarovich, David, 24

Writing on the Wall, The (Boshoff), 108

Zaya, Octavio, 102, 106

Zimbabwe, 33

Zola, Emile, 61

About the Author

Carol Becker is Dean of Faculty and Vice President for Academic Affairs at the School of the Art Institute of Chicago. She has authored and edited several books including: *The Invisible Drama: Women and the Anxiety of Change; The Subversive Imagination: Artists, Society, and Social Responsibility;* and *Zones of Contention: Essays on Art, Institutions, Gender, and Anxiety.*